PHOTOGRAPHY

The Key Concepts

ISSN 1747-6550

The series aims to cover the core disciplines and the key cross-disciplinary ideas across the Humanities and Social Sciences. Each book isolates the key concepts to map out the theoretical terrain across a specific subject or idea. Designed specifically for student readers, each book in the series includes boxed case material, summary chapter bullet points, annotated guides to further reading and questions for essays and class discussion.

Film: The Key Concepts
Nitzan Ben-Shaul

Globalization: The Key Concepts
Thomas Hylland Eriksen

Food: The Key Concepts
Warren Belasco

Technoculture: The Key Concepts
Debra Benita Shaw

The Body: The Key Concepts
Lisa Blackman

New Media: The Key Concepts
Nicholas Gane and David Beer

PHOTOGRAPHY
The Key Concepts

David Bate

Oxford • New York

English edition
First published in 2009 by
Berg
Editorial offices:
First Floor, Angel Court, 81 St Clements Street, Oxford OX4 1AW, UK
175 Fifth Avenue, New York, NY 10010, USA

Berg is the imprint of Oxford International Publishers Ltd.

Library of Congress Cataloging-in-Publication Data

Bate, David, 1956-
 Photography : the key concepts / David Bate.
 p. cm. — (The key concepts, ISSN 1747-6550)
 Includes bibliographical references and index.
 ISBN-13: 978-1-84520-667-3 (pbk.)
 ISBN-10: 1-84520-667-3 (pbk.)
 ISBN-13: 978-1-84520-666-6 (cloth)
 ISBN-10: 1-84520-666-5 (cloth)
 1. Photography. I. Title.
 TR146.B337 2009
 770—dc22
 2009015038

British Library Cataloguing-in-Publication Data

A catalogue record for this book is available from the British Library.

ISBN 978 1 84520 666 6 (Cloth)
 978 1 84520 667 3 (Paper)

Typeset by JS Typesetting Ltd, Porthcawl, Mid Glamorgan
Printed in Great Britain by the MPG Books Group, Bodmin and King's Lynn

www.bergpublishers.com

CONTENTS

ILLUSTRATIONS

ACKNOWLEDGEMENTS

I would like to thank Marcus Bohr and Layal Ftouni for their help with picture research. I would also like to thank Rosie Thomas and Andy Golding at the University of Westminster for their support and research time and Tristan Palmer, the series editor at Berg.

INTRODUCTION

When you buy a camera it normally comes with a handbook that tells you how to use it. With digital cameras this is now even incorporated into the computer chip as preconfigured 'scene' modes. A digital camera I own has preset landscape, portrait, night scenes, food, party and other modes. These instructions in manuals and scene settings usually include tips on how to take better pictures. What these examples give us are not only the rules for how to take better photographs in certain situations, but also an introduction to the typical conventions of photography. The more inquisitive might ask why those conventions are so common and so often repeated within the history of photography.

While this book is in no way an instruction manual, it does aim to provide an introduction to the activity of photography. It is a guide to key concepts in photography. It seeks to introduce the operating conventions of a number of photographic practices, not necessarily so as to make better photographs, but to understand their operations within a more critical framework. Thus it aims to provide an introduction for those wishing to study photography and who are interested in it as a practice and its critical effects. Since photography is employed in so many different aspects of life, across a whole range of cultural and social uses, the scope of such a study is extremely large.

There are many ways in which photography might be introduced. For example, a study of photography could be conducted through investigating the key institutions that use it: advertising, journalism and news, amateur and tourist photography, fashion, art and documentary, police and military or even uses on the www. The sociological anatomy of these institutions might reveal the systems by which photographs are produced, the arteries of power and decision-making, or even the creative space that photographers are supposed to occupy. Such a project is probably urgently needed, but not for my purposes here. It would tell us about the functions of those institutions and only *their* uses of photography.

Yet the same categories of photograph are also found in other institutional uses of photography. For example, the police may use a specific type of 'portraiture' in a mugshot. This picture may then be shown in a newspaper or in some cases on

billboards, thus appearing across at least three institutional settings: the police, newspapers and the sphere of advertising, each with their own specific conditions of spectatorship, discourse and values. Other types of photograph have even more discursive lives.

Photographs are, as almost everyone knows, part of everyday life for many people all over the world. If I wish to travel, a photograph of my face is required to indicate my identity in my passport, without which it would be hard to go anywhere. I am likely to have already seen photographic images of my destination before I have even been there. Tourism, for instance, is a massive, billion-dollar global industry that uses multiple genres of photography to advertise its products: holiday locations. It uses landscape conventions to sell the location, portraiture to represent the types of people who live there (or who you should meet there), while still life is used to show the culture you can 'see' there: food, drinks, tax-free goods, local produce, souvenirs, etc.

Camera companies make assumptions about what a good picture is, based on the widely held popular view and established conventions of photography: portraits, landscapes, close-ups or still life, event pictures such as sports or holidays. The endurance of these types of pictures, their very repetition, is astounding. By focussing on the characteristics of such 'genres' of photography we might see why these types of images have such value and traffic across so many different institutional practices. So I have elected to choose categories for chapters that lend themselves to a diversity of applications.

The first two chapters consider the key concepts of 'history' and 'theory' respectively, as they relate to the general study of photography. 'History' has been a dominant approach towards photography, although it has often fallen short in accounting for the *differences* between photographs. Even so, the relation between history and photography is twofold. On the one hand photographs have made their own impact on history, by providing images of places, spaces, faces, events and things that have existed in the past. Although not to be taken simply at face value, such images provide a new type of historical artefact. The second issue is how or what historical account we give of photography itself, which is a real challenge given the increasingly vast numbers of photographs.

'Theory' has been the province of different conceptions of its object: photography. This now includes thinking about 'what we do with it': ideology. The chapter on theory here considers different phases of thinking on photography and indicates some of the limits and possibilities offered by them.

With the exception of the final chapter, which considers the increasingly important topic of the 'global' impact of photography, the other chapters deal with photography in terms of genre. As a category, genre probably requires some sort of

explanation, if not justification, since its inclusion as a 'key concept' of photography is probably something of a novelty.

GENRE

It is surprising that *genre* (a French word for branch, kind or species) has not been taken up in photography like it has in film theory or the study of literature.[1] The idea that there are categories within cinema or literature is quite normal and genre operates as much in shops where DVDs or novels are sold as they do in academic study.

In film theory, genre was introduced to do two things. Firstly, to displace the then dominant overly subjective criticism in favour of a more systematic type of thinking. The opinions of individual critics or personal taste of journalists, no matter how good or bad, are hardly a basis for 'theory'. Secondly, genre study encouraged 'the question of the social and cultural function that genres perform'.[2] This means that there are conventions at work in structuring all *types* of work.[3] The advantage of this thinking was that it showed that genres were not only a basis for grouping types of work into a category, but also that those categories could reveal the way that they operate to generate fields of 'expectation and hypothesis' for spectators.[4]

We might here briefly consider the value of genre theory for photography via the inter-textual example of the film poster (itself a somewhat neglected genre in academic study). Look at any film poster and you will see that its function is not only to introduce the film (its title, stars, etc.), but also to establish in the mind of the public what *kind* of film it is too. Posters indicate the film's characteristics in the visual presentation of them. Thrillers, comedies, detective stories, musicals, etc. all have different visual looks. In each case, particular features and combinations of elements (figures, specific lighting, colours, graphics, etc.) are used to help the spectator understand what type of film genre it is. If this explanation sounds rather laborious, it is because we tend to 'read' such things so automatically that it is almost painful to think about it. Yet, in the same way that this poster creates an expectation for the film, so a genre in photography – portraiture, landscape, still life, documentary, etc. – creates an expectation for the meanings to be derived from that type of photograph. Each genre creates an expectation for particular types of understanding. Whether the photograph gratifies that expectation is another matter.

Different genres have different functions, whether as films, novels or types of photograph. So each chapter in this book deals with a specific genre, considering the mutations it has received in the hands of photography and the aims that it sets out to achieve.

In a way, this book shows that, for the purposes of study, 'photography' is an abstraction that must be broken up into the smaller, specific – but still general – tendencies that constitute its practice across public and private spheres in most cultures. (Many histories of photography now, for instance in African and Asian cultures, are beginning to reveal similar genres of photographic practice to those used in the West – portraiture, landscape, etc. – albeit with different cultural settings and local coding.) Portraiture, for example, in all its forms, reveals a discourse on identity, whether this involves personal (sexuality, appearance, sub-culture), private or social (family, national, religious, ethnic) or institutional (occupational work) groupings. This book shows how the internal look of certain types of photographs helps to organize types of responses to those pictures.

Genres, however, are not fixed; they are mutable. Genres are processes which evolve and develop or mutate into hybrids. 'Documentary', for example, is almost certainly a specific invention of photography. It created new rules and conventions of picture-making that are now so familiar that we probably do not even notice them, unless specifically engaged within a conscious study. Art, through photography too, has mutated in the way it looks at what artist-photographers are interested in as subject matter. These are not purely formal issues either, because genres involve types of expectation of meaning that link form to content.

Most of the other genres used by photographers already existed as genres, formulated in painting, before photography appeared. Landscape, portraiture, still life, domestic scenes and 'history painting' were all already identified within art academies as modes of discourse for painters to work in. It is not to disinherit photography from its own history (the use and reinvention of these genres) that I freely refer back to painting. It seems important, to me, to not cut photography off from the other visual forms that have or do still inform it, either in history or in contemporary culture. We do not live only in a world of photographs; at least, in everyday life, there is a media environment with intersections between different texts, forms and meanings. Video, cinema, mpegs and jpeg grabs enable a very different type of visual environment.

Historically, as types of visual argument in painting, genres emerged from the eighteenth-century academies and were ranked in strict hierarchy. In France, for example, history painting was at the top, followed by landscape, portraiture, still life and flower painting as the lowest rank (delegated to women painters). Certainly, portraiture and landscape are pervasive across most photographic activity today in one way or another.

None of this is to take away *originality* involved in specific photographs; nor is it intended to. Indeed, originality or invention must be what creates change within (or even across) a genre. Of course there are genres other than the ones here, though they

would require another type of discussion (different from the purpose of this book). 'Family photography', for instance, which employs both 'snapshot' and formally arranged portrait styles, veers across documentary and portraiture, often borrowing conventions from both. A photograph of a wedding cake in a family album borrows elements of the still life genre. Surveillance photography used by members of the police and military security services might be considered as a special sub-genre of documentary, as a more static version of staring, to be considered alongside the 'chaotic' voyeuristic look developed in the codes of paparazzi photography. However, this is not a handbook for detectives, family researchers or star-struck fans of celebrities.

As photography has been more fully absorbed into the art institutions and art market, it has rejected, or transformed, the categories of modern art. Formalism has been replaced by a clear return to thinking in genres: artist-photographers now commonly create a *series* of portraits, a *sequence* of landscapes, or the repetition of distinctive types of 'event'. For all these reasons, genre offers a framework in which to consider and study the function of photography across different social usages.

Genre is a useful category for the study of photography, because a genre is never possessed or only used by one particular institution. Genres are promiscuous. Yet the theoretical importance of genres is that they enable photographers, spectators and institutions to share expectations and meanings. If there is recognition of the terms of communication there is also an expectation of knowledge to be derived from them. Put in this way, visual genres in photography function to organize stock photography archives, as well as the thinking of photographers who produce them, and the viewers who see them. Of course whether a specific photograph within a genre will gratify the expectations of that photographer or viewer is another matter. At this point, I simply wish to conclude with two points to do with the methods involved in the book.

APPROACHES

The chapter on 'theory' proposes – or more correctly, reintroduces – semiotics as a method for the analysis of the structure of photographs. In recent years this method has been replaced most often by the consideration of the effects of photographs. In media studies, 'effect' is mostly studied by asking audiences what they felt after watching a television programme or experienced other media events. In photography criticism, such effects have primarily been understood as a matter of 'personal response'. While any personal response is obviously valid, as a matter of *experiencing* things, it tells us little or nothing in terms of anything systematic about effects of photographs in the way that the sociological, evidence-driven media studies research

does about a whole audience. Photography criticism, perhaps because photographs exist in different types of space, has gravitated towards the industry of art criticism rather than media studies. The development of semiotics in the latter part of the twentieth century aimed to provide a more coherent approach to the study of photography, to address the specificity of its spaces of communication.

Yet, if semiotics failed to address the issue of effect, of 'feelings' and the psychological experience of photography, the second method proposed was that of psychoanalysis. Again, in recent photography criticism, this method has been exchanged for amnesia of both semiotics and psychoanalysis. This is surprising, given that such amnesia has not occurred in either art criticism or art history. The recent book *Art Since 1900*, a standard text book for American art students, starts with a chapter introducing psychoanalysis as the key method for a study of art.[5] While I should make it clear that psychoanalysis is not the only or key method here it is important to note that semiotics, psychoanalysis, sociology, philosophy and history are common to most disciplines that take their subject seriously. In other words, an engagement with these methods in their own right is crucial for the development of thinking through the implications of different types of photography, including those in this book. Photography theory is most often situated between art history and film theory. More positively, this book positions photographic images at the centre, amidst other things. It is from this place, with photography at the centre, that the book aims to 'fray' out. With these overlapping methods in mind, it sets out across the genres of photography to consider ways of thinking and critically understanding those types of pictures. Thus, I allow these methods to emerge in the chapters where relevant.

Finally, as I said at the beginning, this book is an introduction. It is to be read alongside books on the history of photography, and other theory and criticism texts relevant to the particular field of study being investigated or practised. That is to say it should be read as part of a web of 'texts' about photography.

Chapter Summary

- Genres give stability to the image-world of representation.
- Institutions rely on genres to achieve communication.
- Genre is not just a type of picture, it is also a set of processes that involves the producer and consumer in conventional systems of meaning production.
- Recognition of a genre is already an act of communication.
- Genres are mutable, dynamic and polyvalent.

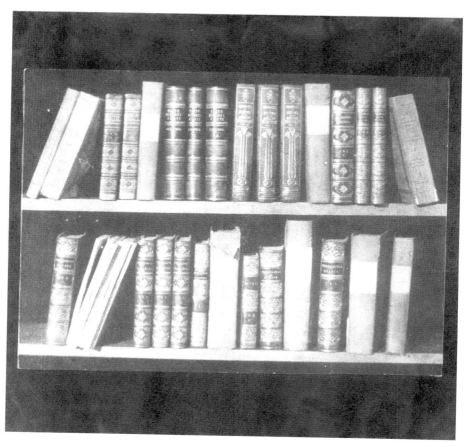

Figure 1.1 William Henry Fox Talbot (1800–77), 'A Scene in a Library', plate VIII from *The Pencil of Nature* (published in six parts between 1844 and 1846). Salt paper print. National Media Museum/Science & Society Picture Library.

Talbot was a mathematician, physicist and philologist but is best known for inventing the negative/positive process to produce photographs between 1835 and 1839. For the first time, any number of prints could be made by transferring the negative image onto special paper to make a positive print – the process known as the Calotype. Talbot's *The Pencil of Nature* was the first book of photographs.

1 HISTORY

If 'history' is the gathering together of documents, artefacts and related materials to narrate the past, what role does photography have in that process? Conversely, what role does history play in any account of photography? Might these two questions be linked?

It might be unusual to introduce a quote from the famous psychoanalyst, Sigmund Freud, here, but his remarks are highly instructive about the human value of technological invention:

> With every tool man [sic] is perfecting his own organs, whether motor or sensory, or is removing the limits to their functioning. Motor power places gigantic forces at his disposal, which, like his muscles, he can employ in any direction; thanks to ships and aircraft neither water nor air can hinder his movements; by means of spectacles he corrects defects in the lens of his own eye; by means of the telescope he sees into the far distance and by means of the microscope he overcomes the limits of visibility set by the structure of his retina. *In the photographic camera he has created an instrument which retains the fleeting visual impressions*, just as a gramophone disc retains the equally fleeting auditory ones; *both are at bottom materializations of the power he possessed of recollection, his memory*.[1] [My italics]

All these 'prosthetic' devices enable the human being to extend their 'mastery' over the world itself. Freud links the invention of photography to the faculty of memory rather than vision. It is certainly true that memory is an important aspect of the function of many types of photography. A portrait of a person stands in for that person when they are absent and a landscape reminds the photographer of a place they once visited. Memory is a way of keeping something, not losing it. Yet these pictures, like snapshots, documentary or photojournalism photographs, also show other viewers something (people, places and things) that they may have never visited or seen before. Furthermore, when photography is combined with other instruments, like the microscope and telescope, it has extended the human capacity for sight; photography becomes a device that adds to the memory of things that the naked human eye *cannot see*.

So if Freud is right, the invention of photography has not only changed the means through which we individually recollect and remember things, events and people, including our experience of them, but it has also completely transformed the entire social relations of any 'collective' or social memory. Photographic images form the base of a vast industry and network of visual representations, along with film, television and the new media dissemination systems. Through recollection and memory the human species accumulates records of its presence on the planet. Modern cultures increasingly represent themselves visually through photographic images. What are the consequences of this for what might be thought of as public memory: history? Let's start with the issue of 'history' itself.

DEFINITIONS

The common conception of 'history', as Raymond Williams notes in his brilliant book *Keywords*, is a 'narrative account of events'.[2] Yet this simple definition quickly comes under question when we consider other uses of the term. In English, for example, history as an 'organized knowledge of the past' is distinguished from story, which suggests a more informal or subjective account, while in French, *histoire* includes both history and story. History can also be used to mean the *process* of civilization itself, regardless of any actual account of it as history. (The *end* of history thus implies the end of progress.) In German, there is a distinction between *Histoire*, referring to the past, and *Geschichte*, which includes the tenses of past, present and future. Other concepts of history include universal history, general history or specific history. We might add feminist history or postcolonial history to this list, each of which complicates what we mean when we use the general term 'history'.

This complication can already be seen in the different titles used to describe the main historical books on photography:

- *A History of Photography*
- *The History of Photography*
- *A Concise History of Photography*
- *The History of Colour Photography*
- *The World History of Photography*
- *The New History of Photography*
- *Photography: A Critical History*
- *A History of Women Photographers*
- *The History of Japanese Photography*[3]

My list could go on, but the point is that each of these types of book takes their object of history to mean a different thing. So history defined as a 'narrative account

of events' is only a general frame within which historians work. Thus the term history is marked by different, often competing, definitions. Perhaps if we were to 'boil down' these books we would see that there were certain repetitive themes, individuals, images, ideas, events and processes that remain as central, such that it could be agreed that there is a *general* history of photography, distinct from *specific* histories.

A specific history deals with, for example, the technological development of photographic techniques as a *technical* and scientific history of the processes involved in producing photographic images; or a biographical history of the personal lives of those individuals who invented, used and developed photography. Would these specific histories help to understand photography more, why it was invented and what people used it for? Should a history of photography deal with such questions at all? Is it better to have a general or specific history, or should the history of photography include all of these things in one vast *total* history? In fact, should a history of photography include all the different uses of photography in all societies? Should it include everything, and if not, why not?

This may seem a list of rather depressing (or perplexing) problems, an array of obstacles designed to put off anyone taking on the task of dealing with history. This is not the aim. Firstly, the aim is to show that what 'history' is can be quite complex and is very dependent upon the questions that the historian sets out to ask. In fact, how a historian defines their objective of history (what they want to find out) will determine the way they construct the historical account: history in practice is not 'objective' at all. Secondly, it is important to recognize that conflict and contradiction are likely to be encountered in any critical questioning and that making observations about these is a good thing. History, like life itself, is full of complexity. Indeed, complexity in itself is not necessarily a problem; it is rather how to give an account of it that is problematic, especially when history involves describing complex historical processes. So, one lesson from history might be that contradictions may not always be resolved, and that to recognize conflict as part of the process of historical research work is crucial. 'Doing history' means identifying the problematic involved in the narration of any event, and the problem(s) identified there will depend on the aim of the historical question: what question informs the historical research.

HISTORICAL PROBLEMS

So, what does it mean to talk about a 'history of photography'? The title *A History of Women Photographers* (1994), for example, implicitly suggests a critique of the previous history of photography. That critique, now obvious – after feminists have pointed it out – is that historical accounts of photography, thus far, have neglected

the work of women photographers. This issue recalls the well-known debate identified in 1970s art history, so clearly articulated by Linda Nochlin in her essay 'Why Have There Been No Great Women Artists?'[4] She eschews the usual response to such questions (the demand to provide a list of 'great' women artists) and instead interrogates the notion of the 'great artist'. In this process, Nochlin reveals the assumptions that define the 'male genius' and she goes on to show how the framework and questions that a historian asks, whether on art or anything else, determine the account produced. This leads her to cheerily ask, at one point: 'why have there been no great artists from the aristocracy?' The irony of her question, lost on those who think that art history or a history of photography is about great individuals and their works as 'genius', highlights how implicit ideological values become normalized. She shows how what is taken to be history is really historical *appreciation*.

HISTORICAL APPRECIATION

In art or photography appreciation, the use of history is highly limited. Photographs and photographers are abstracted from everything except their immediate background and evaluated as good (or occasionally bad) aesthetic *taste*. The palate of the critic, their 'taste bud', is what determines the works 'of genius'. While there is nothing wrong with such appreciation (in a sense we are all taste critics, we all have favourite pictures and so on), to parade such views and values as 'history' is certainly an inappropriate use of the term. Here history is a context or circumstance, invoked only in order to support the work, suggesting, for example, the heroic struggle involved in making the picture or indicating the personal difficulties of the photographer against which they have battled and which makes the work stand out. While such accounts may be true, it is not clear that they have much to do with history.

SOCIAL HISTORY

History, by any definition, is an account of a process, which surely includes the environment that surrounds any individual. Whether that environment is defined as the local social context, ideology, general socio-political-economic condition, intellectual current of thought or some other framework, individuals exist *in* history. They exist in the time in which they live. (Whether they feel they fit that time or not is another matter.)

Over the years, critical historians have drawn attention to this issue and developed ways of writing history that were more dynamic: individuals shown as within a *social* history. When Karl Marx, for example, wrote the historical account of an

attempted revolution (1848–51) in France, he showed the many-sided ambitions and conflicts of the different parties involved. This was a very different picture of history as a *process*. Marx gives a bird's-eye view of the events, showing the actions of various actors and factions, which, in the end, made other accounts look one-sided and full of partisan views. Marx's writings about historical events were sophisticated, showing their complexity, and also witty; certainly not the scribbling of a ranting 'totalitarian communist' as he is sometimes depicted. Consider this passage, for example, in thinking about historical processes critically:

> Men [*sic*] make their own history, but they do not make it just as they please; they do not make it under circumstances chosen by themselves, but under circumstances directly encountered, given and transmitted from the past.[5]

Marx shows, as his starting point, that individuals live within circumstances, but are not simply passive in relation to them. Individuals are active; they are 'actors' where the script is written by them in their actions and not determined in advance. But neither do they live outside of circumstances: history and tradition itself bears down on them. In one of the most famous quotes about history, Marx says: 'The tradition of all the dead generations weighs like a nightmare on the brain of the living.'[6] Marx shows, again in a few lines, the complexity of the 'historical process'. He shows that people act to determine events, but only within limits and pressures that society and its (hard to escape) past provides. We might consider the implications of this 'social history' argument for the history of photography and the historian who writes it.

THE HISTORY OF PHOTOGRAPHY

Read the account of photography by Beaumont Newhall in his famous book *The History of Photography*, reprinted many times since 1949.[7] We can see in Newhall's book an example of what Marx means about the importance of 'circumstances'. Quite simply, the fact that Newhall had been an employee of MoMA (Museum of Modern Art) and based the *History of Photography* book on its institutional collection in New York has a specific effect. The book focussed on works from MoMA's own collection, so other practices and photographers whose work was interesting or historically relevant were not included, partly because they were not – then – in the collection of the institution.

Newhall's *The History of Photography* institutes, like all history books that claim to be *The* history, a 'canon' of works to be studied. Perhaps not surprisingly for this highly influential art museum, Newhall's book argued implicitly that the photography in his history, like in the museum, should be the best of the best.

The critical historian, Christopher Phillips, in his essay on the history of MoMA's photography department, writes that Newhall was involved in 'MoMA's reordering of photography along the lines consistent ... with the conventional aims of the art museum'.[8] Here it can be seen how the specific historical *circumstances* of Newhall's position at MoMA and the publication of his book have been important in the institutional shaping of the historical account of photography. Individual people matter and make choices (to do or not to do something), which *matters* historically. They make history; literally in the case of Beaumont Newhall's book on the history of photography. Of course, we might consider other history of photography books here too, and the conditions of their production, as Newhall is only one example, if one of the most important.

It is nevertheless a testament to the *historical work* of Newhall as a historian that his book is still worth reading today, beyond the obvious shortcomings. It is notably short on important women photographers, for example, and advocates a particular modernist ideology of photography. Indeed, it was precisely this emphasis on an aesthetic history of photography that gave photography an important entry point into the modern art museum, then still mostly dominated by the traditional mediums of painting, sculpture and drawing. Newhall's *The History of Photography* enthused many art students to take up photography as art and MoMA became a beacon of light, key for many aspiring artist-photographers during the twentieth century.

How to square the conflicting views: criticisms of the book for what it excludes and recognition of the historical importance and value of what it includes? It is certainly a more sophisticated history that will be able to acknowledge and discuss these apparent contradictions and conflicts. Criticism of Newhall's project should also include recognition of its importance, what it achieved, its *value* and effectiveness. Such a view also reflects the general historical condition of photography in its relation to the art museum: photographs did not necessarily enter the museum under circumstances of their own choosing. Indeed, a long discussion could be held here about those many photographs taken for a purpose far removed from the one they now find themselves occupying in museums: under a completely different category as 'art'. The violence that this reduction can do to some works is something historians have become more aware of.[9]

For any historian then, the conditions under which research takes place involves pressures and limits. What can be said and done with a subject depends on specific conditions, particular circumstances and knowledge (even if the participants consciously do not feel these to be so), whether for photographers, critics and historians or for the institutions, practices and theories they are concerned with. Even basic practical considerations of time and space, intellectual, cultural, social, ideological,

economic, technological and political factors all have their impact on the aim, scope and ambition of a project. These are important points to acknowledge. In short, circumstances *matter*. We might then ask, in what circumstances and conditions is there a history of photography and what types of photography constitute its history?

PHOTOGRAPHY AS DISCOURSE

It is perhaps the work of photography historian John Tagg that has done most to argue for a history of photography that recognizes the 'multiplicity of social sites and social practices' of photography.[10] Tagg, in his own formative writing during the 1980s, highlighted neglected historical practices: police photography (nineteenth-century photographs of criminals), the medical use of photography to picture 'the insane' and the many albums of photographs taken of working-class slums for government use in legal and urban planning. For Tagg, such examples of photographic practice show that photography is dispersed and always implicated in discourses of power.

John Tagg argues that the history of photography should be reconsidered as within the history of discourses and institutional spaces where they appear – an argument that draws on the work of French historian Michel Foucault.[11] To insist on the specificity of these discourses is not to deny the plurality of other meanings that photographs may occupy (as object of art, curiosity, collection, etc.), but rather to argue for a historical project of photography. A historical project that asks why pictures were taken, what they were used for, how they were made to signify, for whom and where. Through his case-study work, Tagg shows that photography contributes to culture across many *different* uses. Consequently, Tagg argues, 'Photography as such has no identity.'[12] In a sense, Tagg makes the semiotic point that the photographic signifier (the picture) only has a signified (meaning) within the signifying discourses that use it. Signification is a discursive process. Thus history is the work of discussing the relations of photographs to those discourses that used them. For Tagg, photography quickly became a tool in the hands of institutions, whose 'will to power' assumed a benefit in using photography to 'visualize' things. Surveillance and spectacle coalesce in the field of photography, an industrial method of making systematic images. This process of visualization was itself one of the drives in nineteenth-century photography – to *see* society.

While, in the end, Tagg's examples tend to focus mostly on uses of photography as a 'disciplinary' device (by police, mental institutions, government agencies, etc.), the virtue of his argument is that it shows the problems of making a general history

of photography. A general history risks divorcing photographs from the very specific conditions of production in which they were made – an action that is far from innocent of power relations. Tagg is keen to argue that photography is itself not neutral either, that the production of images 'animate meaning rather than discover it'.[13] Photographs are *not* simply the transparent 'evidence' of history but are themselves historical objects, offering a kind of power about which we should ask questions concerning the conditions of their production of meaning.

PHOTOGRAPHS AS HISTORICAL OBJECTS

All photographs are produced within a context. A photographer works with materials (camera, computer, prints, etc.) within a definite social place and time. These materials and the choices a photographer exercises over them, whether conscious or not (i.e. not 'thinking about it') organizes the look of the picture. This 'subject matter', usually regarded as determined by the *intention* of the photographer, is often already socially defined in advance and given by the circumstances in which the photographer is taking photographs, whether amateur or professional: a hobby, at a wedding, birthday, or holiday, as part of work in advertising, journalism, art, travel brochure, picture library, estate agent, government, police force, hospital, Internet site and so on. In this circular logic, a photographer thinks about photographing what interests them in relation to the purpose of the picture. The aim is usually so obvious to those involved that it does not even need to be specified. To this extent it can be said that photographs en-code 'meanings' and we have to ask what is the value of this representation, for a historical, or even any other (e.g. social, personal, aesthetic, political or ideological), purpose? What can a photograph tell us about history?

HISTORICAL EXAMPLE

Let's take a picture as a short case-study example. Look at the picture at the beginning of this chapter (Figure 1.1). It is from the very first book of photographs (salt prints from Calotype negatives): *The Pencil of Nature* by William Henry Fox Talbot. Produced in six parts between 1844 and 1846, it contained twenty-four photographs. This picture is the eighth in the sequence. It shows two rows of books on shelves. The picture title is 'A Scene in a Library', which anchors what we see in the picture: 'a scene in a library'. The photograph does not show an entire library yet it seems and feels – 'looks like' – a library to me. I take it on faith that the books are in a library in the *off-screen* space outside the frame of the picture. In this photograph we are shown

a partial view, a fragment of something: the library. The role that the image and caption play here is crucial; they work together affirming one another. The picture reiterates the statement made in the title, which returns the same compliment to the picture: 'Yes, this is a scene in a library'. It shows a *scene* of books, but we certainly do not *see* a library. Talbot, who invented the first negative/positive photographic process, achieves meaning through the picture on its own (as autonomous object) and the work of the written title.

Now this may all seem like making heavy weather of a trivial point, but it is in order to introduce a critical distinction between the role of the text and image (or *scripto-visual*) relations and what semiotics describes as the rhetoric of photography.[14] Rhetoric names the means by which arguments are made, even in photographs. In his essay 'Rhetoric of the Image' Roland Barthes notes:

> the more technology develops the diffusion of information (and notably of images), the more it provides the means of masking the constructed meaning under the appearance of the given meaning.[15]

In Barthes's definition, the 'given meaning' of a photograph hides the 'constructed meaning'. The apparent innocence of the photograph is what Barthes identifies as the paradox of photography, which 'seems to constitute a message without a code'.[16] Fundamentally, photographs are convincing because they hide 'behind' the referent, the things *in* the picture. The indexical 'naturalness' of *what-we-see* is itself the core ideological feature of photography. This seeming 'innocence' of photography is part of its rhetorical power, a power multiplied in every reproduction of that picture, that we see something apparently 'as it is'. Photographs give the illusion of a transparent access to 'reality' as the real 'language' of photography.

Barthes premised this rhetoric of an image in the distinction between the *denotation* and *connotation* of a picture. A denotation is 'what we see', what can be described as simply 'there' in the picture. Connotation is the immediate cultural meanings derived from what is seen, but it is not actually *in* the picture. In practice, we rarely make such distinctions because they appear together at the same time as a picture's *obvious* features. In the Talbot example, the denotation is the two rows of books lined on shelves, while the connotation is the 'library', which as already pointed out is not in fact *in* the photograph. That is to say, the literal message of books on shelves, what Barthes calls a 'given meaning' hides the constructed (symbolic) meaning: a library scene. We can say that what is shown here is a *metonymy* (a part standing for the whole) of a library.

The simple distinction between denotation and connotation made above shows that the meaning given to a picture, its connotation, is also dependent on the knowledge of the viewer. I need to know, in advance, what a library is for the denotation

of the picture (books on shelves) to signify (library). I need to have a cultural know-ledge of a library as a concept (repository for books and other artefacts) in order for the picture to have cultural connotations; otherwise the picture will remain a brute or mute 'denotation'. The significance of this proposition for the use of photographs in history (e.g. by historians) is crucial: meanings attributed to pictures are also dependent on the cultural knowledge held by the person looking at the picture. As Roland Barthes put it:

> Thanks to its code of connotation the reading of the photograph is thus always historical; it depends on the reader's knowledge just as though it were a matter of a real language [*langue*], intelligible only if one has learnt the signs.[17]

This point also demonstrates that the meaning of any photograph, its connotation, is never entirely *fixed*. Indeed, the discursive knowledge a viewer brings to the picture means that the connotations of a picture are always potentially *plural*. As Barthes puts it, the meaning of any photograph is *polysemic*.

If I now introduce the information, from the Talbot archives, that these books are not books laid out in a library, the meaning of the picture shifts.[18] These books were arranged on a makeshift shelf in the courtyard of Talbot's home (Lacock Abbey), because the quantity of light available indoors was not sufficient (the Calotype negative process required bright sunlight to function). Talbot poses the books as though on library shelves to be registered as an *image*, via the chemical base of the process.

Indeed, other pictures in Talbot's book were taken outside too, even the picture of a table laid for tea, where, if you look carefully, you can see blades of grass at the edge of the picture. We might think that the arrangement of books on the left-hand side, casually leaning towards the right, are put there to suggest a library in use. Some books have recently been removed. Are we fooled? Does Talbot encourage us with his image to think of this as a real library? Talbot has quite literally *constructed* the connoted meaning of 'a library' from an arrangement of books and bits of wood outside his house. He creates meanings with the picture.

If we take 'A Scene in a Library' at face value, as what appears obvious, we see a picture of a historical library as it looked then, in 1844. Such a positivist view of the photograph, so often the view taken by historians, leads us into assumptions about the past that should not be made. Although it is hardly catastrophic in this case (these are books from Talbot's library), it shows how far we need to know historical *circumstances* of a photograph both for a history of photography and for the use of photographs as history.

PHOTOGRAPHIC KNOWLEDGE

What, then, do we know about Talbot's aim; what did he set out to achieve with this picture? Can we tell by looking at the picture? Was it made to show how easy it is to deceive the viewer with the very first book of photographs? How far does the picture and caption *deceive* us? Is the picture still 'true' in that it claims to show 'a scene from a library'? Surely it *does* show a scene that is plausibly like a library? Does it really matter if he re-arranged the books from his real library outside in order to make it look like one? Would it have looked much different taken in the library (if it had been possible)? What is the difference? Is it not true that books are found on shelves in a library that might look like this? How are we to treat Talbot's picture as a historical 'document'? Should it make us question the veracity of other pictures? Neither completely false nor completely true, we are left with a picture and caption that is persuasive, but nevertheless not totally trustworthy.

It might seem ironic today that the inventor of the negative/positive process of photography, for so long the dominant method of producing photographs, was himself a world expert in linguistics. That Talbot, a learned man whose knowledge and fascination with language was extensive, should give rise to a visual 'language' of photography might suggest that the picture shows his love of books, as a writer and linguist. Indeed, it was not his only picture of books.[19] From this biographical knowledge, the discourse about the author, a supposed 'intention' is projected onto the picture as another 'connotation', his love of books reproduced here in the very picturing of them.

Historians of photography and specialists on Talbot in particular argue over whether Talbot was an artist *or* scientist, a schism that defined the discussions of photography in early debates about its use and value. However, if we look at the written statement, by Talbot, accompanying the picture in *The Pencil of Nature*, it is clear that his passion and interest is really *knowledge*, which includes both art and science:

> When a ray of solar light is refracted by a prism and thrown upon a screen, it forms there the very beautiful coloured band known by the name of the solar spectrum ... Experimenters have found that if this spectrum is thrown upon a sheet of sensitive paper, the violet end of it produces the principal effect: and, what is truly remarkable, a similar effect is produced by certain invisible rays which lie beyond the violet, and beyond the limits of the spectrum, and whose existence is only revealed to us by this action which they exert.[20]

Talbot's remarks show his scientific interest in the image: the capacity of light to 'reveal' something in the 'invisible rays' known to exist beyond human vision (beyond

the ultraviolet rays at one end of the light spectrum and infrared at the other). Talbot's written account, juxtaposed with the picture, suggests *his* associations about the possibility of seeing beyond what is visible. Talbot's thirst and love of knowledge, already evident in his work on language and archaeology, is located in terms of what we cannot yet see, to see 'inside' these books.

What I hope to have shown here in a basic and sketchy way is how different discourses and knowledge can change the connoted meaning of a picture. A cultural knowledge of a library, reference to historical documents by Talbot, his biography, a written text from his book or scientific theory on light, etc., these all shift the connotative meanings attributed to the picture. I might ignore all these 'readings' produced and simply say that the library, for a learned man like Talbot who clearly enjoyed knowledge acquisition, is an important space and that is why he bothered to *re*present it on his courtyard. Whatever reading I make, this possibility for *plural* meanings in photographs is the condition of their use within historical processes too.

PLURAL MEANINGS

While John Tagg is concerned to fix the meanings of photographs into the moment of their production, others see this plurality of meanings as potentially productive. The cultural studies theorist and historian, Stuart Hall, makes this point in his essay on news agency photographs of Caribbean migrants to Britain during the 1950s and early 1960s. Hall shows how such pictures can be *re*interpreted to situate the position of the migrant in the 'liminal' space of the railway station on arrival in the new country. The pictures can be *re*read for their content of an alternative migrant history 'of black people in Britain'. As Hall notes:

> The exercise in interpretation thus calls for considerable tact, historical judgement – in essence, a politics of reading. The evidence which the photographic text may be assumed to represent is already overendowed, overdetermined by other, further, often contradictory meanings, which arise within the intertextuality of all photographic representation as a social practice.[21]

History is not merely a matter of pure description. Tackling the contradictory or different connotations systems that various discourses have imposed on photographs is itself a part of historical work. Dealing with history means negotiating these discourses and choosing a path through them. The task of the historian then is to *interpret* documents, including photographs, not to take them as mere 'facts' to be put into a chronology.

Some may still claim that what a photograph shows is 'self-evident', that it is simply what we *see* when we look at it. Of course, as a customer or 'user', I may do

what I like with a picture – ignore it, 'read' it, enjoy it – but these are all, in some sense, kinds of interpretation. History (and theory) both set about understanding the significance of photography and understanding the discourses and plurality of institutions that photography entered.

The virtue of Tagg's work on photography has been to situate the analysis of photography historically within institutions, without the typical sociological model of an institutional analysis made through empirical data (hierarchies of staff, statistics, interviews, bureaucratic structures of organization, etc.). Tagg also shows the weaknesses and strengths of photographs used as 'evidence'. His approach led to a widely accepted idea that photography is made up of *histories* in the plural and is not a singular history. One, perhaps unintended, consequence of this approach is to have atomized the historical study of photography. History becomes histories: plural, fragmented and dispersed. These are histories that are without what postmodern theorists call a 'grand narrative' of history.[22] They are like the shards of a shattered mirror found on the floor.

The only unity, Tagg argues, is in the society or 'social formation' itself, a view that is contested. The eminent social historian Eric Hobsbawm has argued that, while cultural forms like the arts are quite clearly rooted in the society that produces them, their development is also 'in some way separable from their contemporary context'.[23] This has a ring of truth about it. After all, how does newness come into the world if everything is *already* circumscribed by existing discourse? The newness and novelty of photography itself, we can argue, introduced potential new discourses and modes of knowledge. This 'relative autonomy' of cultural forms suggests that at any one given moment various parts do not add up to a single whole, or a social 'totality', as social theorists call it. The concept of society and the 'social process' that produces it should therefore include and accept that conflict and contradiction are part of what determines it. A nation-state can be at war, for example, where many of its population oppose and protest against it, while others continue their lives feeling unaffected by it. The role of all conflict, internal or external, public or private, in social processes can determine the direction and even the outcome of specific events. The role of photography, by representing support or opposition to a conflict, for instance, itself can be counted as a historical force, playing a role in social meanings.

This brings us back to the point made at the beginning of this chapter and the proposition by Freud that the invention of photography empowers the faculty of recollection. What is the impact of this photographic power of recollection? With the constant production and reproduction of billions of photographs on a daily basis, the problem for any historical work on photography today is to find a method that can cope with such quantity. One solution has been to start with the idea of personal

memory, since most people have private archives of photographs, if only snapshots of family, friends, etc. These specific private histories and the social memories derived from them certainly contribute to a new realm of *personal histories* (or, as feminists have insisted, *herstories* too) and give access to a dimension of the social world that was rarely represented hitherto. In the hands of some, these personal histories can become a way of doing social history (a good example is the writings of W. G. Sebald or the work of photographers like Tracey Moffatt, Jo Spence or Dinu Li). In the hands of others, personal history is a means to evacuate any social or general history.[24]

If the purpose of using photographs in history is to 'see' the past, then it is nevertheless important to remember that the photograph is always already a mediated view, an interpretation whose meaning is potentially polysemic, thoroughly *plural*. This is the uncomfortable fact about any photograph or document in historical work; a photographic meaning is not fixed in history, it is the historian who does that: meaning is fixed by the discourse of history.

Chapter Summary

- History is a narrative account of events.
- The account of historical events given will depend on the aim of the historian.
- The history of photography has typically been a general history or specific histories neglected by that general history.
- The historical collection of photography within art museums has tended to emphasize photography as an aesthetic form, selecting the 'best of the best', which ignores that photography exists across a plurality of social sites and institutions.
- Photography creates images for history, but reading these involves making interpretations of complex facts.

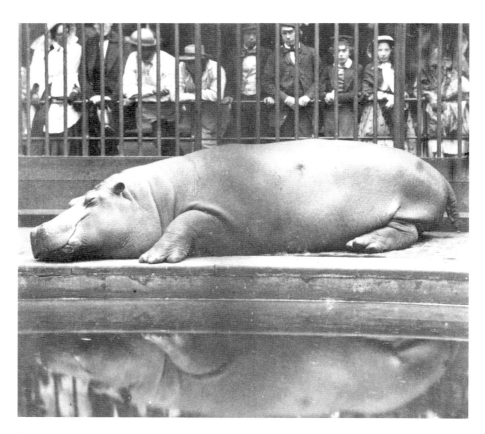

Figure 2.1 Count de Montizon (Juan Carlos Maria Isidro de
Borbón, 1822–87), 'The Hippopotamus at the Zoological
Gardens, Regents Park', London, 1852. Salted paper print,
wet collodion negative using double lens, instant exposure.
Royal Photographic Society Collection, National Media
Museum/Science & Society Picture Library.

2 PHOTOGRAPHY THEORY

The first myth to dispel about 'theory' is the idea that we can do without it. There is no untheoretical way to see photography. While some people may think of theory as the work of reading difficult essays by European intellectuals, all practices *presuppose* a theory. Even someone who claims to be 'against theory' is, ironically, actually articulating a theoretical position on theory (albeit one that is far from new or very useful). Certainly theory can be difficult, but so is ice-skating to the novice. Like most things, theory becomes easier with practice; just like new words and concepts that inevitably belong to that discipline become easier with practice too.

Photography would never even have been invented without theories of chemistry, geometry and optics (and theory of light). Of course, one does not necessarily need to 'learn' all those theories these days since they are now already built into the photographic apparatus itself. However, understanding the consequence of those theories (geometry, light and optics) on the use of a camera will certainly help to attain control over the medium. Indeed, what is called *technique* is really a practical theory: the knowledge of how and what meanings can be achieved with photographic equipment. Theory then, is not simply a matter of opinion, something purely personal, it is what can be taught: photography theory is the method or means for a systematic understanding of its object. Theory – thinking about things – helps us to articulate what it is we are grappling with and to find a way through it. Imagine someone trying to photograph a pet cat. The picture does not come out for some reason. The person turns to the instruction manual for a solution: this is a turn to theory, admittedly a somewhat basic example.

We need theory when there is a problem to be dealt with and an existing mode of thought cannot deal with it. The question to be asked here is: what kind of theory does photography need? In other words, *what* problems does photography raise? As will be seen below, the main arguments have centred on what photography is (identity), how it contributes to culture (value) and why it has been such a successful invention (social purpose).

A SHORT HISTORY OF PHOTOGRAPHY THEORY

We can identify three key periods when outbreaks of theory in and on photography have occurred. The first inevitably started when photography was invented in the late 1830s. The second was at the beginning of the twentieth century in the 1920s and 1930s, then again in the 1960s and 1970s, which rippled over into 1980s 'postmodernism'. The consequences of all these theories remain within contemporary thoughts about photography, but in different ways. Each of these periods had new modes of thinking on photography – which is not to say that interesting thoughts have not emerged at other times, just that the ideas of these periods remain key as influential ones today. If we are still in the shadow of those theories, what better way to evaluate them than to bring them out into the light of day? Let's briefly consider the three periods and the issues they raised.

VICTORIAN AESTHETICS

The initial question posed with the invention of what we now call photography around both Daguerreotypes and Talbot's Calotype was: how far is photography able to copy things accurately? Can we 'trust' photographs as accurate representations of the things they show? The old Greek name for this copying or 'imitation' is *mimesis*, which relates to a much larger philosophical discussion (ontology) of how we represent or see the world – or what the Victorians preferred to call Nature. The title of Talbot's first book of photographs summed up this attitude towards copying: *The Pencil of Nature*.

The second question to emerge in this early period relates to this initial issue, in that, if photography copies things, how can it be art? (This in turn begs the question, whether art is anything to do with copying.) It was not long before advocates of photography began to form an aesthetics that would promote photography to the status of art, although the advocates disagreed as to which qualities of the medium made it art: precision or composition, clarity or idealism, *Naturalism* or *Pictorialism*. The values of 'artistic photography', combined with the first question, formed what can be called Victorian aesthetics, a set of debates that attempted to situate photography within a field of visual art. This field was already dominated by painting, which in turn had responded to the invention of photography with specifically human theories of vision, i.e. *Impressionism*. Of course to consider these questions in the 1840s, when photography was only just spreading across the world, is very different to thinking about them today.

All the same, a modern commonsense view of photography, where access to a camera is overwhelmingly common, still arrives at similar conclusions to those early debates on photography, albeit in a different vocabulary. In the popular view, a camera is a kind of automated vision that records things, but requires a creative being to bring it into 'art'. The longstanding Romantic belief in the special ability of human *imagination* is required to make a modern technology like photography 'creative'. As a society develops science and technology, techno-science, the distinction between special qualities of the creative imagination and technology are put under tension and revised. The faculty of human imagination, seen as separate from technology, is embodied in the photographer who uses the technology. It was not until the 1930s that such propositions were really interrogated – that is, the full impact of photographic technology on all the arts and culture – when photography began to change the entire notion of creative imagination.

MASS REPRODUCTION IN THE 1920s AND 1930s

The emergence of mass democracy and mass media reproduction of photographs in the 1920s and 1930s were bound up together, when photography and cinema emerged as key modern mass media tools. Artists proclaimed photography and cinema to be the new technology of the twentieth century, a technology for the masses. Avant-garde and modern theories of photography exploded during this period, and tried to situate the place of photography in the new century in different ways. After the First World War accelerated the technological development of photography, almost anything seemed possible in the new, changed political landscape and many of the ideas generated in this period still have an impact on thinking about photography today and are worth revisiting. Concepts of montage, realism, formalism, democratic vision, modernism, documentary, political photography, psychical realism, and others, were all formed in this period in avant-garde manifestos (Constructivism, Futurism, Surrealism, etc.) and by individual writers and photographers.

It would be impossible to summarize all of them, but one of the key essays from that explosion of theory to endure today is 'The Work of Art in the Age of Mechanical Reproduction' (1936) by the German writer and critic Walter Benjamin. Although Benjamin wrote several essays on photography, all fascinating, his 'Work of Art ...' essay puts its finger on precisely the real significance of photography in its impact on art and culture. In a famous passage, Benjamin writes:

> Earlier much futile thought had been devoted to the question of whether photography is an art. The primary question – whether the very invention of photography had not transformed the entire nature of art – was not raised.[1]

He immediately overturns the nineteenth-century debate. Benjamin's essay is packed with discussion and arguments that explore the way that the photographic production and *mass re*production of images have transformed relations to social rituals, art objects, people and the spectator. It is a veritable goldmine of thoughts. His arguments would go on to inform many subsequent arguments, including the massively popular book by John Berger, *Ways of Seeing*, first published in 1972.[2] Initially a television series, Berger's book developed the argument that photography had not only transformed ways of seeing high art painting, which had lost authority with the rise of the new mass media advertising images, but also demonstrated how all these images helped to structure the way we see each other as men and women. The virtue of Berger's book is that it paid attention to the pictures themselves, how they 'work', and linked this to a critical analysis of the social purposes for which those images were intended. *Ways of Seeing* located photography – as it still is today – within our social environment, and showed the massive significance photographic images have in terms of their meaning. This emphasis on meaning and social context provided a platform and introduction for the more sophisticated analytical work on photography that had been developing in France through semiotics.

THE 1960s AND 1970s

There is no doubt that the rise and consolidation of the communications media industries, including advertising, television, fashion, marketing and cinema, all became major agents of culture in industrial societies. The role of photographic images in these cultures provoked a range of studies about their significance. In a book called *Photographers at Work*, the American sociologist Barbara Rosenblum tracked working photographers in advertising, news photography and fine art to find out how their particular roles determined the look or style of their photographs within that institution.[3] In 1965 the French sociologist, Pierre Bourdieu, examined the role of photography among the middle classes as a leisure activity, which despite the scorn thrown upon it showed a distinct ambition, no less than the activities of a professional. Roland Barthes, one of the most sustained influential writers on photography today, had already published two theoretical essays on photography in 1961 and 1964 in the French journal *Communications*: 'The Photographic Message', on news photography, and 'Rhetoric of the Image', on advertising.[4] The intellectual and cultural excitement of new thinking about society and culture in Paris (labelled as *Structuralism*) also broke out onto the streets with the student revolt of 'May 1968'. In the USA, civil rights movements raised the issue of race, while the Women's Movement internationally challenged the existing subservient social position allotted to women.

The outbreak of theory, including the theory of photography, coincided with these new movements, in their sense of critical social purpose. In this same context, conceptual artists began to use photography too, as a means to challenge the orthodoxies of fine art. Unlike fine art photography, where the craft-value of the image production was itself part of the meaning-value, the use of photography by conceptual artists documented actions, installation work, performances and events or was *part* of an artwork. In essence, these artists began to use and interrogate the way photography had overturned traditional notions of art in the manner that Walter Benjamin had indicated in his 1936 'Work of Art' essay. Probably most significant here is Victor Burgin, the English conceptual artist who turned to photography as a basis for his own practice and began to draw together the different tendencies: the critical semiotic theory of Roland Barthes (and others) and the conceptual framework of art and photography theory. His edited volume of essays, *Thinking Photography* (1982), draws together some of the key new theoretical arguments about photography during this period.[5] By the end of the 1980s, photography finally began to be absorbed into art institutions in the way that it is currently seen – as a dominant modern art form. Photography now forms a vital component of the institutional value of art (see Chapter 7: *Art Photography*). However, photography theory of this period remains a main reference, so it is worth mapping a more detailed introduction to what it contributes to critical thinking on photography.

THEORY OF REPRESENTATION

Do people ever really think about whether photography is important in their lives? While there are millions of cameras in the world it is hard to imagine people grouped on a street having a heated discussion about an advertising billboard or a newspaper photograph as part of everyday life. Most of us experience photographic images 'in passing', a fleeting glance and an occasional stare as we go about our business, walking down a street, turning on a screen or looking at a magazine page. Art galleries and photography books are perhaps one notable exception where concentration on specific pictures is more common. So, although photographs surround us in our daily lives in so many spheres of cultural activity, we are rarely very conscious of them. What role does this environment of photographic images play in social relations, in how we see the world, other people in general, or even ourselves? Is it precisely because of their prolific dissemination that we do not really notice the photographs around us? What effects do they have? Do we even *see* them *as* photographs?

In my fridge, a milk carton has a photographic image of cows on it. Shown in a green field on a sunny day, the cows look 'fresh' and 'happy', so I think of them as

'healthy'. Such photographic images are hardly artistic statements (for a start they are in my fridge, not a gallery), but they are significant in how I see the product. Although the cows in the picture are probably not the ones who produced the milk in the carton, I imagine that ones like them did, even though this may be wrong. When you start to look for them, *idealized* photographs are everywhere, used to incite the desire and appetite of the consumer, and not only in the domain of food.

Fashion, travel brochures, cosmetics, music, cell phones, computers, automobiles, photography, people – in fact, almost everything – can be made to look attractive photographically. Governments explicitly acknowledge how powerful photographic images can be in their control of advertising images. The role that photographs play in our everyday life is important, such that what we are allowed to see is a matter of political judgement and decision by social institutions. Although many of us probably see dozens of photographic images almost every day, it is easy to forget their impact upon us.

Critical analysis of such images can help reveal something about how we see ourselves (and how we do *not* see ourselves), our ideology, the practical knowledge that we use to live in terms of our beliefs and values. The French philosopher, Louis Althusser, argued that ideology was primarily communicated through 'images, myths, ideas or concepts' in ways that we do not usually think about.[6] These ideas, manifested through representations, are 'unconscious' in that we do not really think about them (what psychoanalysis would call 'pre-conscious' ideas). Ideology is *re*-produced through the ways in which a society represents itself to itself – what people claim is 'common sense'. Some might judge these ideological values to be 'true' or 'false', or simply 'wrong', but this does little to understand how such ideas are perpetuated and supported, often by people or institutions who have the least to gain from them. The first serious attempt to develop a *systematic* theory of the ideology of photography was through the discipline of *semiotics,* a method of cultural analysis most famously proposed and developed by Roland Barthes during the 1960s.

STRUCTURALISM

In the 1960s, 'theory' derived from France created a great deal of excitement and Roland Barthes was one of the many involved.[7] At first these intellectuals were grouped under the term structuralism. Structuralism, as its name suggests, focused on structures and the system of rules that underpin and organize any practice and was based primarily in a new, expanded use of linguistic 'semiotics' (or semiology). The aim was to find out the 'grammar' of forms, like language. Later critiques revised the method using psychoanalysis and deconstruction and gave the new name: poststructuralism. These theories, structuralism and poststructuralism, had

a profound impact on a whole range of disciplines, specifically literary theory (the study of literature), film studies, media studies, cultural studies, art history and photography theory.

Although Roland Barthes was primarily a literary critic, his writings covered a wide domain. He wrote essays on art, cinema, photography, fashion, rhetoric, pleasure, music, his experience of Japan and many other things, right through to what he called 'mythologies'. His book, *Mythologies*, is an amazing critical analysis of everyday phenomena in 1950s culture: washing powder, automobiles, wrestling matches, tourist guides, the Tour de France and 'steak and chips' – all subjected to ideological critique and still worth reading today.[8]

During his brilliant literary career, Roland Barthes frequently demonstrated his specific interest in the operations of photography and wrote about its various uses: news photographs, advertising photography, film stills, shock photographs, art and his own personal family photographs. (In *Roland Barthes by Roland Barthes* he also produced a book, somewhat ironic, about himself as a 'signifying system', including the photographs taken of him.[9]) In each essay on photography, Barthes tackles how photographic meaning is achieved, using his own experience to test and develop the semiotic methods and approaches to photography. Although he died in 1980, the literary richness of his work and the fact that he was trying to work out *how* to theorize photography has meant that his essays are still widely read as essential reading among photography students. His last book, *Camera Lucida*, perhaps now his most popular essay on photography, was something of a departure from his previous work and emphasized phenomenology as its method instead of semiotics – a fact that many have ignored – in a project that still bears the trace of his work in semiotics.[10]

SEMIOTICS

Semiotics is the study of sign systems. Early semiotics originated in the linguistic theory of language systems (English, French, Russian, etc.), but was quickly developed to think about other possible 'language systems'. In *Elements of Semiology*, Barthes tried out the idea that you can treat food, furniture or fashion as a 'language'.[11] The project aimed to identify the fundamental rules (*langue*) that enabled a practice (*parole*), in the way that the *rules* of chess enable players to participate in a particular chess game. We could then ask: is photography a language, does it have rules that define it? Let's first consider the semiotics of language, in order to move on to the semiotics of photography.

One of the key founders of modern semiotics, Ferdinand de Saussure, argued that language is an organized system of signs that we operate (speak and write) so as to be

able to represent ourselves in human culture. None of us 'owns' language, we all use it and that is the basis upon which it works. If I say 'I', this is the same 'I' in language that everyone else uses. You could say I have borrowed it temporarily.

Saussure argued that every linguistic sign gains its significance and meaning not from the object that it names, but through the difference between signs *within* the language system. In the English language system, the basic structure is the alphabet. The letters ('phonemes') are used in combinations to construct words, e.g. 'tree', 'cat', 'mat', 'and', 'etcetera', all based on *difference*. Words or 'signs' are put together in a particular order to construct sentences, as in: *The cat sat on the mat*. Not very original, but it reveals the basic structure of language in the syntax of the sentence. A particular combination of letters in a specific order is required to construct meaning, such that any variation from the sequence can dramatically change the meaning, for example: *The mat sat on the cat*. Or, if I put the letter *b* instead of *c* in front of the letters *at* I have *bat* (instead of *cat*), which makes *The bat sat on the mat* and has completely changed the logic and meaning. One phoneme has made a world of difference. In one sense, this is what poetry and humour does; it *re*arranges the expected order of syntax and normal logic, mixing signifiers up to make language seem strange or even create *non*sense meanings, which, in effect, disrupts the sense of reality we expect from language.

It was thus possible to claim that there is a fundamental structure, a set of rules and organizing principles that underpins the logic of language, which has little to do with reference to 'reality'. The system operates through each of the terms in the basic system of elements (the alphabet) taking their definition from their *difference* to the others in the system. So, the letter *c* only has an identity by not being the letter *z*, *e* or any of the other letters. The system works through the combination of different letters put together, creating difference between signs like 'tree' and, say, 'free'. It is the infinite variation of such combinations in daily life that we take for granted, such that we inhabit this system of linguistic difference as our living habitat.

It is perhaps only when encountering a different language that this gap between language and the world of objects (the objects that language designates) actually begins to reveal itself as 'unnatural'. Suddenly, the way language names things in the world comes upon a different system. The animal called a 'dog' in English, in French is '*chien*', whereas in Greek it is a '*skilos*' and in Japanese '*inu*'. If the words that name objects and actions are 'natural' properties of the things they refer to, why do they *not* have the same name in every language? Surely a dog is the same thing in all languages? Should not this creature have exactly the same word to represent it in every language; does not language reflect nature and the world? Why is something, the same four-legged animal, given different signs to designate it in different languages? Which one is *correct*?

The answer is that these signs – dog, *chien*, etc. – only have their meaning within the particular language, the code or system in which those signs (and their users) operate. 'Skilos' has no meaning within the English language, it is only in Greek that *skilos* has a signified sense. In short, the relation between a sign and the object it designates is *arbitrary*. There is no real reason why we call that animal a 'dog', except as a matter of cultural convention. No amount of etymology will prove that the words we use to name things have any ontological base in the objects they designate. Saussure showed that the signs in any language are arbitrary, 'unmotivated', and have no particular relation to the signified objects, except cultural convention.

Saussure went further, dissecting how the sign and its components construct meanings. The linguistic sign, he argued, is made up of two components: *signifier* and *signified*. A *signifier* + *signified* = *sign*. The *signifier* is the material aspect of the sign: a picture, written word or verbal sound (e.g., t-a-b-l-e). The *signified* is the mental image referred to, the *idea* or concept of a table. Saussure likened this *signified* image to the way that: 'Without moving our lips or tongue, we can talk to ourselves or recite mentally a selection of verse.'[12] The signified is the concept of the thing 'in our head', the psychological image of it. In the example of dog/*chien*/*skilos*, etc., these are all material *signifiers* in different languages, for a *signified* concept ('dog'). The signifier only has a *meaning* within a language system when the *signifier* and *signified* are joined, that is, a unity between sound/image/word + concept. If I do not know the English language, then the signifier '*dog*' does not have a *signified* meaning.

This sort of argument can have quite an uncanny effect, when I realize suddenly, the table in front of me is no longer the object I thought it was. In Saussure's semiotics, a 'table' is now only a 'concept' referred to by language through a conventional signifier: t-a-b-l-e. Saussure saw the work that language does to secure 'reality', that our very habit of the use of language 'naturalizes' the relation to objects around us. It is in this sense that the world is what we make it *in* language and that is why language itself is so often the site of ideological struggle. Is a picture of someone throwing a bomb an image of a 'terrorist' or 'freedom fighter'? The same visual *signifier* can have different 'polysemic' linguistic *signifieds*, depending on the viewpoint where *meaning* is sometimes a political battle over the representation of the world. Language is not a passive reflection of a 'real world'; it is the way through which we come to represent and see it as 'reality'.

So how we make sense of a photograph, what we 'read' from it, will already depend at a basic level on the language system used: English, American, Japanese, Spanish, etc. It is not that we need to utter the actual words (though it is surprising how many people are unable to do this when asked) of what we see, because the signified is a 'psychological image' *in our head*. At its most simple level, a picture of a dog signifies 'dog' to an English-speaker, whereas the same picture would signify *chien* in French, *skilos* in Greek (if it is male), etc.

Here we can also see straight away how even the most fundamental signified *meaning* of any photograph (or other sign) is partially dependent upon the viewer's language, as well as the various codes that it employs and their cultural knowledge. In other words, the codes with which we are familiar (the English language, four-legged animals, photographs, etc.), enable messages to be transmitted, which the spectator 'reads' to generate meanings. We should not underestimate how far this theory has relevance for the theory of photography.

PHOTOGRAPHIC CODES

To use a language, the sender and receiver need to know how to operate and understand the same 'code'. In photography, many codes are already built into its materials, such that we do not have to think about them. The geometry of perspective, for example, is already built into the camera and lens. The lens organizes light to fall on a surface plane to create an image in perspective. So to pick up a camera is to use a set of predefined codes. We can vary the perspectival codes by *point of view* (moving the camera) and change the look of the scene with *different lenses*: wide, normal or telephoto. To 'read' these codes we need to be familiar with what the Italian semiotician (and novelist) Umberto Eco named as the *perceptive codes*.[13] Children learn to read perspectival images, so it may seem natural that we all can, but it is not obvious. Like learning a language, visual legibility in pictures is something we learn too.

Focus is used in photography and film to indicate relevance and importance. An out-of-focus object is relegated to the 'background', while an object in focus is important in the picture. Specific focus on something is a way of saying 'look at this' rather than 'that'; e.g. in portraiture, the eye is always supposed to be sharp. The use of focus is literal in its impact on the photograph, but also figurative (rhetorical) in the same way that someone might say 'focus!' to mean 'concentrate'. Try watching a film without sound and you can quickly spot how focus is used ('pulled') to draw attention to different characters in conversation or change emphasis in a scene, action or event. Moving to 'out-of-focus' is also used in cinema to signify the state of 'losing consciousness' of a character from their point of view, e.g. 'drugged' or 'dreaming'. Similarly, blur is used to signify 'movement'.[14]

Different genres of photography tend to emphasize different combinations of codes. For example, in portraiture, *codes of recognition* are very important because the expression on the sitter's face is a key factor in understanding the character of the person depicted. The face is one of the most complex units of signification of 'body language' or kinesics, and is not specific to photography. Yet a portrait depends on the use of these conventions of facial expressions, which gain their significance from

one another: a 'smile' is not 'sadness', a 'frown' not 'anger' or 'happiness', 'pain' or 'ecstasy', etc. (see Chapter 4: *Looking at Portraits*). The general signifiers of these moods are organized by an arrangement of graphic marks, as seen for example in the simple everyday email or text message:

:)

:(

We recognize these basic signs for 'happy' and 'sad' as 'facial expressions', despite the fact that they are an almost completely abstract code. They indicate how simple *and* complex the 'face' and its arrangement of eyes and mouth can be as 'expressions' to connote mood. Strictly speaking, facial codes are not all legible, which is what can make a portrait so fascinating.

Lighting is culturally coded too, even in the theatre, cinema, painting and everyday life. A direction of light has meaning – for example, 'top light' from above can signal an otherworldly presence or 'angelic' innocence (a legacy of godliness in Christian art). Move the light behind the head and you have 'glamour' photography light, while use 'bottom light' from the floor or put a torch under your chin to make a 'devilish' shadowy face. A given situation may already come with a lighting code. A street lamp at night, for example, might give a dark, moody feel (a crime scene). This would be quite inappropriate to light a wedding scene, so if the photographer does not understand the code it can be a problem. Umberto Eco does not refer specifically to lighting as a code, central to photography, perhaps because lighting is implicated within so many other codes. Lighting contributes to at least the *tonal*, *iconic*, *taste* and *rhetorical* codes.

Eco has a provisional list of ten photographic codes, which it would be tempting to simplify, however, it is rhetoric that has been the most developed within a semiotics of photography, no doubt because rhetoric is the discipline that can help provide a summary of how all photographs make their arguments.

RHETORIC

In terms of photography, rhetoric defines the organization of codes into an *argument*. Rhetoric is the art of persuasion, aiming to move, to please and instruct. The history of rhetoric goes back before antiquity, even before the famous book by Aristotle, *The Art of Rhetoric*, a basic textbook for the educated classes of Greek society, somewhere around 350 BC.[15] People learnt to be persuasive in their speech, so as to be effective, primarily in public life. The turn to studying rhetoric via semiotics in the 1960s had its specific impetus in the rise of mass communication techniques and the aim to analyse them. Hence Barthes's 'Rhetoric of the Image' essay makes

a rhetorical analysis of an advertising photograph to de-construct the ideological meanings produced, but the implications of such an analysis were clear to see for all photography: rhetoric was at work in the construction of meaning of *all* images. As Victor Burgin had already argued in 1975, meaning is not a matter of 'genius', 'lucky snapping' or simply something purely individual, but 'our common knowledge of the typical representation of prevailing social facts and values'.[16] It is from drawing on the stock of rhetorical forms that individual photographs can become 'original', seen as 'creative'.[17]

In photography, codes are combined to produce a rhetorical argument. By themselves, codes are meaningless, like phonemes in language. It is only when codes are put together in specific combinations that they are effective in producing what we call a 'good photograph'. It is from a particular configuration of such codes (whichever ones are included) that the *rhetoric* of the image determines the range of meanings available from the photograph.

THE 'LANGUAGE' OF PHOTOGRAPHY

In the 1960s and 1970s, the orthodox theory of photography against which semiotics was seen to emerge and be opposed was *realism*. Realism is an aesthetic theory based on 'similarity' or an identity between the photograph and depicted reality. The seemingly special characteristic of photographs to carry their own referents (the represented objects) within the picture is a key ideological issue within the theory of photography. Many theorists have taken this idea very seriously. André Bazin, for instance, the great realist film critic, compared the photographic image to the process of 'embalming the dead'.[18] In this 'mummy complex', he claimed, we ward off death and the passing of time by keeping the body present, achieved analogously in photography. For Bazin, with photography and cinema it 'is no longer a question of survival after death, but of a larger concept, the creation of an ideal world in the likeness of the real, with its own temporal destiny.' This is 'essentially the story of resemblance, or if you will, of realism'.[19] The argument is that the photograph is *indexical* – that is, caused by its referent. Documentary photographers, for example, are typically close to this position, often talking about the referent, as though the photograph *itself* is not present at all (see Chapter 3: *Documentary and Story-telling*). Indeed, ultimately, this aesthetic theory privileges the original object over the image.

Semiotics, the other approach, emphasizes the way difference is involved in photographic signification. As Umberto Eco and Victor Burgin both argued, if we pay

attention to the *difference* between the photograph and the real object represented, we can begin to highlight what photography (in all its guises) brings to the viewer.[20] So while realism holds to the idea that the signifier (the actual photograph) is the same as the signified ('reality'), semiotics starts with the difference between these things. You could say that in realism the signifier (photograph) has *disappeared* into the signified (referent) and we only see the subject matter. Put this way, realists often find semiotics a tiresome interference and unnecessary complication to the business of photography. The picture is seen to imitate reality, in an argument of *mimesis*. This idea is a central one for any theory of photography, even so-called 'digital' photography where the referent still involves the same issues of realism.

So, what theory is best, and do we have to choose between them? Realism or semiotics? In fact both theories are useful because they draw attention to different aspects of photography. The theory of realism shows us how people think about photography, about the similarity it appears to have with reality.[21] Semiotics, in contrast, highlights the difference between what we see in a picture and the actual reality it depicts as 'non-identical'. Whereas realism privileges *similitude* in the analogy between codes of perception and human vision, semiotics shows how *difference* operates in *all* the codes.

Let's take an example. Look at the photograph by Count de Montizon at the start of this chapter for a moment (Figure 2.1). What do you see?

POINTS OF VIEW

The photograph is quite witty, a simple visual 'anecdote'. At the centre of the picture is a hippopotamus being looked at by people. More details quickly ensue: the people are all standing behind a fence and the hippo is lying down beside a pool of water, and so on.

In terms of realism, there is a sense of immediacy to the scene, I feel *as though I was there*. I see what I see. In terms of semiotics, however, I know very well that this structure of 'immediacy' is organized by codes of perception analogous to my own vision and codes of recognition that draws on specific cultural knowledge (zoological specimens). Where realism sees a *similarity* of the picture to a real scene, semiotics sees a perceptive *difference*. As Eco notes, human vision is already coded in the very act of perception, so that I can detect, for example, whether I am looking at a photograph or a real event and know the *difference* between them. Of course, the perceptive codes of a camera are normally monocular, whereas human vision is binocular. Looking at the photograph my vision is reduced to a monocular viewpoint. If I had been there I could detect movement or look beyond the confines

of the rectangular space of the picture and shift my focus from one plane to another. So there is no 'message *without* a code'.

Certainly, realism is right to argue that I look at the picture *as though I was there*. However, semiotics also reminds me that this famous reality effect is a product of the codes of geometry and perspective, which have enabled my *imaginary* identification with the camera. 'I' am not there, the camera is, but the feeling that 'I *am* there' comes from the identification with the position of the camera. What the photographer has done, for example, is not to show us reality but to position the camera so as to organize elements – things in the world – into a rhetorical argument, even our sense of *being there*.

Our point of view, for example, positions us as looking 'directly' at the hippopotamus. The picture creates a contrast between our own invisible position, which seems natural, 'direct' and even innocent, while the people within the photograph look from 'out-side'. We seem to be inside the cage with the hippopotamus, whereas the other people are outside. (The photographer may have actually been outside the cage too, taking the photograph through railings, but the point is, 'our' viewing position *is* inside the cage.) Our proximity is in contrast to their distance as outsiders. This is already a rhetorical argument, which naturalizes our own position; we are given, quite literally, a privileged viewpoint to the scene – compared to the other people in the photograph.

I do not imagine this viewing position is the first thing we think about consciously when we look at this picture, yet it is crucial to how this, or any picture, works. In this respect, *where* we stand in our point of view to the depicted scene is unconscious. Like 'syntax' in language, we might rarely think of it in everyday life, yet it is always there, it is how meanings are organized in any specific utterance. The same is true of photographs, although it is important to stress there is no sequential order to 'reading' visual image codes (as in speech or written language). In pictures, different codes are received at the same time, *simultaneously*, whereas in language they unfold in time.

DENOTATION – THE VISUAL SIGNIFIERS

We can go further. Let's consider the key signifying elements of the picture and the signifiers of its 'syntax'. I note the hippopotamus is much bigger than the humans; there is a contrast in *size*. Secondly, the humans are all standing, whereas the hippopotamus is lying down, a contrast between vertical and horizontal, which in fact organizes the two halves of the picture: the top half emphasizes the vertical while the lower half is orientated towards the horizontal. In addition, of course, the

hippopotamus is 'asleep' or 'snoozing' while the humans are all 'awake', standing and 'looking'. Thus far, a series of oppositions or contrasts between *animal* and *humans*:

- *large/small*
- *lying down/upright*
- *asleep/awake*
- *inside/outside*

The picture makes a set of contrasts between humans and a zoological specimen: the hippopotamus. The rhetoric of the picture is a series of overlapping oppositions or *contrasts*. The technical word for contrast is *antithesis*, and we can see it at work in this picture.

In the study of rhetoric, antithesis is one of the common forms of argument. You can find it in everyday figures of speech. People contrast one thing with another, like 'chalk and cheese'. When someone remarks 'I think you are nice despite what everyone else says', the joke uses an antithesis of *opinion*. In advertising, image-makers are fond of making a contrast between 'new' and old (either can have positive value, depending on the product advertised): an antithesis about *age*. A contrast between rich and poor is an antithesis of *wealth*. In itself, rhetoric has no political allegiance whatsoever, moreover even 'neutrality' can be said to be a particular form of rhetoric.[22] Understanding how a rhetorical device like antithesis is at work in an image in photographic codes helps us to understand how meaning is derived from them. So, if we now know what the basic rhetorical elements of this picture are, what are their cultural connotations?

CONNOTATIONS – THE CULTURAL SIGNIFIED

Thus far, the signifying elements relate to oppositions between humans and animals: perpendicular/horizontal, inside/outside and so on. We can see that these signifiers (humans and animal) lead to a chain of cultural significations about the value of culture and nature. Each rhetorical element in the picture contributes towards this signified meaning in its own way.

For example, the image of people standing 'behind bars' (in English) is a metaphor for the idea of being 'in prison'. This, I suspect, is a juxtaposition the photographer saw and realized would make a 'good picture'. The animal is 'lazily' lying down *horizontally*; the humans are vertical, perpendicular. There is surely a comment here, even a moral judgement about the human species in this picture: that humans have imprisoned themselves within 'civilized' culture. This reading is reinforced by the fact that the hippopotamus is reflected in the water. The creature seems to be

bathing in its own reflection, in a narcissus-like state of being, a position of envy for the onlooking people. Further to this argument, the hippopotamus looks like it has a wry smile (anthropomorphic) on its face. This crooked smile makes it seem a bit 'smug', as though to confirm the happiness of its Rousseau-like blissful (ignorant) condition in nature; a thought that, I suspect, rarely escapes any visitor to a zoo when looking at the animals.[23] This might lead one to consider, with perplexity, how we humans got into this condition, separated from nature and stuck within the 'prison' of culture. This, of course, is ironic, given that the picture is set in a zoo and the animal is really the one in captivity. But this is surely the point of this picture, the witty remark that it makes: humans are in prison, not animals; it has reversed the usual point of view of animals in zoos.

It is the humans who are behind bars in order to look at the apparently relaxed mammal. With this antithesis, the signifying rhetoric of the photograph can then be read within different discourses. A Darwinist humour might locate these 'poor people' in the picture as somehow inferior to this majestic beast from the past that has only temporarily emerged from its muddy swamp life. Furthermore, that progress in 'verticality' (the point when humans became bipedipal – walking on two legs instead of four) has only succeeded in imprisoning humans against nature. In the discourse of an anthropologist they might find the behaviour of these humans of more interest than the animal.

Such discourses assume a cultural knowledge about zoos, the separation between wild animals and humans, and ideas about looking at animals. My *identification* with the scene can lead me to forget that I am looking at *a photograph* and that this scene must have happened, that it really existed, because it is real in my mind. Yet what proof do I have of it? If you think about it, the picture has very little in common with what it shows. It hardly resembles reality: the objects are flat and much smaller than if in our presence. Furthermore, we cannot smell the animal, or if we were there, we could move our head to detect any movement or see if anything was 'fake'. In fact what we see tells us very little about reality. Perhaps the photograph is a montage, the hippo cut out from another photograph? The people and railings could have been pasted in from another picture? Or were these people all actors, posed by the photographer for the camera? Maybe the hippo is not real? (Concrete replicas of such creatures, including dinosaurs, do exist in a London park, popular in Victorian England at the time of this photograph.) How could I tell? Is there anything in the photograph to prove one way or another any of this? Can I ever know the 'truth'?

From historical archives it is known that the snoozing hippopotamus at London Zoo in the photograph was captured in August 1849, on the banks of the White Nile, and sent over to Queen Victoria by the Egyptian Pasha. However, the photograph

does not prove this 'fact' either; I would need to produce the evidence that this was so from other documents.

In the thinking of realism we 'forget' validity, and proof comes from seeing, which in fact is always mediated via other texts, language or documents. A photograph *mediates* meaning where realism is different from *reality*.

REALISM AND REALITY

Reality is what we believe exists whereas 'realism' is the mode of representation that supports that reality. For example, during an ongoing war, we may not see many actual dead soldiers in reality (unless directly involved), but it would not be completely strange to us if a picture from the war showed them to us as a result. (Notwithstanding the fact that governments understand that 'body counts' create opposition to war.) The realism of an image corresponds to a preconception of reality. A photograph showing 'aliens abducting soldiers', no matter how realistic or believable as a photograph, is unbelievable (except possibly to UFO 'experts' and other alien believers) simply because we do not believe aliens exist. The point is that any picture is usually tested against preexisting suppositions and knowledge about the world. The reading of any picture will already involve assessing how far that picture is credible or plausible. Witness the 'compulsion to repeat' in viewing at the time of 9/11, partly because it was simply 'unbelievable' that it had happened. People struggled to grasp the 'reality' of what transpired, precisely because of the uncertainty of reference; such things had only been seen previously in *fictional* Hollywood movies and not as a *reality*.

In advertising, a picture may show something unbelievable (e.g. that young people can reverse their heads on their body), but this does not challenge our concept of reality if we believe people cannot do that. In other words, how far a photograph corresponds to pre-existing conceptions of reality is partly to do with how far it fits with pre-existing beliefs about 'reality'. Photographs are tested and assessed against these beliefs in the very act of perception, about how I already *see* the world. While this might seem like a tautological argument, it *is* the argument put forward by the realism of the photograph: the world is like this because this is how it looks. But it can look different, which depends on *how* it is photographed.

What is certain is that, when the zoo photograph was made, in 1852, many people in England had never seen a hippopotamus, let alone a picture of one. We might speculate that the photograph of this gigantic and 'exotic' mammal was itself met with incredulity at the time. A thing from 'another world' or time, just as the aristocratic photographer, Count de Montizon, seems to have been struck by these 'ordinary' people, lined up against the railings looking at this creature. The

photograph, it might be argued, has brought him closer to nature (the hippo) than to these ordinary people. This is also the same position his photograph offers us in the viewpoint given by his camera. In a way, then, one perhaps unintended conceit of the picture – its unconscious – is that the photographer also gives a 'privileged' point of view (an unmediated reality), which here happens to be that of an aristocrat: a Count. In that conceit, we are given not only a rhetorical position but also an ideological *cultural* position, one that is not only closer to nature, but somehow more noble and elevated than these ordinary people 'behind bars'.

No doubt photographers often need to think of themselves as having a special point of view, a privileged position, in order to function. It is one of the miraculous features of photography that viewers feel they share in that privilege, the viewpoint of what is seen. This remains one of the core ideological values of photography, the sense of veracity that it claims and organizes. So it is important not to forget that there is *difference* involved in photographs. What the realist takes for granted as 'reality', semiotics argues is constructed through a photographic discourse, of codes. Contrary to the views of some sceptics, visual semiotics does not refute the existence of 'reality', rather it develops a way to speak about how the graphic marks on a flat piece of paper come to signify a 'reality'. However, this is not a static procedure. Meanings do not 'stand still'. To unpack a photograph, as I have done here, is only to temporarily stop the flow of meanings, which constantly circulate in society, between and across people in the world.

POSTSTRUCTURALISM

The signified meanings that I attribute to the picture in this chapter are only temporary. While the basic signifying unit (the photograph) itself does not change, the chains of cultural connotations with which it may be attached are never fixed; a context or discourse are only temporary. Discourse is a process. The French psychoanalyst Jacques Lacan, drawing on the studies of rhetoric in linguistics, selected *metaphor* and *metonymy* as the two most important rhetorical figures, because they account for the 'slippages' in language that occur in everyday life – and in the mechanisms of dreams, including day-dreams and cinematic movement from one scene to another. This should return us to the point made earlier: that we operate language, but that language also operates us.

In short, we are never quite in control of language or *all* of its significations and in the case of photography, which is generally less precise than language proper, unintended meanings occur. What Roland Barthes once called 'obtuse' meanings may be in play in a photograph as much as the 'obvious' ones.[24] It was towards this

aspect of non-sense and human motivation in looking, desire and the drives, that poststructuralism generally turned. Like Sherlock Holmes, the detective (a brilliant reader of hidden signs), the visual semiotician also has to become a psychologist: the 'motives' and the reality of the human psyche are also needed in the theoretical tool kit. These questions of motivation will emerge in the following chapters.

Chapter Summary

- Theory is essential to all aspects of photographic practice in that any practice, willingly or not, constitutes a 'theory'.
- Photography theory has developed new ways of thinking about it alongside the transformations of the use of photography in the wider social context, i.e. the rise of advertising and editorial photography.
- Semiotics makes a distinction between the photographic signifier (the photograph) and the signified (concept). Photographs require a spectator to give the picture its signified meaning.
- Meanings are not fixed, but polysemic, mutable and contingent on the context.

Figure 3.1 Berenice Abbott (1898–1991), 'Blossom
Restaurant; 103 Bowery', 3 October 1935. Gelatin silver
print. From her series *Changing New York*, first published as a
book in 1939. Works Progress Administration/Federal Art
Project. Photography Collection, Miriam and Ira D. Wallach
Division of Art, Prints and Photographs, The New York
Public Library, Astor, Lenox and Tilden Foundations.

Berenice Abbott proposed *Changing New York*, her grand
project to document New York City, to the Federal Art
Project (FAP) in 1935. The FAP was a Depression-era
government programme for unemployed artists and
workers in fields such as advertising, graphic design,
illustration, photofinishing, and publishing. Abbott assisted
Man Ray in Paris around 1923–6, where she also rescued
and promoted the work of Eugène Atget. Learning from
Atget's ambition to 'document' old Paris before its
destruction, Abbott developed her own documentary
approach in *Changing New York*.

3 DOCUMENTARY AND STORY-TELLING

Telling a story with pictures is an old device (e.g. stained-glass windows in churches, tapestries, illustrated manuscripts), but documentary photography gave the idea a new life and social function. Documentary emerged as a popular practice across a variety of media after the First World War and developed throughout the twentieth century. Neither art nor advertising, documentary drew on the idea of information as a creative education about actuality, life itself. Documentary aimed to show, in an informal way, the everyday lives of ordinary people to other ordinary people. This idea, of showing 'everyday life' of one group of people to another group, rapidly became popular in the early twentieth century and remains a significant component of modern mass communications culture today. In this respect, the modern notion of documentary is a media product of the twentieth century.

This birth of documentary as a popular form is clearly linked historically to the rise of a large-scale mass press, particularly in the 1920s and 1930s (and even during the Second World War[1]). The emergence of popular illustrated photo magazines, which began to flood the commercial magazine markets from the mid-1930s, like *Life* in the USA, *Picture Post* in Britain, *Drum* in South Africa, and many others, created a constant flow of news stories and pictures, documentary 'stories' on everyday life. The photographer became a new media field-worker required to supply magazines and newspapers with photographs to fill the magazine pages. This demand accelerated the industry of photography and photographer-reporters, who began to play a key role in the competitive production process of magazines. (Picture agencies developed, to represent the interests of these photographers.) The photographer was the one 'out there' bringing photographs home, a 'reporter' of everyday life who supplied the pictures (and in some cases stories too) for this growing market. Many of the famous documentary photographers from that period, now known as authors in their own right, first cut their teeth working on various magazines. (The tendency to extract individual pictures from the original sequences and put them in art gallery

exhibitions has eroded the historical context in which many 'great' documentary pictures were produced.[2]) Pictures or picture stories that seemed innovative or creative were often produced in this context of photographers responding to a 'brief' set and published by a magazine.

The aim of social documentary work was not only to record and document, but also to enlighten and creatively 'educate'. The new photographically illustrated magazines emerged all over the world, with photographers as the new journalists, 'reporters', and information gathers who developed a 'picture story' – a sequence of images that could tell a story by itself with only basic, minimal contextual writing to accompany it. These stories showed the world in motion and full of life, represented by people 'in action': shown smiling, laughing, or looking angry while 'doing' something like work, play or travelling.

EDITORIAL CONTROL

The arrangement of pictures on a page could help to organize the story, such that the layout of pictures on the page became a key means of articulating a story. Individual pictures could be put in a sequence (even if they were not shot in that order) to show an event or social process unfolding in time. Pictures could be organized to indicate their significance and meaning; for example, several smaller pictures gathered around a larger central portrait could be used to show the different aspects of a character (happy, lonely, excited, etc.), or different aspects of their life (work, home, etc.). Initially, these picture essays 'translated' the literary conventions of novels – a sequential logic – but quickly developed more innovative arrangements to tell a visual story: journalism through pictures. Not strictly linear as in writing (i.e. reading from left to right and top to bottom of a page), pictures were organized *spatially* to construct a narrative effect, reinforced by basic written captions, an introductory text and title. As is now well known, cropping of photographs is an essential part of this process, to emphasize specific meanings.[3]

However, the creative art of page layout was not often in the hands of the photographer, which meant that the specific meanings attached to the individual pictures, the way they were organized in the page layout in relation to the events they depicted, could be beyond the photographer's control. The picture and magazine editor determined the choice and order of pictures, and the way they were used (captions, etc.). Editors had to think about their advertisers and audience, matters of social taste and potential legal or political issues. Censorship and editorial control could easily seem inseparable. This division in editorial work – the photographer handing control of their pictures to editors – often highlights the potential conflict of interest

between what a photographer or journalist saw and intended the photographs to say, and what the magazine wants. Even the sequence of pictures on a page can radically affect the story told. Editorial control is a key issue and the conflict between photographer and editor over photographic meaning remains highly relevant for documentary photographers today, i.e. the question of where, how and under what conditions to publish the work. This issue of control and meaning, coupled with ambition, led to photographers publishing their own work as photography books.

AUTEUR PHOTOGRAPHERS

The 1930s was also the time when documentary photographers became 'auteur' photographers, authors with control over their own work, publishing their photographic work as photo-books.[4] Brassaï's famous book *Paris du nuit* [translated as *Paris After Dark by Night*] (1933) is only one of many examples from this period: Bill Brandt's 1938 book *A Night in London* and even Weegee's later, more journalistic, book *Naked City* (1945), followed this model. In these documentary photo-books the photographs were given more prominence than the writing that accompanied them.

Brassaï was a journalist during the daytime (and one-time painter) and took up photography to supplement his written journalism work. Ironically, it is now those photographs that he is most remembered for. Photography certainly came of age as a modern mass industrial technology during this twentieth-century period.

There was an obvious technological factor here too. The sense of immediacy and spontaneity involved in the production and consumption of photography and cinema (accelerated by technical developments like the flash light bulb, 35mm film, faster lenses, the Erminox and Leica cameras) meant that these media were understood as intrinsically 'modern' and 'democratic'. Photographic still and moving images were also linked in a general way to a growing sense of political and ideological urgency after the First World War, for a new and different world that was struggling to emerge: democracy driven by the 'common people'.[5]

DEMOCRATIC VISION

The impetus for the commercial development of documentary came from the rise of mass democratic movements, given inspiration by the Russian Revolution of 1917. The revolutionary avant-garde ideas of Productivism, Factography and Constructivism in the USSR and the popular importance given to ordinary people (no matter how it was understood politically) gave a massive jolt to people within

Western democracies (and, arguably, to indigenous peoples in colonies too). Inspired by the idea of Factography, the 'representation of the people' was essentially absorbed widely into societies that had little or no tradition of it, like Britain.[6] The early years of the twentieth century saw the birth of a whole range of documentary movements around the world, groups of people who organized and made representations of themselves or others for a wider public in film, photography, writing and sound recordings. Cinema too, as the massively popular new form of entertainment, gave an optimistic sense that the world belonged to (or soon would) 'the people'.[7] The ambitions of most of these documentary movements can be seen as driven by the demand for a new reality and a recognition that what ordinary people did in their lives *mattered*.

Pictures and text (writing, voices, sounds) were 'recorded' and combined to create vivid images of the social fabric of people's real existence – their 'reality'. 'Sensation' meant *feeling* and *knowing* reality, no matter how gaudy, shocking or banal. How bread was made, for example, was fascinating to *see*. For the documentary photographer or film-maker, freed from any baggage of painting or art history, social truth was embodied in the modern technological process of 'documenting'. Documentary photography was thus a tool in a broader movement of social change and liberal attitude. The idea was to *inform* the wider population, to encourage them to understand, become involved and informed about life in the 'century of the common people'.[8] In this respect, 1930s documentary was mostly orientated towards social and democratic knowledge (if not socialist goals of greater equality), if only in terms of education. It is worth remembering, for example, that this was a time when mass literacy was still an ambition and had not yet been achieved. There was a belief that mass media communication would lead to a better world, that information was education, and that education meant the social good.

Such optimism, not yet shattered by the Second World War, would later coalesce around a basic demand for humanity; 'humanist' photography became the dominant post-war documentary tendency, what Martha Rosler calls 'liberal documentary'[9] (see 'World Photography' in Chapter 8: *Global Photography*).

In the 1930s, 'worker photography' movements across Europe, inspired by the Russian example of the 1920s, insisted that common people ('workers') should represent themselves in photographs to show their shared 'common condition'.[10] Self-representation was a form of self-knowledge, which would help to transform social relations as experiences were shared with others around the world. Internationalist in perspective, such organizations embodied optimism about photography as a tool of international, if not yet global, communication. Even less radical uses of the documentary mode were positive and optimistic about the impact of *visual knowledge*. When magazines like *Life* (one of the most successful) ran picture

stories on 'illicit love' or 'The French leaving Vietnam' after Communism had taken root, they were still stories from the 'real world', whatever their importance or the ideological view given to them.

All these uses of photography were conceived as *social* documentary, aimed at the depiction of the real world and people in it, whether in public or private, at work, at home or wherever. Social documentary was emphatically about social experience. This was an aim far removed from the general idea of a photograph as a 'document', as a type of proof. While not totally dissociated, social documentary was a far cry from the use of photography by the state as 'documents', for instance in police mugshots or social surveillance, etc., the use of those pictures as visual evidence, photographs as documents within a legal/judicial system, whose apparatus of the court would decide the validity of them as documents.[11] Certainly, the idea of photography as 'documentary' can be read across both social documentary and evidence pictures in institutional disciplinary uses, but it would be wrong to confuse the value of a photograph in a court of law with the *affective* value of social documentary pictures on a more general public. Yet, it *is* here that the problem of defining documentary photography emerges.

Documentary can refer to a category so wide as to be meaningless (*all* photographs as 'documents') or so narrow that it cannot deal with even its own eclectic history in social documentary. Even during the 1930s, the look, approach and feel of photographs that were regarded as documentary varied enormously, such that it would be wrong to define social documentary as a singular style. This also makes the criticism of documentary a more complex issue too. If documentary practices are as different as the visual means used to achieve them, then how to define documentary photography as a social practice? Should we separate or collapse together the types of work that set out to define particular social groups as a problem with those that seek to undermine their social stigma as 'others'? How might we interrogate whether all such practices create images of victims? How to locate the ideological or political attitude seen in social documentary work, whether as a form of humour, political criticism, or even as 'reality entertainment'?

HOW THE OTHER HALF LIVES

In retrospect, we know that there were photographers working in a documentary mode earlier during the nineteenth century, long before it became a popular form in the early twentieth century. This tendency came out of social criticism or journalism. Usually reformist, these projects used photography with written texts, combined as 'facts' to demonstrate the truth of a social concern, the issues of poverty, child labour, abject social housing conditions, the plight of the poor and other social

and political injustices. Nineteenth-century photographers, like Matthew Brady, Jacob A. Riis and Lewis Hine in the USA, or John Thomson and Henry Mayhew in Britain, are all example forerunners of those interested in a photo-documentary mode. They all aimed to inform, educate and disseminate the truth about an issue by using photography, alongside writing. The issues they documented – war, slums, immigrants and child labour, and street workers (respectively) – already pre-empted the territories and subject matter of later social documentary photography. These men (early campaign photographers were mostly men) wanted to demonstrate that documentary seeing was a way of knowing and, further, that knowing would improve humanity. The emphasis on 'seeing' was to show something as true, associated with giving the reader empirical evidence with a strong pedagogic or even judicial tone. The idea of the photograph as providing documentary 'evidence' came into currency.

Matthew Brady's photographs of the American civil war (or the ones ascribed to him) can be seen to have defined the genre of war photography: battlefield scenes of the aftermath of death, destruction and decay. Jacob Riis, initially a police reporter, took up photography himself to record the slums of east New York during the late nineteenth century. His work can already be seen as orientated towards a more sensationalist journalism, showing, even staging, scenes in the ghetto, which excited the anxieties of his middle-class lantern slide audience and newspaper readers. His infamous 1890s book *How the Other Half Lives* nevertheless gave a startling new 'photographic' visibility to a hitherto unseen, hidden world (the first edition had halftone and line engravings).[12] The later work of Lewis Hine is more exemplary of modern campaigning social work. Not only did he meticulously photograph children at work in their industrial environments and note all their details, but he also disseminated these documents in magazines as proof of the need to legislate against child labour. As an active political campaigner, Hine promoted photography as a tool of social criticism and, in particular, the need to represent people at work.[13] His pictures of children, for example, are not defined as a 'problem' (as in Riis's work) but as exploited and in need of protection (Figures 3.2 and 3.3). John Thomson's 1870s pictures of London streets, published as a book, *Street Life in London*, categorize people by trade, yet maintain a vivacity of life about them, in the manner of later documentary images from the 1930s of ordinary people in the real living conditions of their working lives.[14]

This tradition was developed and refined in Germany in the 1920s as part of the 'New Objectivity' (*Neue Sachlichkeit*), which in the hands of August Sander became a systematized photographic method of observation. Sander developed a taxonomic model of portrait photography where the identity of the sitter was defined – photographed – in their social role through standardized conditions and

Figure 3.2 Lewis W. Hine (1874–1940), 'Sadie Pfeifer, 48 inches high, has worked half a year. One of the many small children at work in Lancaster Cotton Mills. 30 November 1908. Location: Lancaster, South Carolina.' Photograph from the records of the National Child Labor Committee (U.S.). Library of Congress Prints and Photographs Division Washington, DC, USA.

photographic technique. Although no longer part of any social or political campaign, the work was thoroughly democratic in inspiration, since whoever was photographed (skilled or unskilled, gypsy or office bureaucrat, butcher, etc.) had the same 'visual' treatment: a self-dignity in their social identity whatever it was or whatever it meant, via a direct gaze at the camera. Walter Benjamin, the often-cited German critic on photography, wrote at the time:

> Sander goes from farmers, the earthbound men, and takes the viewer through all levels and professions up on one hand to the highest representatives of civilization and down on the other to idiots. The creator came to this task not as

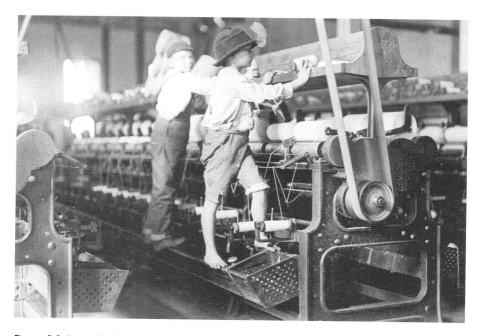

Figure 3.3 Lewis W. Hine (1874–1940), 'Many youngsters
here. Some boys were so small they had to climb up on the
spinning frame to mend the broken threads and put back
the empty bobbins. Location: Macon, Georgia. 19 January
1909.' Photograph from the records of the National Child
Labor Committee (U.S.). Library of Congress Prints and
Photographs Division Washington, DC, USA.

a scholar nor instructed by racial theoreticians or social researchers, but, as the
publisher says, "from direct experience."[15]

While certainly a type of social documentary photography, this comparative tech-
nique (typology of character) developed by Sander, so indifferent to the prejudices
of the viewer, was a long way from the optimistic campaign social documentary
seen in many magazines. These other types of photography were inspired by the
dynamic compositional techniques of Soviet Constructivism, Factography and
worker participation. A dynamic angle in these photographs represented not merely
a political or aesthetic metaphor for social change, but (for Alexander Rodchenko
at least) a *literally* different view of the world. In comparison, Sander's photographs
looked more socially static, some might even say stagnant, with little sign of
social 'change' (only indicated vaguely in the dress codes of the avant-garde artists
photographed by Sander). The perceived 'neutrality' in Sander's work, the lack of

expression in the subjects' faces (an absence that still draws interest to the pictures today) despite their attentiveness to the camera, was a long way from the *expressive* photography in magazine-based social documentary work. Here ordinary people were seen in a range of emotions, like laughter, sadness, boredom, frustration, etc. The new 'century of the people' demanded that the subjective expressions of the people be represented along with the appearance of their bodies in action.

By the 1930s then, it is possible to see two general modes or tendencies operating within the idea of documentary photography: one can be loosely defined as 'objective' and the other as 'subjective'; a binary opposition proposed by Otto Steinart in Germany after the Second World War in his thesis on subjective photography.[16]

These two tendencies privilege either a *neutral* camera view, the so-called 'objective' approach (e.g. John Thomson, August Sander and the Parisian, Eugène Atget[17]), or the subjective idea of an instantaneity, the 'capturing' of a fleeting instant as the expression of everyday life. Technically, in semiotic language it might be said that the former 'tripod-photography' emphasizes the *informational* codes, the qualities of the lens and film (e.g. depth-of-field, high-fidelity information), while the other 'shutter' photography privileges the *stylistic* and *iconographic* codes (e.g. blur, cut-off edges, human movement indicating speed and time) of the camera. It is the latter, although already known since the 1890s, that becomes a documentary innovation of the early 1920s, developed in the idea of *reportage*.

REPORTAGE

As the historian Eric Hobsbawm notes:

> 'Reportage' – the term first appears in French dictionaries in 1929 and in English ones in 1931 – became an accepted genre of socially-critical literature and visual presentation in the 1920s, largely under the influence of the Russian revolutionary avant-garde who extolled fact against the pop entertainment which the European Left had always condemned as the people's opium.[18]

Although reportage was partly derived from the idea of the 'snapshot' photograph, already prevalent in amateur photography of the 1890s, this type of picture seemed to imply a greater expressive quality, 'subjective' both in its mode of production and the visual connotations it produced. The mode of 'objective' photograph was already an established convention, long before reportage and documentary were coined as the general terms for the photographic expression of a social interest. (Seventeenth-century Dutch 'descriptive' paintings exemplify the objective tendency too.) This distinction between objective and subjective is useful, and only meaningful, in relation to the actual appearance of a picture. The idea that one picture *is* more

objective than another only really means that one has hidden its ideology within a rhetoric of neutrality and description, while the other flaunts its codes of subjective investment. We might then speak of these as two key different modalities of documentary. We could describe the objective mode as *cold* and subjective as *hot*. Thus in the ambition of documentary to show and tell 'social stories', different strategies can be employed.

In Peter Wollen's fascinating essay 'Fire and Ice', on photography and time, he makes the clear distinction between three categories of photograph and their respective potential to signify:

> News photographs are perceived as signifying *events*. Art and most documentary photographs signify *states*. Some documentary photographs and Muybridge's series in particular are seen as signifying *processes*. From what we know about minimal narratives, we might say that an ideal minimal story form might consist of a documentary photograph, then a news photograph, then an art photograph (*process, event, state*).[19] [My italics]

Wollen then shows how early narrative cinema conventions also followed this pattern to create short stories in an image-sequence, as *process, event, state*. This is useful here because social documentary employs all three of these strategies, moving across and between them to narrate the stories of everyday life through photography.

The photograph by Berenice Abbott at the beginning of this chapter shows a street scene in New York, taken as part of her documentary photographs of New York City for the Federal Art Project during 1935–9 on 'changing New York' (Figure 3.1). In the picture, a complexity of written messages appear in the photograph that serve to indicate the 'busy character' of the street. A restaurant, barber shop and hotel all have signs – indicating at least three different activities in this area. The picture shows how it looks, but also points to social *processes* that occur there too via the display of signs. The figure ascending the staircase meets our look, constituting an *event*. His response to the photographer is directed at the viewer too, in a kind of 'decisive moment', as though asking what 'we' are doing there. His look challenges the spectator directly, and we are put *outside* the scene. (He is not saying: 'Hi, come in'.) This positioning, between the viewer and the scene, finds us *looking into another world*, which is partly why the photograph is successful.

Documentary pictures can show social processes, the actors within it (events) and the conditions in which it takes place (state). The 'neutral' type photograph shows the state of something, its 'condition', while reportage uses both event and process to show them as life story 'experiences'. This helps to explain why documentary is itself such a slippery category too, since it can embrace different modes of practice, using techniques from art, news and journalism. Perhaps such eclecticism encourages a more critical engagement by the spectator, more of a collection of facts to be

Figure 3.4 Walker Evans (1903–75), 'Flood refugees,
Arkansas', c. 1937. Gelatin silver print. A detailed shot
of flood refugees' feet showing their shoes; Forrest City,
Arkansas. Farm Security Administration, Schomburg Center
for Research in Black Culture/Photographs and Prints
Division, NYPL, USA.

interpreted. This may also account for the recurrent popularity of a photographer
like Walker Evans, known among specialists as the 'photographer's photographer'.
His highly influential work emphasizes the photograph as a 'document' in a
variety of different ways, as seen in his photographs for the 1930s Farm Security
Administration documentary project (Figure 3.4).

Already familiar with the work of August Sander and Eugène Atget, Evans
believed photography should be a 'photographic editing of society'.[20] All manner of
cultural objects and common processes are subject to the scrutiny of Evans's camera:
objects, people, things and signs for things, in fact anything that made up everyday
life. This eclectic subject matter is then given a treatment of 'frontality' – objects
depicted 'directly' (from the front) as in the work of Atget and Sander, but combined
with a more 'subjective' framing (a close-up or casual cropping of subject matter),
nearer to a snapshot style. The combined effect of all this is to produce a fragmented
feeling, the picture as one part of a larger whole not yet seen.

Documentary photography hovers *between* art and journalism, between creative treatment and actuality, the very terms that the founder of documentary film, John Grierson, had combined to define social documentary: the 'creative treatment of actuality'.[21] 'Reportage' is similarly an ambiguous concept, ranging from the reporting of an event as news to the description of social processes and their impact on people, whether as individuals or as a whole social group. The photograph as 'document', then, might be used to refer to the representation of a state or *condition* of something, while 'documentary', as used in the 1930s, implies the depiction of a process or event. While the rhetorical conventions of the objective photograph (the portrait, the landscape, etc.) merely privilege codes of neutrality and description, those of 'subjective' photography prioritize action and movement as 'expressive realism'. The key theory of this expressive realism in social documentary is most famously embodied in the terms of the auteur-photographer, Henri Cartier-Bresson: as the 'decisive moment'.

'DECISIVE MOMENT' AS *PERIPATEIA*

Henri Cartier-Bresson's famous idea of the 'decisive moment' fuses a notion of instantaneity in photography (the freezing of an instant) with an older concept from art history: story-telling with a single picture. The problem of how to depict an entire story or event within one picture was the problem that beset 'history painting', the genre that deals with the depiction of important historical events. Although history painting did not have the immediacy of photography, it did have the similar task of depicting a story in one instant. The ideal way to represent a complex event, it was argued by the eighteenth-century German dramatist and critic, Gotthold Lessing, is to show the 'pregnant moment' of the story, where the past, present and future of the story can be read, summed up, 'at a glance'.[22] Otherwise known as the *peripateia* (from the Greek, meaning 'dramatic moment' or 'sudden change of fortune'), the pregnant moment is the instant when the future of the story will be determined; the moment of 'anticipation' when the story is in the process of being decided.

In the Cartier-Bresson picture shown in Figure 3.5, the natives [*sic*] carry the heavy picture of their European (Dutch) colonial governors out of the stately building. The picture was taken in Jakarta, Indonesia, the day before independence was formally recognized by the Dutch in December 1949 (although it had been proclaimed four years earlier, on 27 August 1945, it was fought over until then). The picture in fact shows one of three hundred portraits (of Dutch governors) being moved out of the Governor's residence (later known as Istana Merdeka or Palace of Freedom). The picture shows the 'change of fortune' in this story of independence as the Indonesian and the two younger boys bear the weight of history in the literal

Figure 3.5 Henri Cartier-Bresson (1908–2004),
'INDONESIA. Jakarta. Independence. 1949.'
© Henri Cartier-Bresson/Magnum Photos.

'heaviness' of ridding themselves of the image of their former Dutch masters. This is the pregnant moment in action: the literal and symbolic representation of achieving independence, pictured as the weary end of colonial rule. (Indonesia went through a huge social revolution as well as political struggle during the four-year period of struggle.)

Cartier-Bresson, already a keen snapshot photographer before he became famous, was almost certainly familiar with this concept of the pregnant moment from his art tutor, André Lhote, the established art critic, teacher and cubist painter, whose own paintings had a conception of *instantanée*. In fact, Henri Cartier-Bresson formulates his concept of the decisive moment in a very similar way, as: 'one unique picture whose composition possesses such vigour and richness, and whose content so radiates outward from it, that this single picture is a whole story in itself'.[23] The pictorial anecdote that 'radiates outward' from a single frame to a 'whole story' was also theorized in montage cinema too, notably by Sergei Eisenstein, whose work Cartier-Bresson explicitly cites as influential for his photographic work. Probably the most common device in Cartier-Bresson's own photography is his use of a figure whose foot is about to touch the ground. The striding foot indicates a future event,

caused by the past whose outcome is anticipated by what we see in the picture. The viewer of the picture can run their imagination back and forth across the time before and after the depicted action to *imagine* the sequence of events constituting the story, which a single picture can only *imply*.

The use of *peripateia* is also typical in successful news pictures, especially war photographs, which can be seen as the heirs of history painting. In fact *famous* war photographs usually become so precisely because they seem able sum up an entire episode of a significant historical event through a single image (e.g. the famous Eddie Adams Vietnam photographs, or even the Abu Ghraib snapshots from Iraq). The decisive moment is thus the instant when the photographer must click the shutter (harder to do with the slow shutter delay of some modern digital cameras) to capture not 'reality', but the *dramatic instant* that will come to signify it. In this mode of documentary work, the camera is perhaps better thought of as a *portable* theatre or studio, where the photographer 'stages', creates a scene from the flux of life. The photographer operates the camera when the figures are juxtaposed in the right combination of gestures, expression and action. This art of staging is the common trade of the cinema and theatre, but also crucial to documentary and news photography too. We might, like film and theatre studies, also employ the concept of *mise en scène* in photography, since it recognizes the work of staging and mediation that goes into the production of any visual meaning. It is at this point that the criticism of documentary as *realist,* and its claim to truth and reality, begins to plague the photographer.

STAGING REALITY

The inevitable *mediation* involved in all photography, decisions about the position of the camera within and toward the event, the spatial relations of it, etc., are what organizes the *staging* of the scene. 'Composition' is here simply the organization of raw material into photographic codes, a rhetorical form to create a *reality effect*. The 'neutral' mode of descriptive photography merely attempts to circumvent such criticism by signifying its 'neutrality' through frontality. By facing the subject matter head on, it is also deploying the rhetoric of photographic codes too. This is not to dismiss documentary, but, as John Grierson, the acknowledged founder of social documentary once said in a lecture:

> The only reality which counts in the end is the interpretation which is profound. It does not matter whether that interpretation comes by way of the studio or by way of documentary or for that matter by way of the music hall. The important thing is the interpretation and the profundity of the interpretation.[24]

For Grierson, a good documentary is a good 'interpretation' of real life, one that 'lights up the fact'.[25] The means is not proscribed as essentially one form or another, as 'staged' or not. So documentary could include a number of approaches; it is about *interpretation*, not objectivity or truth. In this sense, the two modes of documentary discussed here offer different genres (sub-genres) of social documentary interpretation. Reportage (and snapshots) signify human involvement and expression of life in events (from a subjective and fragmented viewpoint), while so-called objective or descriptive photography offers a more disengaged position (an objectified, distanced position) to the scene. Despite the differences, both subjective and objective are variant modes of the 'straight photograph' and depend on the idea of witnessing 'life', which is so crucial to the documentary form.

EYEWITNESS

The aim of documentary is to make the spectator into an 'eyewitness'. A spectator can participate by *seeing* 'with their own eyes' what the photographer has seen; an argument built on trust that what we see is what the photographer had seen. This contract between photographer and audience is thought to be independent of any context in which we see the image, and must 'tell the truth' by itself. The photographer becomes an agent of truth, producing 'documents' whose responsibility to truth is ultimate and ethical. Caught up in this ideology of vision as premised in truth, documentary argues that we can 'see' truth *visually*.

The two tendencies in documentary photography as first-person or third-person documents (expressive/neutral, subjective/objective) positions the viewer differently in relation to the events. The subjective viewpoint appears involved and engaged *in* the event, while the neutral picture seems to lack commitment, as almost indifferent or disengaged. The 'concerned' photographer might therefore find reportage more attractive as the rhetoric of engagement in life. This human expressive aspect remains a key feature of reportage-type photography in snapshots and subsequent digital practices even today, no matter how far ideals of photographic truth are critiqued or dismissed. Equally, with descriptive photography we live with the fact that someone has chosen or (by default) used a point of view, lighting, and so on in the depiction of things, people, events, whether an event in a newspaper or anonymous holiday snaps. Pictures show something we tend to believe exists if it fits with our picture of reality. However, being a witness always implies a definite point of view, standing here or there, which makes a difference. Documentary photography is no different, and it can be thought of as the point of view of a witness who is telling the story about a social event or process.

In fact, 'story-telling' implies a potential for fiction and subjectivity. When you or I witness an event, our stories may be quite different; because of where people stand it can seem different, even though it was the same event. In a court of law the judge will decide what is true (though they might still get it wrong), but in the world of documentary the viewer is not necessarily in any position to 'judge the facts', beyond what they are given, and can only form an opinion based on what is given or already known. In this sense, documentary photography always has an opinion, no matter how subjective or innocent the picture (or the photographer who took it) appears to be. A documentary photograph *always has a point of view.*

The stories implied in Henri Cartier-Bresson's photography, for example, are all wilful 'interpretations', comments whose rhetorical form can be revealed by analysis of the images. It becomes possible to 'see' how they stage a particular set of relations.[26] Cartier-Bresson's humanist approach was formative for a whole school of documentary-inspired 'street photography', as a means to comment on everyday life, but less concerned with goals of social reform or general education. This type of photography worked well for the photo book, as in Cartier-Bresson's extensive post-war books (e.g. *The Decisive Moment, The Europeans, China in Transition, The Face of Asia, About Russia*), where the work could maintain an extended argument, an independent essay with a coherence less possible in the short space of commercial newspapers and advertising-led magazines. In Cartier-Bresson's photo books each photograph reads like a part fragment of a larger picture, adding up to a coherent yet still fragmented picture of modern life. Almost filmic, this photographic form was developed by Robert Frank in his seminal 1950s book *The Americans*, which feels even more fragmentary and fleeting, as though seen from a passing automobile. This of course was part of what caused the initial hostility towards it and the later success: that it had recognized – as in a road movie – the transience of youth of 'America' itself as an image of ideals and life.

The attraction of such work is the vision of the free-roaming individual, the photographer, out for 'decisive moments', as a romantic but sustained version of reportage. Rather than working for a newspaper, the photographer is separated from the masses, yet living among them, anonymous like a modern *flâneur*. This idea has a strong appeal not only for its air of independence and way of seeing, but as a way of life.

For the jobbing photographer, however, impatient for a quick story and short of time to achieve it, it was not unseen to encourage things to happen by giving a 'helping hand' to reality. This was not frowned upon at all (and laid the origins for paparazzi as *provocation* photography), but not publicized either. In 1930s Paris, Brassaï, for example, like many others working in the same field, was known to 'stage' decisive scenes and paid people as models or employed friends to act out

scenarios that he had seen or envisaged.[27] 'Staging' here is not a negative term, a criticism. In the theatre 'staging' can mean *realist*, *naturalist* or *anti-realist*. There is no reason why staging (*mise en scène*) cannot be used in the same way for photographs. 'Staging' refers to the act of creating a scene, it does not imply any lack of reality, it merely acknowledges the work involved in the production of meaning in any pictorial composition.

REALITY AND REPRESENTATION

Documentary, as the founders of the movement knew, relies on the construction of an image of reality *in representation*. This construction, on which the whole project of documentary was based, can also be described as manifesting a desire *for* reality. That is to say, documentary emerged as the wish to see something recognized as a reality. It is in this sense of persuasion that documentary was, at origin, a political project. Whether it was the recognition of the plight of the poor in the American 1930s depression, as represented by the Farm Security Administration project (still, to date, one of the most significant collective documentary photography projects in the USA[28]), or more recent work on wars and their aftermath, like exploited migrant labour, racism, genocide or other catastrophes, documentary contributes to how and *what* we see *as* reality. The very recognition of what was not 'recognized' in public (e.g. the plight of migrants, homeless, poverty, excluded ethnic groups, etc.) as reality has given the justification for taking photographs of these people or their lived circumstances. However, this desire for recognition of reality is not only on the part of the photograph; it also involves the spectator. Documentary pictures tend to suggest that is there *is* a reality – 'look at this!' – and it is in this sense that we must argue that: documentary photographs construct *representations* of reality, according to someone's view, their desire to see.

DESIRE TO SEE

While 'reality' is what we believe exists (in this sense our views are always thoroughly ideological), it also involves what individuals *wish* to exist. Images of devastating poverty or explicit racist discrimination may, quite simply, not fit that wish, and it is here that the politics of vision comes to play a role in the crucial issue of what viewers *do* with the knowledge presented to them in documentary (or in fact all) photographs. 'Confronting reality' is not something that the human species has always been very good at. 'Denial' and disavowal are well-known issues for psychoanalysis, just as much for teachers, students or anyone else who has experienced them. So it is not

surprising if a documentary that sets out to change the mind of its audience does not succeed easily or even completely fails to do so. Yet that does not mean that the work of *representing* is pointless. Nothing can be given in advance.

The idea of witnessing invokes the concept of voyeurism, defined as an illicit or obsessive act of looking. Even legitimate (socially acceptable) looking, as in documentary, nevertheless has a component of voyeurism within it. The often-felt sense of guilt or shame that accompanies voyeuristic looking, with its origins in sexuality (an infantile curiosity in the details of other people's bodies[29]), is directed at what is seen, as though the thought 'how dare you show me that', manifests in being annoyed at the photograph; at what is shown in it; or even at the photographer. Outrage and protest at photographic representations show that representation can intervene in a spectator's belief in reality. Seeing equals truth, but only where a spectator has an investment. The French psychoanalyst Jacques Lacan, puts it like this in his essay 'What is a Picture?':

> How could this *showing* satisfy something, if there is not some appetite of the eye on the part of the person looking? This appetite of the eye that must be fed produces the hypnotic value of painting. For me this value is to be sought on a much less elevated plane than might be supposed, namely, in that which is the true function of the organ of the eye, the eye filled with voracity, the evil eye.[30]

Lacan's thesis, that looking can be invested with jealousy, introduces the less noble aspect of looking. Looking (the wish to see) is not necessarily *seeing* (as knowledge), but merely the wish to observe, to make sure someone does not have what you have. While none of this is necessarily specific to documentary alone, it is relevant here because of the reality effect invested in the documentary genre. The eye, full of envy, may even enjoy the sight of destruction, via the sadistic component in looking. In short, whether conscious or unconscious, the narcissism of the viewer (in Freudian theory 'narcissism' is what helps to maintain the human subject, it is not a judgement of character) is involved in the capacity to recognize, deal with or perceive 'alien' matter. Documentary photography, like other domains of visual knowledge, negotiates these complex dynamics via the spectator's interest in 'visual pleasure'.[31] Even the use of painful images in charity advertising, where guilt and shame in looking at those less well off, is explicitly used to raise funds, has to pass via this same economy of visual pleasure.

This brings us back to the question of who is looking at the pictures under what conditions, where, when, how and why, which should not lead to the, somewhat generalized, criticism that documentary constructs a victim for its always privileged audience in terms of class, ethnicity, gender or other social category. However, the dignity of the subject viewed in social documentary photography is not guaranteed

by any particular viewer, conditions of viewing, or in the fundamental signifying trope offered in the specific images. The direct address to the viewer, for example by a subject in the picture, does not ensure that pity, empathy or respect are felt by that viewer. Under such conditions, documentary has had to renovate itself, adopting different strategies to attract audiences.

The development of the visual form of documentary, into what is usually called 'modernist' aesthetics, has been one way in which documentary photography has renewed itself and the interest in depictions of everyday life. It is worth just concluding here with some aspects of this type of renovation – most obviously, with the turn to colour from black-and-white photography in the early 1980s and the more recent turn to a higher fidelity image quality (medium-format film cameras and high-resolution digital cameras).

COLOUR DOCUMENTARY

The idea that reality is depicted in monochrome grey, as 'black and white', remained a dominant conception in much documentary work until the late 1970s. Gradually, during the 1980s, the use of colour photography began to appear in documentary and art. After Cartier-Bresson, 'street photography', as a specialized type of documentary and art photography, stayed steadfastly a black-and-white world. Documentary was distinguished from advertising and commercial editorial photography, which all used colour, by being *monochrome*. The argument in documentary cinema as much as documentary photography was that colour was too 'easy', 'superficial' and 'cosmetic', too close to advertising (as openly fake).

These arguments eventually gave way to colour becoming the 'new reality' during the 1980s, with the emergence of colour photography in newspapers too.

Certainly, visual pleasure played a part in this shift as much as technological developments (greater stability in colour materials), with the sense that colour might bring a 'new' veracity to concerned photography. Yet there is an aesthetic twist here too. The use of colour photography had been increasingly dominant in amateur snapshots from the 1960s onwards.[32] The idea of snapshots as offering a more authentic access to reality, due to its '*naive realism*' helped to renovate documentary as offering an unmediated access to reality. The more 'authentic' realism of the colour snapshot was gradually absorbed into the style of documentary photography – a newer, so-called 'amateur' *snapshot aesthetic*. The shift of focus from the public social sphere to more intimate and private spheres of often quite personal issues, not only renovated an interest in documentary topics perceived as 'worn out', but also regenerated a whole new interest in documentary photography as art. Although not

entirely documentary, William Eggleston's work (*The Democratic Forest*) would be an obvious example here, alongside Nan Goldin (*The Ballard of Sexual Dependency*), both from the USA, while Richard Billingham (*Ray's a Laugh*) in Britain or Boris Mikhailov (*Case History*) from the Ukraine have all employed a snapshot-based aesthetic in their work. Simultaneously, since the 1980s the use of medium- and even large-format cameras with colour film has created a newer, higher fidelity colour documentary tradition. Documentary photographers have recently returned to the use of the tripod to make static views of the world, reinventing documentary through combining portrait and landscape genres. The conventions of Atget or Sander, for example, are now revised and developed in the work of German art photographers like Andreas Gursky, Thomas Ruff, Candida Höfer and Thomas Struth, to mention only a few.

TABLEAUX ON THE STREET

Straddling these different tendencies are Jeff Wall's art photographs, what he calls 'near documentary', which represent a reincarnation of the *peripateia* tradition of history painting in photography for the art gallery. Although reminiscent of illuminated advertising billboards, Wall's images use the historical device of the *tableau* (a constructed decisive moment) combined with the logic of realism and instantaneity of the photograph. The themes of his work also certainly belong to a kind of social documentary and the tradition of critical realism in painting.[33]

Yet the two dominant modes of documentary, *expressive* and *descriptive* (or the problematic, *subjective* and *objective*), continue to vie with one another and keep the original idea of contemporary social documentary alive. This has even manifested in the newer forms of dissemination, the domain of the www. 'Reporters without Borders', 'citizen journalists' and bloggers providing 'realistic' accounts of everyday life, politics and cultural affairs, and suggest a renewed vitality and fascination in sharing life experiences via documentary and reportage. While many of these practices within the public domain only require uploading to the www, others working within the major institutional media sites of power are still subject to the same processes of filtration (selection, editing and control) discussed at the beginning of this chapter. So the rhetorical form of documentary photography still exists, but has had to cast off the older pictorial values that it subscribed to, if only because they have been relentlessly parodied. Thus, documentary reality had to find another voice and place within the contemporary media spectacle, like in art.

Chapter Summary

- The making of documentary work not only involves shooting pictures, but also the process of selecting (editing) pictures from those taken to make a body of work. This may include cropping, use of captions and titles, establishing the overall context for the work.
- The motivation for documentary photography is to 'creatively inform' an audience about another part of the population, whose life and experience may be unfamiliar to them. The aim of the work may be to criticize, celebrate, support or attempt to reform the situation they describe.
- The tactics adopted by photographers range between tripod-based *views* and hand-held *scenes* (tableaux), which create distinct viewer positions usually perceived as either an objective or subjective 'witness' position.

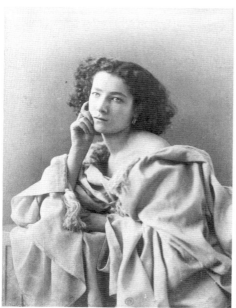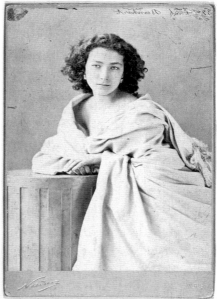

Figures 4.1 and 4.2 Nadar (Gaspard Félix Tournachon,
1820–1910), 'Sarah Bernhardt', 1865. Printed from a
collodian negative. © BNF, département de la reproduction.

Sarah Bernhardt (1844–1923), the famous French stage
actress, was about twenty-one when she posed for Nadar
in his studio. She is one of the first 'celebrity' portrait stars
in photography and also became an early movie screen
actress (1900–23).

4 LOOKING AT PORTRAITS

Today, almost no one blinks at having their portrait photograph taken. While we may not like the look of our face on a passport photograph or identity card, we do readily recognize the importance of 'looking right' on those occasions where pictures matter personally. How we look to friends and family in photographs matter (e.g. especially in social rituals like weddings, birthday celebrations, religious ceremonies, vacation trips, meeting people on the Internet, etc.), because we know they are part of how people *see* each other.

IDENTITY

If the photographic portrait is a shorthand description of a person, then portraiture is more than 'just a picture', it is a place of work: a semiotic event for social identity.[1] Portraits fix our identity in what is essentially an art of description. Whether it is in the public sphere, used to certify our legal identity (passport mugshot), in our private life (snapshots, formal studio portraits, etc.), or for another social purpose (e.g. anthropology, art, social, political, legal, medical, institutional, etc.), the portrait aims to say, 'this is how you look'. This visual description of persons abounds across all kinds of institutions: the media (television, film, photo-journalism, www, paparazzi etc.), art, advertising, tourism, the military, the police, medical institutions, in a family album and so on. Indeed, we find portraits almost everywhere we look. Universally abundant, they are a direct result of the massive impact photography has had, ever since the *reproduction* of photographic images became possible. The *different* uses constitute a large part of the history of photography. The modern panoply of portraiture is the direct consequence of that historical development of photography, a history that shows how portrait photography itself became a valued commodity within the nineteenth-century industrial revolution.

THE INDUSTRIAL PORTRAIT

The early commercial industry of photography was dominated by the development of studio portraiture. People wanted portraits or 'likenesses'. Portraiture popularized photography, which sought to supply the seemingly inexhaustible demand for portraits, initially in major cities, but very quickly spreading far wider (see Chapter 8: *Global Photography*). It is amazing how quickly in the history of photography all this developed. Masses flocked to have their portraits made by photographers. The impact on the miniature-portrait-painting industry was dramatic, resulting in its conversion to the use of photographic processes instead. It did not take long before photography became a cheaper and quicker method of making a portrait of someone, as much less labour was involved than in a painting. Painting took time and skill, and while photography required skill too, it took less time. As photography developed and became faster and cheaper, the means of picturing people accelerated the whole business of having a portrait made. The subsequent historical development of photography studios as the standard place to make 'people-pictures', in advertising and fashion, was only accelerated when electricity and artificial lighting made the studio into a theatre, where any simulated environment could be constructed.

The early values of studio portraiture were inherited from painting. A studio location was used partly due to a technical and practical convenience, the demands of the technology. Although photographers required a good deal of light to expose plates, they also needed chemicals in darkrooms to develop the pictures. A studio was practical and clients could easily visit it like a shop. Fixed in one location, props, backgrounds and costumes could all be stored at the studio and provide a variety of possibilities for clients to choose how to appear in their portrait. Immediately one can see that the studio context provided the opportunity for people – clients – to see themselves in a picture as *they* wished to appear. In every respect, the commercial studio became a place where social identity was a kind of performance for the camera, although this was not necessarily a luxury afforded by the criminals photographed by the police.

The photographic revolution of nineteenth-century photographic portraiture created a situation, which John Tagg calls a 'democracy of the image', where it was no longer a privilege to be pictured but, as his book title puts it, became: *The Burden of Representation*.[2] No longer a luxury, a sign of the prosperous to be pictured in a family tradition, the portrait became a means of identification of the population, even those who did not wish to be recognized, like criminals. In this respect, the dramatic rise of portraiture transformed not only the industry of portrait painting, but ushered in a completely new social relation to visual images as they emerged across a whole range of institutions. As Tagg argued, the centrality of the portrait is

as a 'sign whose purpose is both the description of an individual and the inscription of social identity'.[3] The commercial portrait became immersed in a complex visual system, where identities are marked out as visual difference.

MASS PORTRAITURE

The conventions of portraiture existed long before photography. In the history of Western art it was in painting and sculpture that many of the conventions later taken up and developed by photography were first established. Photography, in turn, also modified these conventions, right from the early years of its invention.

In his book *Art and Photography*, Aaron Scharf describes how painters, despite their general hostility towards photography, were more or less obliged to use photographs as the basis for painted portraits and in so doing began to change the conventions of posture and style in their own paintings.[4] So, for example, the hand used to prop up the face to stop it moving in early photography became a conventional pose in portrait painting too – as a considered or thoughtful look. Of course, photographers also borrowed from painting and there are many examples of this to choose from. The French photographer (Gaspard Félix Tournachon) Nadar, for example, took up the function of a traditional portrait artist: the need to satisfy a sitter with a society portrait that idealized the sitter for future generations to look up to (Figures 4.1 and 4.2). Nadar brilliantly combined the existing formal rules of aristocratic portrait painting with the intimacy of the Daguerreotype, thus satisfying the demand for images by an emergent bourgeoisie who wished to be modern (photography) and traditional (aristocratic posture, style and setting). Just as a successful fifteenth-century Florentine merchant commissioned his portrait painting for posterity as soon as he had a new set of clothes, so the *nouveaux riches* Victorian middle classes rushed to have themselves pictured in the modern photographic portrait studios to show off their new status. André-Adolphe-Eugène Disdéri's invention of the *carte-de-visite* in the 1850s did the same thing for the slightly poorer (middle class) 'masses' as Nadar and others had for the wealthier clientele (Figure 4.3).

Disdéri's '*carte-de-visite*' was, as its name suggests, like a 'visiting card' (about twice the size of modern business cards today). Pocket-sized, it was easy to carry around and cheap to produce in comparison to whole plate portraits. Disdéri's cameras had several lenses (four, six or more), designed so that several different pictures could be taken on one plate. Cameras like this increased the number of portraits produced from each plate, thus instantly cutting the cost of each picture by a quarter or more, depending on how many lenses the camera had. As a result, more clients could afford to have these cheaper portraits taken. Disdéri's cheaper *carte-de-visite* invention flattered the aspiring classes with images that mimicked the trappings

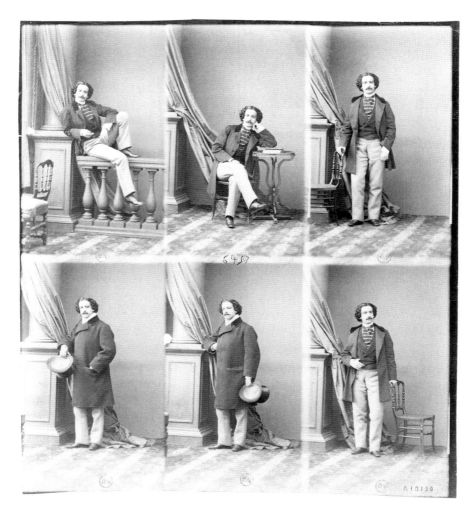

Figure 4.3 Disdéri (André-Adolphe-Eugène, 1819–1989), 'Jeune homme' [Young Man], 1858/9. © BNF, départment de la reproduction.

of bourgeois settings. To be pictured holding a learned book, or photographed in front of the backdrop of a stately home, revealed the aspirations of the sitter more than their own actual status. *Carte-de-visite* photographs typically emphasized these social aspirations of the sitter, while more 'up-market' social portraits emphasized that sitter's particular 'personality'. (This is obviously not to imply that poor people did not have any personality or particular characteristics, merely that the time and

effort spent on this 'photographically' was minimized, costing more than the Disdéri *carte-de-visite* afforded.) That said, there are many poorly arranged studio portraits that nevertheless have something special about them. It may be something obvious, the look of the subject at the camera, their particular gesture or pose, their gait or something more obtuse, what Roland Barthes later renamed as *punctum*.[5] Such portraits remind us that even in the most functional social portrait (i.e. a mugshot) there is always an element of the personal, an intimate detail at work.[6] It is perhaps the peculiar combination of social *and* personal features involved in portraits that lends them their special fascination to questions of identity.

BUREAUCRATIC PORTRAITS

The capacity of the new photographic portrait industry to picture masses of people with a relatively inexpensive technology enabled an emerging industrial society to find an instrumental use for photography. In the social history of portraiture, photography was used to portray people not hitherto represented. With the mechanization of image production, the police, doctors, army, various schools of scientists, local and governmental agencies all developed archives of photographs to be kept and used as evidence, a 'pure record' in a statistical archive. The mechanical imaging system of photography was employed – as digital computer images are now – as statistical data systems, as a utilitarian gathering of information, quantifying, qualifying and evaluating the population in recording systems for testing various 'scientific' propositions or 'disciplinary' uses. For the police, the photograph provided a 'systematic' imaging system with which to identify suspects and convicted criminals (Figure 4.4).

Francis Galton attempted to take these ideas of identification further. The cousin of Charles Darwin, Galton theorized eugenics and was interested in the idea of human biological 'degeneration'. His method of 'composite printing' combined several negatives to make one single picture, a portrait that was supposed to show, for instance, what a common murderer looked like.[7] His theory was that if the portraits of several criminals charged with the same crime (e.g. murder) were put together, that composite picture would show the key facial features and common traits of a murderer. Thus, any criminal might be identified in advance of a crime if it could be proved they all had common facial features. The physical appearance of an individual was assumed to be proof that they were typical of a certain social type, whose psychology is indexed to their appearance and can be read off from that visual profile.[8] (The idea was developed by Nazi ideology to justify a systematic removal of 'degenerates' from society.) Now obviously discredited, this idea should not be confused with the way that today we might still try to read a facial expression as

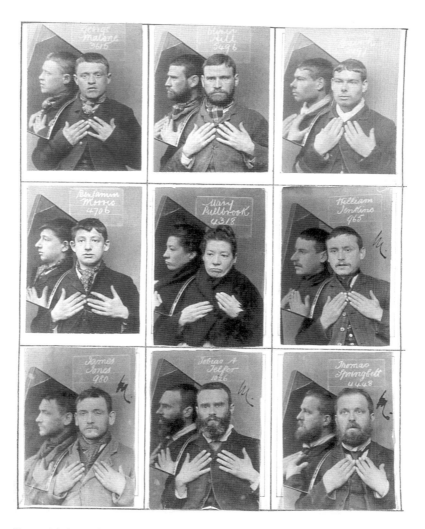

Figure 4.4 Anon. Photographs of prisoners,
Wormwood Scrubs, London, c.1880. National Media
Museum/Science & Society Picture Library.

The criminals hold up their hands to show any
identifying features, such as tattoos or missing fingers.
A mirror placed on their right shoulder shows their
profile. The use of photography to record known
criminals – the 'mugshot' – had been in evidence as early
as the 1840s. In 1871, the Prevention of Crimes Act
made it a legal requirement that all persons arrested for
a crime in Britain must have their photograph taken.

revealing psychological thoughts. Cultures depend on facial expressions being made even in basic greetings; a sombre look or bright smile may be more or less appropriate to a particular occasion (a funeral, a wedding, a judge in court, etc.). Such expressive conventions are *coded* as a matter of cultural, social and personal convention; they have little to do with the idea of any genetic disposition to 'criminality' or other ideology of phrenology.

In general, no class or section of the population was necessarily exempt from these new fields of photographic portraiture where social identity was inscribed as a visual image and designed to be 'read', whatever functioning discourse it was in (e.g. legal or personal, etc.) and whether it aimed to idealize, describe or exemplify. What all portraits have in common, in their overlapping and different ways, is the central issue that the portrait is a means employed to establish the identity of a sitter, regardless of whether they are viewed as a social problem or a human being with positive features.[9] In other words, the main arguments about portrait images circulate in relation to questions of social identity and processes of identification.

What are the basic conventions of a portrait, the components that go to make up their codes of description? We can begin to compile the basic ingredients of the portrait as a genre.

ELEMENTS OF A PORTRAIT

Even from a cursory glance at the history, then, we can quickly identify that almost all portrait photographs are typically made up of four key elements:

- **face** (including facial expression, hair, etc.) – personal appearance
- **pose** – manner and attitude, 'upbringing'
- **clothing** – social class, sex, cultural values and fashion
- **location** (or background setting) – social scene of the person in the picture.

Different types of portraiture (we might call them sub-genres) vary their emphasis on each of these components. Each element affects another in the overall potential for meaning. Passport photographs, for example, usually have plain or simple backgrounds, which serve to foreground the face of the sitter – the main function of this arrangement is to scrutinize the face. With no 'background', the picture removes potential social connotations, i.e. any social-geographical-personal context about the sitter. In effect, the use of the four elements (face, pose, clothing, location) and their combined relation in the picture are what organizes the rhetoric of a portrait. Combined with the various photographic codes of framing, angle of lens (long, medium, short), focus (shallow, deep, differential), lighting (soft, hard, direction and size of light source), use of props, etc., all these codes, which pertain to photographic

portraits, are ways of controlling the four key elements, as outlined above. Let's briefly consider each of these elements in turn.

THE FACE

The expression on a face in portraiture is crucial and can exert a considerable impact on how a portrait signifies meaning. An expression can have a dramatic impact, even with the slightest movement of the eyes or mouth. The mouth is read as smiling, sad, angry, gaping, pout, etc. Eyes can seem 'alive', 'glaring', 'seductive', etc. The dress of hair could be a whole chapter in itself. We 'read' these components of the head and the face for mood, temperament and character in relation to ethnicity, sex and age, and for their 'attitude', including attitude towards the viewer. We can also understand something of the value of the face in photography by considering the close-up in cinema.

While cinema uses the same traditional long- and medium-shot photography of people (head to waist, or head and shoulders), so familiar from portrait painting, film-makers quickly developed the close-up. The face (or another part of the human body, i.e. hands, feet, eyes, etc.) is used to stand in for the feelings of that person. Sergei Eisenstein famously uses the close-up of a clenched fist (a general convention) to signify that a person is angry. In Eisenstein, this metonymical signifier expresses the anger, not only of that individual person but of a whole social group too (a body of revolutionary workers).[10] In contrast, a relaxed, open hand might signify passivity, i.e. death or sleep.

Similarly, facial expressions signify a repertoire of 'states', indicating the potential mood of a person wearing them: anger, sadness, frustration, melancholy, etc. These conventions are articulated across different representational systems, like art, theatre, television, cinema and photography. In horror movies, for example, 'terror' and 'pain' are often abstractly depicted as a distorted expression, registered on a victim's face.[11] Romantic comedies show women weeping (then smiling), while men in the same films look baffled, over-confident, awkward or anxious. I suspect we could all easily demonstrate these types of expressions without much trouble, precisely because they are so common and conventional. Heroes, villains, comedians, news-presenters, etc., all use a repertoire of expressions commonly repeated across that same media culture. In Britain, television news-presenters use serious expressions when describing serious tragedies, but look amused when a 'light-hearted', more trivial, story is told. In short, the whole gamut of emotions about life has conventional expressions signified via the face.

There is another dimension to the close-up: it is used to satisfy the spectator's visual pleasure in seeing a star on screen *close-up*.[12] Developed early in the history of cinema, the Hollywood cinema industry readily acknowledges and even promotes

the idea that we go to the cinema to look at stars, to be close to them, to stare at their famous faces – and often their bodies too. Film-makers quickly saw the potential of the close-up to beautify the female face, as a cinema commodity.[13] The fashion industry, especially cosmetics, quickly adopted this idea to the close-up photograph, using celebrities and models (who may become celebrities as a consequence) to adorn their products. Effectively, the juxtaposition of a celebrity with a product serves to legitimate one with the other. The celebrity gives connotations to the product and the product comes to embody whatever the character is employed to promote (e.g. beauty, fame, wealth, ambition, femininity, masculinity, elegance, confidence, charm). The product and model that wears or uses it offers the viewer a point of identification – one gives beauty to the other in the rhetoric of *comparison*.

The 'face' as a close-up shot in such practices thus serves several functions: it puts the viewer into an intimate position with the person seen; it shows the commodity ('the star' of the film or advertising product) and offers a point of psychological identification; and it gives things a value and mood. Obviously, different types of face by themselves can connote different things: 'ruggedness', 'softness', 'kindness', 'brutality', 'authority', etc. Such logic depends on stereotypes, the typical features of signs. Stereotypes, like genres, help to organize our expectations about a character, so actors and actresses are often chosen to play parts where their face already signifies a basic set of social and personal characteristics, even before they act.

In traditional studio portrait photography, the photographer may have the task, rightly or wrongly, of counteracting the outward appearance of a client, so as to make them represent their actual character, where appearance and character contradict one another. Thus, if a client was considered 'ugly', for example, the photographer might redeem this appearance by organizing (or *re*organizing) them (clothes, setting, pose) to make them look more sympathetic as a character possessing 'honest dignity'. We soon arrive at the common problematic of portraiture, as expressed in the question: whether 'to take something at face value'? The face, it seems, is something to trust and distrust. Someone looking downwards might be showing 'piety', 'sadness', 'modesty' or 'shyness' (Princess Diana's photographs frequently showed such expressions), the differences subtly modulated by bodily gesture, facial expression and our expectations. Whether smiling or frowning, looking happy or sad, bored, indifferent, angry or excited, we know that these are 'expressions' and not necessarily a fixed state of being. Yet, we may still try to read beyond these surface characteristics in portrait photographs, because we know they are not permanent states. They are temporary or even merely masks. Sadness may well be the mask that anger wears. We try to fathom the person beyond what we see, their identity, to the beyond of the portrait. How? Precisely through trying to judge and evaluate the combination of different elements that construct their appearance.

POSE

The pose of sitters is itself a visual argument, a form of rhetoric. Whether the person in the picture is standing upright, slumped in a chair, 'thinking', has sternly folded arms or has them dangling loosely by their sides, such postures are 'read' in combination. It is the job of the portraitist to spot or direct these combinations, to understand (or control?) what they signify together. A pose can be a self-consciously adopted manner intended to express a specific cultural 'identity', e.g. as goth, punk or business manager.

Pose and poise connote all kinds of aspects of a perceived character (mental, physical, social, etc.) of the person depicted. Whether it is strength or weakness, power or the lack of it, wealth or poverty, well-being or anxiety, anguish or anger, healthy or unhealthy, being immoral, evasive or honest … The list could go on, but what is important here is to grasp the *register* in which such connotations take their meaning. Does an 'upright' pose help to signify an 'upright citizen', or does it mean the character is simply self-conscious about being photographed? These characteristics are sometimes social and at other times psychological and to do with mood, or a combination of these. The pose *signifies* and, in a sense, the art of a good portraitist is to recognize this rhetorical aspect of the picture (even if they have never heard of 'rhetoric'). Just as the expression on a face is the rhetoric of mood, so the pose contributes to the signification of character, attitude and social position. How a person carries their body – posture – and conveys it in gesture can be read as 'embodying' their psychological attitude, pointing to a social or sociological grouping and revealing anthropological (ethno-cultural) habits. Rarely does a portrait involve simply one of these and, more often than not, will combine aspects of all of them (individual, social, anthropological). Portraits of celebrities and 'stars' have or have cultivated highly manufactured, fixed appearances (iconic codes). Paparazzi photography can be seen as the attempt at a corrective to those images. Contradictory in ambition, paparazzi attempts both to catch an 'off guard' face or pose of that celebrity, to show that their public image is only *one* facet of their personality, that their identity has another, more complex side, one often opposite to the public image.

Passport photographs (in common with police photographs) famously try to abolish all aspects of 'subjective' emotion in the portrait. Quasi-scientific, passport and police identity pictures all attempt similarly 'neutral' codes, intended to inscribe an identity *beyond* any mood or character, to see people *as they really are*. Passport photographs are meant to be like a fingerprint: neutral, indexical and 'objective', without prejudice. The fact that the banishment of a smile and the fixed lighting conditions of lighting-camera-subject distance make us all look like criminals at least

puts everyone on a level playing field. This convention is a crucial part of their strategy: to diminish 'subjective' differences and decrease empathetic identification with figures in the pictures. We might thus conjecture that the 'smile' (a rarity in the history of painting) emerged in photography as a popular convention precisely to signify the willing – 'happy' – participation of the sitter 'to-be-photographed'.

CLOTHES

Clothing (or its absence) and the various accessories that go with it, jewellery, hats, gloves, scarves, burka, etc., all contribute to the rhetoric of the portrait too. Clothes indicate a great deal about someone's social identity and how they relate to it (in their pose). A uniform, for example, makes it easy to distinguish a factory worker from a police officer, a nurse from a doctor.

Although it is not a formal uniform, denim jeans, invented in America, signify a 'casual' dress code. They have become 'universal' in value (practical, 'hard-wearing' worker quality) as a sign of 'equality' and a 'democratic' bisexual dress code. (Ironically, jeans only go further to highlight the visible differences between male and female, despite their claim to bisexual functionalism.) Jeans show a 'no frills' approach to dress, they are something outside fashion (as the male suit once was) and identified as freed from social constraints. Advertising for jeans often claims 'liberty' as their fundamental right: jeans are supposed to allow you to become 'free'.[14] Whether they do or not, they still tell us a good deal about the person in terms of how they are worn. Needless to say, there are as many types of jeans as other types of clothing, the subtle distinctions of which are all meaningful: loose, baggy or tight, flared or tapered, a brand identity (or not). Some jeans are very expensive, while many denims have various textures and thicknesses too. To misquote Roland Barthes, from *Mythologies*, we can say that 'jeans are the uniform that does not want to be named'.[15]

The body too is caught up in this rhetoric of clothing *as difference*. Which part of the body is covered or uncovered, clothed or unclothed is crucial in fashion. Roland Barthes, for example, argued that fashion – eroticism – is located in the *gap* of clothes, the parts of the body that are *revealed* by fashion clothing.[16] Each year, the fashion moves around, to emphasize different parts of the body. Apparently random, one year it is 'short skirts' that reveal legs above the knee, another year a dress designed to reveal a cleavage, another time the protruding belly – I am of course referring to the fashion of women, not men. A dress that reveals a cleavage hints at precisely what is concealed: the breasts. The cleavage highlights or hints at what is concealed within the garment. A protruding, bulbous belly shows that pregnancy is fashionable and hints at the sexual activity behind it, by revealing an

adjacent part. This sort of displacement (or *metonymy*) is common to many social sign systems, where modesty in clothes permits a body to speak.[17]

Although we are not formally trained in the semiotics of clothing (fashion historians and designers may be an exception), most people are practised in it. We read the rhetorical combinations of clothes every day to distinguish a ticket inspector from a fellow passenger. We are probably all just as guilty of making short-circuited judgements about individuals based on their clothing. Someone who appears 'scruffy' we may well think is the same inside their head.

Even when someone says they do not care what clothes they wear, this still 'says' something about them too. The well-worn stereotype of an English academic, the 'absent-minded professor' type (who makes regular appearances in Hollywood movies), is someone who is so focussed on their work that they have no time or interest in other things, like their clothes. Yet strangely they do all seem to wear the same type of clothes: a dusty tweed jacket and equally worn baggy trousers, or long skirt if female. Of course such images are stereotypes and not all academics are like this (there are other stereotypes of academics), but it shows that even 'functional' and consciously non-fashion dress codes still signify too. There is no escape, it seems, from clothes having a meaning. Clothes signify something about a person's identity, though the context in which they wear them – the location – also infers a message about the depicted person.

LOCATION/SETTING

The setting or background behind the sitter, whether in a studio or an everyday exterior/interior location (e.g. the street or inside a building), provides a 'context' for the sitter. It quite literally *locates* the sitter within a social place and we judge their position accordingly. In fashion photography, editorial portraiture, family pictures, documentary, or even a police mugshot, the perceived location is important. In cinema, advertising, fashion and even art photography, location scouting is crucial to finding places and spaces that will provide the right connection to the character in the picture. An urban 'back alley' is the typical location for villains to be seen as villains (or the homeless). In fashion, a winter coat might look good against the same kind of urban space background (a coat to protect you against the 'elements'), while a summer dress or bikini in that setting may seem rather too 'vulnerable'.

Portraits set in studios or locations allow a range of contexts: the home (posing in front of it, doing domestic work, relaxing 'at leisure', gardening, etc.); the workplace (industry, trade or profession, etc.), shown 'working'; or travelling (shown in 'foreign' places, exotic or 'imagined' scenes) or strange fantasy scenarios. Many of these have been explored in different photographic practices where human figures are key:

amateur, art, advertising, documentary, fashion, family, editorial and paparazzi photography. The use of settings for portraiture varies as widely as the institutions and clients that commission them. In all cases, the location and foreground figure form a relationship, a juxtaposition that is crucial in framing how we see them.

The four elements work together: clothes, setting, pose and the facial expression of the sitter are balanced (or not) in the rhetorical argument of a portrait. Modern Hollywood cinema has the maxim: 'See the spaces, sell the faces', meaning that a *long shot* (whole location setting) is shown next to a *close-up* shot of the actor. In the repeated montage of long shots and close-ups, the sequence maximizes the two elements of scene and actor, landscape and portrait. Portrait photographs, however, have no need to cut between these two because they are always combined together in one single frame. The meaning given to the scene, figure, pose and expression all arrives at once, simultaneously. In this respect, the condensation of these elements in a photograph provides the aesthetic and rhetorical form from which the demand arises that the spectator *reads* the picture.

'READING' PORTRAITS

The question of how much can be 'read' from an image of a thing depicted is an ancient discussion and goes back to Plato and his distrust of surface visual appearances. The argument that appearance is merely surface or 'cosmetic' and tells us nothing about depth-reality is a view only reinforced by the advertising industry's use of photographs. In this argument there is always a critical suspicion that the surface is hiding or covering something over, in a kind of deceit.[18] Such problems and their responses are always limited by the fact that in the field of the visual, virtually all the viewer has to go on is the appearance of some thing or someone. Additional written information can provide a contextual knowledge, or anchor specific meanings to that surface appearance, but we are still left with the surface as a means to judge or read any message. Yet, as such, the problem of 'appearance' and 'reality' or *surface* and *depth* is not entirely the right question or issue, since it leaves the intentionality of the spectator out of the equation, a point that I will return to shortly.

RECOGNITION

What is it that we do when we look at a photographic portrait? Why? In a simple sense we are confronted with the geometrical representation of a human figure. In the perceptive act of looking at a portrait we *recognize* the human figure. There is a pleasure involved in this very process of recognizing. There are many circumstances

in which we intuitively experience such acts of recognition as ones of pleasure: the sight of a loved person in a picture, an unexpected encounter in the street or suddenly meeting someone last seen long ago. The jubilant pleasure of such encounters should not be underestimated in the act of looking at photographic portraits. This aspect certainly accounts for the unprecedented and extraordinary popular rush of all kinds of people to have their portrait made when photography was invented, especially in Paris. Hence Charles Baudelaire's famous remark about the *narcissistic* craving of the masses to be photographed: 'our loathsome society rushed, like Narcissus, to contemplate its trivial image on the metallic plate. A form of lunacy, an extraordinary fanaticism, took hold of these new sun worshippers.'[19]

The term recognition itself already suggests that cognition is repeated, a *re*cognition. Thus recognizing something is a return to an already known, already experienced pleasure before. Sigmund Freud identified a 'compulsion to repeat' as an unconscious mechanism that gives individuals pleasure in repetition.[20] He showed, again and again, how there is a pleasure in repetition. Children like to repeat the same games or stories. Adults enjoy repetition of the same pleasures too (even compulsive behaviour), seemingly driven by an unknown force. By 'recognizing', you are seeing something already known, and *re*discovered *again*. Freud argued that this pleasure in repetition could be accounted for partly as a drive to master the original experience, but also that repeating something already known offers a kind of pleasure as 'short circuit' thinking, as assurance of *the same*.

In portraiture we probably encounter three general categories of people, all of which entail different aspects of recognition. The encounter with portraits usually involves people who are:

- *Familiar* – friends, family, ourselves, relatives, neighbours, acquaintances, colleagues, etc.
- *Unfamiliar* – strangers, foreigners, etc.
- *Known* representations – people who exist as a *discursive knowledge*. These people are 'familiar' as 'representations', but are not actually 'known', primarily because they are represented as *famous* (celebrities, stars, politicians, royalty, etc.) or *infamous* (criminals, terrorists, villains, etc.). Whether they are fictional (like James Bond) or real (a president), they are known (seen, heard and written about) primarily across the daily pages of magazines, websites, television, newspapers, journals, advertising posters, etc., as a character in a *discourse* (e.g. politics, entertainment, sport, etc.).

The images of people we are *familiar* with are typically circulated within a personal realm (e.g. domestic family albums, computer desktops, mobile phones, etc.), while the *known* representations of people circulate in public discourses

(media, advertising, etc.). These two categories (*familiar* and *known*) can be seen as comforting, since they repeat, in different ways, figures who are already 'images'. The pleasure is in seeing the familiar and known again and again.

Those seen as *unfamiliar* either struggle to be represented at all (fight to be represented) or find themselves already represented in ways that do not fit or correspond with their self-image. The work by photographers who are conscious of representing the unrepresented in new ways, which do correlate to their actual identities in some way, is of much value – and this is often where innovations in portraiture are achieved, precisely because they interrupt the comfortable economy of the *same*.

The pleasure of recognition is at work, whether it is the re-finding of a loved one's picture, the recognition of a *famous* or *infamous* person (e.g. someone who has committed a crime *recognized* from a police photograph) or the uncanny impact of a stranger's face. In *identifying* the sitter, the viewing spectator derives a pleasure from the act of recognizing and identifying, a process that engages the scopic drive (drive to see). How?

IDENTIFICATION

One aspect of this structure of recognition is already accounted for in the identification of the spectator with the geometrical position of the camera. The viewer's primary identification with the camera projects us into the space of the picture, the 'here I am in this scene'. This identification with the camera can itself offer specific types of pleasure, often ruthlessly exploited by the cinematic industry.[21] The camera can offer a 'thrilling' point-of-view shot, hurtling down a cliff, or following the trajectory of a bullet. In addition to this primary identification with the camera, which is a precondition for seeing the depicted object, there is another type of identification where visual pleasure figures: an identification *with* something or someone. In this sense, a photographic portrait may offer an image of someone that the viewer can identify with, as being *like* them. Even if this is simply a wish that can never be fulfilled, it nevertheless provides a visual satisfaction in the fantasy of identification. ('Fantasy' here is defined as the hallucination of a satisfaction.[22]) Thus far, in relation to looking at portrait photographs, we can distinguish four types of identification:

1. With the camera, as viewer.
2. *Of* the person depicted (recognition).
3. *With* the person (or object) depicted.
4. With the *look* of the person(s) in the picture at us or other characters in the picture.

We might elaborate on each of these. In (3), for example, identification with a person in a picture might be with someone you *are now*, or as you *wish to be*, or were like *in the past*, or *as part* of you.[23] In this way it can be seen that looking at images of others engages our own sense of self, whether consciously or unconsciously.

NARCISSISM AND LOOKING

For Freud, in the early stages of life, pleasure in looking (scopophilia) is primarily an 'auto-erotic satisfaction', a kind of self-pleasure, where an infant takes its own body as object of the look.[24] Voyeurism develops out of this, leaving primary narcissism behind (exhibitionism remains within a narcissistic formation) for the pleasure of 'an object other than itself'. These other objects, however, often turn out to be things that satisfy the auto-erotic body too, but in a roundabout way, like food, a sexual object or a person who gratifies some other appetite.

Jacques Lacan, the influential French psychoanalyst, developed this idea in his famous paper on the mirror phase, where he describes how an infant achieves recognition of itself (as an 'I', a 'person') through its primary identification with its mirror image or other person (e.g. mother/father). The fact that a child's identity is instituted through an identification with an image that is 'over there' means that its identity is based in a *mis*recognition, an alienated image taken as itself. Thus, human identity (social, sexual, political) is always a precarious structure, precisely an *identification* (process) that is subject to 'others'. In this respect we might see that a central gratification of portraiture is precisely an address to the imaginary question: am I like this person or not? The 'jubilant' pleasure the infant has in front of its mirror image or smiling parents, as discussed by Lacan, is repeated via the pleasure of recognition of the human face in portraiture. Perspective has constructed a model apparatus for the photograph to repeat, again and again, an attempted mastery over identity, an enjoyment of recognition and mis-recognition of one's own body (in the image of others). If such processes of identification and visual pleasure are central to the spectatorship of portraits, we should also consider the phenomenon of *projection*, which, like identification, has implications for what we do with portraits.

PROJECTION

In 'projection', the viewer casts off uncomfortable feelings, which arise in themselves, and relocates them within another person or thing. So, for example, a set of feelings about a mother or father might be projected onto those people met in everyday life who can serve as their substitutes, like employers or colleagues. Or, equally, the racist

finds his own prejudices confirmed by projecting them into the image of an other. Despite the hostility such projections create for the recipient 'other' of this hatred, the release of pleasure for the racist is in expelling emotions that cannot properly be accommodated within themselves, hence the delight in the frequent exclamation: 'See, I told you they were like that!'[25] This may also throw light on the vexed issue of stereotypes, where the fixity of stereotypes, which beleaguers many social groups, is the manifestation of a delight in repetition (also found in jokes) where some ideological value is (rightly or wrongly) 'recognized'. The same structures of projection can occur in the viewing of a portrait photograph.

Maybe this concept seems strange, but Ernst Gombrich already introduced the idea of projection into art history to understand aspects of the success of certain portraits by Thomas Gainsborough, the English portrait painter of the 1700s. Gombrich takes up an argument made by the Royal Academy painter Joshua Reynolds (in his famous late-eighteenth-century lectures on painting at the Academy) that the 'striking resemblance' in Gainsborough's portraits is achieved by leaving 'many important features undetermined'.[26] This, a backhanded compliment by Reynolds about the 'unfinished manner' of Gainsborough's paintings, implies that Gainsborough's technique invites the spectator to fill in the missing details with their imagination, thus allowing an increased verisimilitude of the traits of the person depicted in the mind of the spectator beyond what is actually attainable in any painting.

THE BLANK EXPRESSION

The most celebrated historical portrait picture to do this in the world today is the 500-year-old painting by Leonardo da Vinci: the *Mona Lisa* (*c*.1502). It still attracts massive crowds at the Louvre in Paris. Pictorially, it has a balanced but uneven composition, achieved by the dynamic relations between background and figure, dress, pose and facial expression. The hands, which often give away a good deal about a person in portraiture, are perfectly placed in front of her, no sign of awkwardness. The landscape and her face are uneven from one side to the other (breaking with the conventional wisdom that symmetry in a face is what defines pictorial beauty or *photogenia*). The Mona Lisa's face, primarily her eyes and mouth, have an 'enigmatic' quality, derived from a painting technique, where Leonardo da Vinci slightly 'smudged' a facial expression. Called *sfumato*, this technique leaves the key features of the face 'indistinct'.[27] As Ernst Gombrich notes, the *sfumato* technique means that she seems to smile or frown depending on the mood we project when looking at her face.[28] The picture draws the spectator into an intimacy that ironically is caused by what we want to see (an issue that is at the heart of portraiture); the portrait

reflects the viewer's desire in looking. The picture appears to make us judge the mood of the figure in the picture, whereas it is we who have produced the signified meaning and effect.

A technique similar to the *sfumato* is developed by photographers too (not named as such). Using soft-focus blur of the face, photographers like Julia Margaret Cameron and later Edward Steichen made facial features slightly vague as the means by which spectators might more easily project impressions onto the portraits. This technique, denounced as 'fuzzography' (a non-photography) by Victorian critics, was sometimes likened to the soft 'painterly' techniques of Rembrandt, the Dutch seventeenth-century artist. His famous self-portrait series, made across his lifespan, show the ageing process, drawing attention to the vulnerability in all of us when looking at pictures of other people: our narcissism.

In Gombrich's discussion of Gainsborough, he argues that what the strategies really enable is an increase in the ambiguity of meaning, so that the spectator is caught up in an oscillation between different readings of the portrait in their imagination. This same structure can be said to operate in the field of photography in an opposite sense where there is an *excess* of detail in an image. In large art portrait photographs (for example by Thomas Ruff), the yield of legible information of the individual depicted is very high, such that every eyelash, spot or blemish seems to signify something.[29] But it is precisely this surfeit, this abundance of detail, that exposes a surveillance model of scrutiny to ridicule. All this 'too much' information, an over-accumulation of facts, means that one cannot decide for certain *what* is signified and even less what the seen subject is thinking. It is here that the viewer is left a space for identifications and projections to flourish and fester in and across the image. The spectator is left in a space where every gesture or mark within the portrait image is a threat or promise of meaning.

In a sense, what I am arguing is that the meanings of the image are always corrupted by these processes of spectatorship, such that the viewer invests their meaning based on their relation with the signifying elements of the extant portrait. In this way the viewer is pulled into the scene, and the drive for mastery, which underpins all scopophilia, remains dissatisfied so long as the image is not mastered. It is no doubt for this reason that Leonardo's *Mona Lisa* sustains interest as the continued attempt to master the meaning of that smile (see also Figure 4.5).

If various forms of portraiture are concerned with establishing social identities, then we surely need to consider the pleasure in viewing these images and begin to interrogate our own investment in them, if only to begin to understand how and why pleasure in looking, and psychological and social identity, are all intertwined within the eternal question that portraits seem to address: *who are we?*

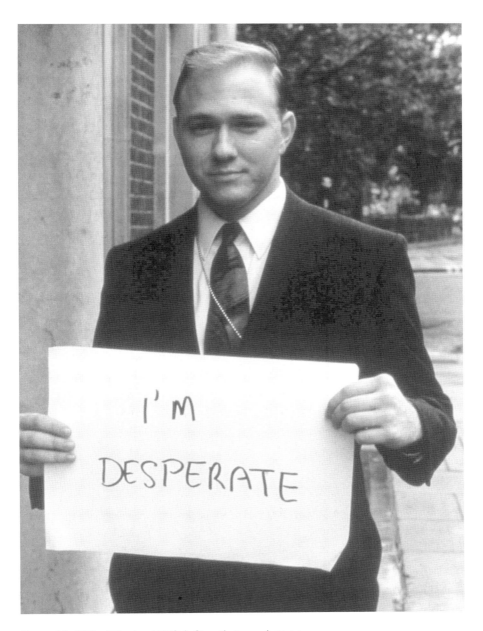

Figure 4.5 Gillian Wearing (1963–), *Signs that say what you
want them to say and not Signs that say what someone else
wants you to say*, 'I'M DESPERATE'. C-type print, 1992–3
(MP-WEARG-00198). Courtesy Maureen Paley, London.
(Original in Colour.)

Chapter Summary

- Portraiture was central to the historical development of photography as a commercial industry.
- Portraits are used to identify and make *visible* different sections of the population.
- We can identify key semiotic features of portraiture, whatever the public/private purpose of the portrait.
- 'Recognition' is a component pleasure in looking at portraits.
- In 'projection', a viewer can implant their own feelings in a portrait photograph even though it seems as if these meanings come from the actual portrait.

Figure 5.1 Tony Ray-Jones (1941–72), 'Glyndebourne', 1967.
Opera fans at Glyndebourne. © NMeM – Tony Ray-Jones.

The annual opera festival at Glyndebourne was founded
in 1934. Tony Ray-Jones created most of his images of
the British at work and leisure between 1966 and 1969.
Travelling around Britain, he recorded the unguarded
moments of people in British society with a distinctive and
highly individual style.

5 IN THE LANDSCAPE

How to account for all the diverse uses of photography called 'landscape'? There are several narratives that could be explored or examined here, from the contemporary practices of art photography and their history, through to the uses of landscape pictures in many various industries. Tourism, for example, depends on photographic views to sell holiday destinations in its brochure images; views which are then often bought as postcards or reinterpreted in personal photographs (snapshots) by holiday-makers. There are many others: urban planning, military reconnaissance, Google maps, architectural planning, war reportage, gardening books and heritage sites, to name only a few; all have what can be called landscape view pictures as central to their practice.

More abstractly, we could generalize the definition of landscape as the geometry of a space, the organization of a point of view towards a town/garden/city/country/suburb/park or industrial wasteland/wilderness/public space, or architecture, land and nature. In all these spaces, the point of view of the camera, whatever time of day or night, organizes what is there into a cultural artefact: a landscape view. Yet this does not take us very far, as it is probably already quite obvious that landscape pictures pervade everyday culture. The inventions of photography, cinema, television, rocket science, satellite imaging, computers and the www have all been quick to develop, if not exploit, modes of landscape imaging. They have all, in different ways, expanded the visual mapping of space, so that it might be said that 'landscape photography' today exists within an expanded field of landscape imaging. The visual mapping of space now extends beyond the geometry of photographic images, to include thermal imaging of a territory, aerial mapping of land and even the invisible profile contours of land and sea, now seen in sonic imaging. Across such inventions for picturing space, the main question about landscape still remains the same: what view are we given of that space? Moreover, what is it that we do with those images, what is their purpose? Photography remains absolutely central to such discussion of technologies of vision, not least because 'photographic vision' still occupies a key reference point for the contemporary and historical depiction of the environment. Indeed, photography is pivotal in the history of picturing anything.

So, what is important to grasp here is the specificity of what landscape views bring, as images, to social knowledge and what photography contributed to this field of vision.

VISION AND KNOWLEDGE

What is shown in a landscape picture? The environment, now dominated by the presence of humans as much as by any putative 'nature' itself, is what is always *re*-presented in landscape pictures. What this means is that, whatever is seen is always *coded* via the picture. Therefore, *how* the material is seen *in the picture*, the way it is pictured, is as critical as what is shown. It is worth tracing here the impact (but certainly not *all* the lengthy debates) that the idea of 'photographic vision' has had on notions of painting, on the philosophy of art and aesthetic values that sustained the practice of landscape picturing. Since the goal of landscape painting was always more than just showing a scene, what emerged as a dilemma, as much for photographers as for painters, was the type of vision implied in a picture.

The invention of photography created a new problem for painting: the issue of 'truth' and 'fidelity' in vision. John Ruskin, for example, the English aesthetic critic who used photographs himself, nevertheless complained that 'microscopic poring' and 'exaggerating the powers of sight necessarily deprives us of the best pleasures of sight'.[1] The mechanism of the photographic process was thought to reveal a nature 'laid bare', ugly in its lack of 'aesthetic beauty'. Photographs could show 'too much'.

This idea immediately points to the categories that painters and art critics were concerned with in landscape: notions of pleasure, sight and an aesthetic view of nature. These ideas dominated their attitudes towards photography as well and provided an allegorical figure for the views of a cultural elite towards the industrial revolution – in which photography was obviously implicated. Symptomatically, the new picturing system of photography was seen as 'crude' and lacking in subtlety (just like the industrial life of a factory so rarely pictured in them). Mechanical and chemical, photography was imagined as an 'industrial' vision placed in contrast to painting, where the talent of the artist was supposed to reign supreme over the materials. Rather than pursue this polar dispute between different technologies (as industrial or organic, mechanical or human), it is more relevant here to consider what such debates created – that is, the effect of photography on painting and the aesthetic ideals of painting on photography. I want to introduce here the notions of beauty and landscape, a 'philosophy' of art which became important in the development of photographic 'landscapes' as a particular way of seeing. In short, the

impact of these aesthetic debates on the idea of photographic vision remains crucial, even in modern debates on photography.

HISTORY OF LANDSCAPE

Early photographers interested in art readily pursued pictorial values derived from the genres of painting – one might say photography 'cannibalized' the genres and values of painting, as they existed in the Art Academies. In nineteenth-century England, the highest of the academic genres was landscape, unlike in France where history painting reigned supreme. This was to do with the particular, perhaps peculiar, relation to landscape via the concept of the *picturesque* in England and in English culture. A consideration of this will highlight what is involved in the aesthetics of landscape.

The picturesque, a word of Italian origin meaning the point of view of a painter, was elaborated as a theory in England between 1730 and 1830.[2] It is a theory whose practice took the form of poetry as well as painting. This interest in the Italian picturesque was imported by wealthy English visitors who travelled to Italy as part of their 'grand tour' and brought back – filled their houses with – Italian paintings. It was from those paintings that garden designers, like 'Capability' Brown, began to create country home gardens to resemble the paintings.

Landscape gardeners like Capability Brown were regarded as artists in their own right, able to command large fees to undertake monumental land work. Brown's capable reputation came from his ability to turn a molehill into a mountain, designed to give 'philosophical thoughts' when you looked at it. A garden building built as a 'ruin' would provide a contemplative sign for the potential demise of any great civilization (Rome, Greece), and serve as a warning to the contemporary viewer. Such landscaped gardens were organized as a philosophical walk, with vistas from fixed viewpoints intended to provoke 'feelings' (e.g. contentment, happiness, fear, anger and anxiety) and thoughts in the mind of the spectator. Passion, love, war, beauty, public life, action, friendship, virtue, politics and the ruin of civilization could all be allocated a place in the garden scene. The walking spectator was a 'philosopher' of life and the poetic garden was a book with which to read it. In both the reworked land and the landscape picture, the 'poetic garden' was a pictorial spectacle designed to arouse the spectator's emotional and intellectual senses.

Thus, ironically, paintings were the models upon which these 'designs' for organizing the land were actually based; a reversal of the usual assumption that pictures are secondary representations of a pre-existing world. Nature was shaped according to how it was already seen in pictures. The seventeenth-century paintings

of Claude Lorrain can stand here as emblematic of this type of landscape picture, which the eighteenth-century English picturesque drew upon.

While landscape painting as a pictorial genre is generally attributed to Nicolas Poussin (1594–1665), the most famous early painter of this European painting tradition is Claude Lorrain (1604/5?–1682). Claude Gellée from Lorraine was a French artist trained in Italy, whose success came from his ability to sketch from life (areas around Rome and Naples) and combine the 'best' parts of these places into a single, unified 'virtual' landscape. His scenes were drawn from nature but collated into singular idealized landscape compositions. Claude's paintings made composite ideals, perhaps the first 'virtual' landscapes (a modern Claude might have used a computer to composite such pictures today). These *imaginary* spaces were anchored mostly to the depiction of biblical scenes. The stories, set in time and space 'far away', were bathed in warm, sumptuous sunlight and his pictures conjured up an imagined antiquity, an 'Arcadia' with long shadows and deep horizons. Such imagery is still evocative today, found, for example, in the final departure scene of the last *Lord of the Rings* film (*Return of the Kings*, 2003). For Claude and modern audiences, the low sunlight on the horizon of these pastoral scenes meant dusk *or* dawn, connoting both an end *and* new beginning – the endless cycle of life. Although nostalgic, the pastoral space is nevertheless open to the vista of an unknown future (hidden) beyond a 'golden horizon'.

Dutch artists also developed this type of Arcadian landscape painting at the same time as Claude and they travelled to Rome too (regarded as the source of 'Antiquity'), for inspiration for painting their idyllic scenes. (One of them, Herman van Swanevelt, even shared a house with Claude in Rome.) A key difference between the Dutch scenes and those of Claude was that they emphasized 'simple' contemporary rural life, which although idealized, had no direct reference to biblical stories as in Claude, who drew on stories in the bible for his depictions. The Dutch painters adapted the depiction of the Roman lands to their own homeland scenarios, depicting a rustic rural life with a domestic tranquillity and security (although sometimes juxtaposed with Roman ruins as an allegorical reminder of the failure of all civilizations, the ghosts of antiquity). Such pastoral scenes romanticized the reality of rural life, depicting it as 'it should be', not 'as it is'. The idealized human figures were perfectly located, figures within the general landscape where everyone was 'in their place' – and seemingly happy with it. At the time of the invention of photography the paintings of John Constable (1776–1837) developed this tradition in English rural scenes, quickly adopted, and developed, by photographers like Henry Peach Robinson.

The contrasting type of landscape picture was the '*sublime*', as found in Salvator Rosa (1615–73) or J. M. W. Turner (1775–1851). We could thus contrast – as a

rough, general and simplified distinction – John Constable and William Turner as picturesque and sublime respectively. This distinction between picturesque and sublime was certainly important then, as much as it is still important today, in that they are latent categories in contemporary discussions about beauty in photography landscape pictures.

However, even if the eighteenth-century period is attributed as the common origin of the picturesque, it is worth noting that there is both genre painting and pastoral poetry to be found in the ancient Greek Hellenistic period. The eighteenth-century picturesque is therefore already an emulation of an earlier Greek picturesque and Arcadia.[3] The longevity of this form, its historical repetitions and renewals, should indicate that it most likely has a significant function in relation to fundamental processes of human thought. Indeed, 'landscape' is the taking shape in symbolic form of a space for the projection of psychical thoughts on culture, identification and 'civilization' under the name of nature, as much as a treatise on any actual nature or question of environment itself.

'Landscape' here can be seen, as it was in nineteenth-century debates, as a general name for substances – it can mean bricks and mortar, leaves and fields, the desert, automobiles on a street, overcast or sunny skies, rural and suburban trees, concrete architecture, ghettos, a seascape at night, a seaside resort, the post-conflict rubble of a war-torn city, a tourist resort, industrial spaces, interiors or panoramic views. 'Landscape' is not all things to all people, but a highly differentiated discourse on representing space.

BEAUTY AND THE SUBLIME

In the mid-eighteenth century it is Edmund Burke, in his 1757 book *A Philosophical Enquiry into the Origin of our Ideas of the Sublime and the Beautiful*, who tries to theorize the aesthetic – and emotional – effect of beauty.[4] Burke is credited with making, as the title of his book indicates, a distinction between beauty and the sublime landscape. Other writers followed and developed a general fashion for the *picturesque*: a landscape scene in nature suitable for 'picturing' – hence picturesque. For example, the Reverend William Gilpin wrote books, sparsely illustrated with rough sketches, advocating various parts of the British Isles as 'picturesque'. Nature became the 'beautiful' to be consumed by an increasingly urban public. Essentially, William Gilpin and other travellers' writings served as guidebooks for those who followed in their paths, including painters who subsequently rendered these specific sites into scenes (with appropriate pictorial visual style and coding) of beautiful nature. This version of the picturesque is important, since it anticipates the modern conventions of the tourist industry, where tourists with cameras follow in the

footsteps of earlier travellers, repeating the same picturesque scenes within their own photographic images.

In the eighteenth century, a typical picturesque scene was 'rustic': an autumnal landscape with an old farmer or parson and daughter by a cottage, river or old oak tree with a donkey, cows or sheep. Alpine-type hills were especially popular, hence the rush to North Wales and the Lake District (a heritage site today) by painters and writers in the 1760s. Almost exactly one hundred years later, in the 1850s and 1860s, there was a similar rush to the Lake District with the same enthusiasm for the picturesque by photographers like Roger Fenton, Francis Frith and many others who trod in their path. The picturesque landscape was a calculated response to industrialization: to escape it. The growth in democracy of travel and new 'leisure' time (a product of industrial life) enabled a whole new industry, which mapped the routes of picturesque travel for the 'masses'. It was an industry whose very success in encouraging masses to visit these places, in turn, became precisely the activity that threatens to ruin the picturesque quality of those views.

What those views gave were idealized scenes of the countryside as 'nature', as *natural*. This sort of picturesque view gave nature its modern conventional sense as 'beautiful', a type of nice view that is already known, already seen. It is still ever-present today in stock photography libraries, advertising images (e.g. health, holidays, automobiles), picture postcards, tourist and heritage (historical) industries, and the history of art and photography. The tourist who visits a picturesque destination is the consumer of a pre-constituted view, one that is still given today under the name, in English, of the 'beauty spot'. It is an easy pleasure. We go to a beauty spot on a day off to stand where the view can be 'appreciated' and inhaled. The beauty spot is the place where everything has already been arranged for you to feel and appreciate the beauty: 'this is where to stand and see it' – a view that is already represented from the same given point of view in the postcard, travel brochure or guide. (There is a long tradition of documentary photographers who pursue this idea as a project, looking at what tourists do in specific places of tourism, showing the often less than ideal behaviour of tourists.)

In contrast, the *sublime* has a set of characteristics more akin to what the English Highway Code designates as a 'black spot' sign, or a representation of 'warning'. Unlike the beauty spot, the black spot is a space associated with danger, a place that is threatening, fearful and given an aura of menace. Salvator Rosa's paintings, for example, have threatening, half broken, overhanging trees and rocks – invoking 'nature' as something which is far from calm and with the potential of a totally destructive force. The National Gallery in London has a painting by Salvator Rosa of 'Witches at their Incantations' (*c*.1646), a scene in which it is the nature of the human figures who are coded as wild and threatening. Turner's sublime is mostly (though

not all) represented with scenes of the sea – not a calm and tranquil picturesque, but nature in all its fury and force. The sea is stormy and threatening, and for the small figures clinging to the tiny boats on it, almost completely overwhelming.[5] The sublime is something that threatens to overwhelm you and causes fear, but as a spectator the threat is at a level that can be tolerated. It is about the capacity to experience being fearful, but not being absolutely overwhelmed, of still being able to tolerate and contain it. This is clearly articulated in Burke:

> Whatever is fitted in any sort to excite the ideas of pain, and danger, that is to say, whatever is in any sort terrible, or is conversant about terrible objects, or operates in a manner analogous to terror, is a source of the sublime; that is, it is productive of the strongest emotion which the mind is capable of feeling.[6]

It is perhaps easier to think about this in more modern forms, one of which is of course the 'horror' genre. Those novels, films, etc. – 'thrillers' that seek to test the capacity of the viewing subject to tolerate more and more scenes of terror which, if readers participate in them, are threatening scenes. Clearly the relationship to pleasure and beauty in these texts is complex and, although this is not the main argument here, these industries that produce horror as entertainment could certainly not be sustained if there was not some form of pleasure in it derived by the spectators who pay for the pleasure of such experiences.

We can extend this argument to other domains, where the sublime is at work in, for example, a city environment, which is frequently seen as scary or wicked. This contemporary sublime is probably more familiar, since today the city is the more common environment for many populations and thus a privileged site for the sublime. Indeed, the city as a threatening place is probably one of the most common attributes given to cities now – likely to invoke fear equal to a brutal country landscape. Any cityscape offers endless potential spaces for anxiety and fear: dark streets, urban chaos and fear of the unknown is easily represented as such. Victorians who photographed the slums of Britain often showed them as dark alleys, dirty and sublimely threatening so as to demonstrate that their demolition was justified. More contemporary pictures of burnt-out automobiles, trashed buildings and dark passages are used to invoke fear and anxiety, rather than pity (or political anger). Within tourism, however, cities are more likely to be picturesque, wherever they are.

We might consider war photography as a special case of the sublime. Like the above example of 'horror' films, war photography engages with the domain of violence and threat, an anxiety of seeing, potential bodily dismemberment. War pictures are obviously about real violence, although propaganda war pictures may well try to give a more 'picturesque' view of soldiers at work. A lot more work needs

to be done on this area, examining the dynamics of spectator response to violent war pictures.

Yet the same elements, whether of nature (fields, trees, etc.) or culture (wars, cities, farms, etc.) can be used to signify *either* a picturesque or sublime. 'Nature' can be shown as 'gentle' (picturesque) or full of brooding 'anger' (sublime). A sky is picturesque when blue with nice clouds, 'a beautiful day', while the same place is sublime when the sky is heavy with threatening clouds, overcast with thunder and lightening. The sea can be picturesque when it is calm and tranquil, or sublime when wild and stormy. Such images of violent scenes or calm depictions are used to signify different human feelings or states of mind. Trees can be healthy, showing 'vitality', and 'full of life' or twisted, 'weak' and poorly nourished. The meaning of the environment is organized as a series of differences. Photographers and painters choose to represent elements – consciously or not – to make the meanings they wish to create. Even the earth can be made to signify opposite states: rich or barren, natural or contaminated, tended and cared for or wild and neglected, and fresh or worn out.

Animals too can be sublime or picturesque. Pets are largely shown as picturesque, 'cute' and cuddly, unless they have become wild and out of control like a 'mad dog'. Postcards showing wild animals can also be picturesque and sweet looking (even crocodiles can seem to smile), but they quickly become sublime objects of fear when they show any menace to humans. Sharks have achieved a mythical status as a pure sign for sublime anxiety (although the sad specimen in Damien Hirst's famous 'sculpture' shows this is not an essential feature either). Animal rights activists often show pictures of tortured animals in public to provoke anxiety among humans who see them and to invoke the same pain they feel the animals have experienced. The animal-lover viewer is made to suffer visually. In a similar (but often milder) vein, environmentalists also picture the environment as 'suffering' too. These are all compositions that invoke a kind of visual pain.

The terms picturesque and sublime gave us names to these general signifying economies, the way that different elements can be combined in pictures to add up to a gestalt metaphor for cultural values, feelings about life and ideology. In short, picturesque and sublime scenes offer a space for the identification of two different types of feeling and emotions in the viewer, located in a pictorial space. The 'landscape' is a set of social and psychological meanings. We all know that a certain room, for instance, can give off a sense of depression, excitement or even irritation. The disposition of objects within it, the light and sense of space created by these elements, *affect* us. The landscape genre works almost entirely in this way, using the coding of the elements to produce meanings.

So, now these two modes of picturesque and sublime, or beauty spot and black spot, need to be related back to the issue of *photographic vision*, which became the ideal media for the 'neutral' description of land.

PHOTOGRAPHIC VISION

In the nineteenth century a new and important category of image emerged, the idea of a specifically *photographic* vision. With the invention of photography, land, or other things, could be surveyed 'photographically'. This type of vision was different from the aesthetic vision of 'landscape' in the discourse of painting, where beauty/picturesque and the sublime remained the dominant criteria. In this photographic vision, it was the idea of 'pure fact' that dominated it, the idea of a visual description devoid of any 'human soul'. As Ansel Adams (1902–84) put it in a 1935 essay:

> Pictorialism discards the pure photographic technique and view-point in favour of superficial imitation of other graphic mediums. While a shallow imitation of the other art-forms was often obtained, their aesthetic substance was never achieved by the Camera, and Photography was thereupon vulnerable, and properly so, to depreciatory criticism and the frank denial of a position among the fine arts.[7]

Adams, in fact, describes four periods of photography (from 1825 to 1935) in sequence as: Experimental, Factual, Pictorialist and the New photography. The last – his own – represented a 'Renaissance' return to 'pure photography', what is known as 'straight photography'. If there was any aesthetic at all involved in this, it was argued, it was the capacity of photographs to reveal visual facts in a *photographic vision*.

'Pictorialism', however, was the name given to the various disputes about how and under what conditions photography was an art, between the 1890s and the early 1900s. The self-conscious, often tedious debates raged about whether 'artistic' photography was constituted by, for example, soft or sharp focus. Soft focus was often thought artistic because it was 'painterly', therefore not 'photographic' (see, for example, Figure 7.2 in Chapter 7: *Art Photography*). (Such debates about photography are not without interest. In 2006 a print of Edward Steichen's 'Pond-Moonlight' (1904) sold for US$2.9 million at auction in New York.) Away from these debates about artistic values, the idea of a descriptive vision took hold – pure photography was 'factual'.

This idea that photographs are visual facts has operated from the early years of the invention and has also returned at regular intervals. In the 1970s, the American

New Topographic photographers (Robert Adams, Lewis Baltz, Stephen Shore, Joe Deal and others) turned away from any aesthetic pleasure in photographs of the land and aimed for total 'neutrality'.[8] The early photographic expeditions by Europeans to their colonies and Americans to the 'unknown' interior of their continent were also primarily justified in terms of a topographic visual knowledge, as *surveys* of the land. Surveys were not 'aesthetic' expeditions. This type of photography was to have nothing to do with aesthetic pleasure or beauty, it was to be an art of pure description, the 'record' of a space, a 'document' (not documentary) that would provide a topographic description.

EXPLORATION

The aims of nineteenth-century expeditions were invariably multiple, open to the visual knowledge of land for various purposes: geological, political and scientific. Photographs of land claimed an innocence or neutrality in their point of view, as a visual fact. Yet the motives for taking them ranged from the planning of military routes and railroads, map-making, and the discovery of minerals to gathering natural, botanical and archaeological specimens and, not least, the government gaining knowledge about the 'ethnographic' dimension of land for imperial political projects.[9] Exploration 'photographically' was never simply a 'fact'. The ambition to explore and the *views* that photographs provided offered *positions* caught up in power relations.

This is not simply to argue, reductively, that topographic photography was only in the service of blatant political projects like colonialism, but rather to indicate how the idea of neutrality itself was implicated in a variety of uses of these pictures. The ideology of factual looking informed the photographic vision that was produced. At the level of the picture – photographic signification – the ideals of a non-aesthetic picturing informed the act of composing of any view as *descriptive*. Not least involved here are the often extraordinary technical and geographical obstacles to making topographic photographs. In the early years of photography this meant carrying cumbersome jars of chemicals, glass plates, darkroom equipment, heavy cameras and tripods across lands hostile to their transport.

However, once the camera is in place at a scene, the question became, how far can the photographer *avoid* the aesthetic categories of picturesque and sublime in their composition – that is, achieve the *non-aesthetic* description of the land in their photographs? If the ambition was that photography could escape the genres of painting by becoming 'photographic', by making 'literal' description its art, then the non-aesthetic landscape nevertheless found it hard to avoid the issue of composition.

(At root the *camera obscura* was as much the basis for a history of Western landscape painting as it was for photography).

We can see this issue, for example, in the work of early-nineteenth-century European photographers who travelled to the Middle East. In the 'Orient' they found themselves caught in the dilemma of representation: how to represent the land without turning it into an aesthetic picture, a 'landscape' – as it would become in later tourist imagery. The English photographer, Francis Frith, was one of the first to become famous for his photographs of Egypt and Palestine in the 1850s. He went on several trips there to take glass-plate negatives and make albumen contact prints intended for publication in books. Frith included 'archaeological and ethnographic' notes to accompany his photographs in the books he published to help to locate the pictures within a field of visual description and cultural knowledge, to *see* the 'real' Egypt in a series of photographic views. The idea of the photographic *view*, although not attributed to Frith, was an attempt to insist on a difference – that photographic seeing of landscape was an observation in a 'scientific' register, as fact, more than any specific aesthetic 'painterly' effect. Indeed, Frith was certainly among the first to represent these territories photographically, only hitherto seen by him in drawings and paintings or read about in literary description.[10] Even for colonial bureaucrats, now the land that was to be *owned* could be seen 'as it was'. So did Frith's photographs show his European audiences what these 'exotic' lands really looked like?

Frith was highly successful. His photographs were worked systematically; he set a scene with a long-shot landscape and a detail or closer view and, like a modern visual anthropologist, carefully dated and inscribed details of the picture on the edge of the glass plate negative. This specifically photographic discourse of the 'view', the land as topography, tried to avoid the aesthetic conventions that photography had been born into. Shot on large (10 × 8 inch) and very large (16 × 20 inch) cameras (he later took stereoscope photographs too) the originals provided a great deal of detailed information about the subject matter. Photography clearly introduced a new pleasure into the genre of landscape: *detail* as a pleasure of *information*. The optical detail, the high-resolution detail of photographic information (what Walter Benjamin called the 'optical unconscious' of photography[11]) could itself become a kind of aesthetic pleasure, even a fetish. Frith went on to develop a massive photographic agency, which photographed the coast, towns and country all over the UK. Increasingly picturesque, the photographs were mostly published in popular books that described a region in pictures.

AESTHETICS OF DESCRIPTION

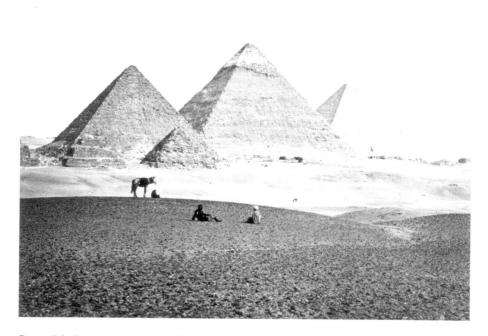

Figure 5.2 Francis Frith (1822–98), 'The Pyramids of
El-Gizeh, from the South West', Egypt, 1857. Albumen
print from wet collodion on glass negative. National Media
Museum/SSPL.

Look at the picture by Frith, the 'Pyramids of Giza', taken in 1857 (Figure 5.2). In
a vast landscape, the pyramids are symmetrical in his compositional arrangement of
them. The three triangles overlap each other (it would have been different if he had
moved the camera to another position) with a smaller one in front of them. On the
foreground hill, which appears like a natural 'bump' cast in shadow, are a mule and
three small figures, beautifully contrasted with the massive pyramids in the view
of Frith's camera. They give a scale to the distant pyramids. (See also the image by
Martin Parr in Figure 5.3.) The scene yields high information but it is picturesque
too. While the effect of photographic veracity, an *actuality* of visual information,
intervenes into the aesthetics of landscape discourse, even in this image – view – of
the pyramids, the picturesque has crept back into the actual composition of the land
as topography. Frith emphasized the 'truthfulness' of his pictures and claimed they

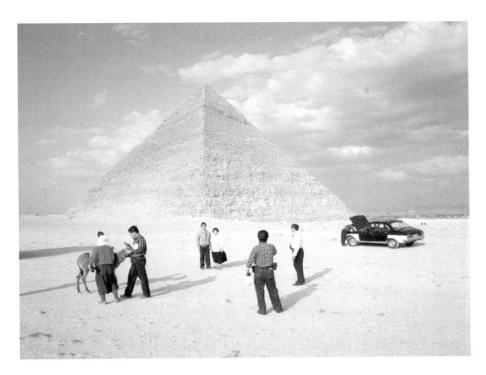

Figure 5.3 Martin Parr (1952–), 'The Pyramids', Giza, Egypt (1995/2007). © Martin Parr/Magnum Photos. (Original in Colour.)

were 'independent of general or artistic effect', but the temptation to make any scene picturesque was hard to resist. When Frith advised other photographers to make the most of each plate, he resorts to the example of the painter: 'Think of the careful thought and labour which are expended over every successful piece of canvas ...'[12]

Interestingly, in later life Frith did become a landscape painter. The symmetry in his picture, the lack of awkwardness in the scene, makes a view of the land into a picture 'worth looking at'. It is easy to see here how and why this photographic vision was attributed the properties of a 'scientific' realism, a new photographic looking that immediately intervened into the existing aesthetic conventions of landscape painting yet did not completely escape them. The picturesque and sublime, as aesthetic rules for landscape compositions, would not go away, but with the invention of photography, were now overlaid by the values of a specific photographic vision. This vision is still always subject to the category of beauty and its associated visual pleasure in the act of 'composing' pictures.

COMPOSURE

In his 1934 lecture 'The Author as Producer', given in Paris (delivered at the Institute for the Study of Fascism), Walter Benjamin says, in a now famous remark about the development of photography in the 1930s:

> It has become more and more modern, and the result is that it is now incapable of photographing a tenement or a rubbish-heap without transfiguring it. Not to mention a river or an electric cable factory: in front of these photography can now only say, 'How beautiful.'[13]

Of course, to make an ugly or 'unpleasant' object into something beautiful, at one level only demonstrates the skill of the producer to subdue the ugliness into the appearance of something beautiful in the picture. But, the issue of beautification needs to be looked at in a different way if we are to see the politics of beauty in relation to landscape.

Concerned photographers have attempted in their oppositional practices to undo this reduction of the world to the category of the beautiful. From whatever starting position, such 'de-mythologizing' practices have had the shared project of throwing off the shroud of beauty, to show how the idealization of subject matter represses, ignores or misrepresents our social relations to the *real* environment. In other words, they have tried to demonstrate how the experience of a picture as beautiful, or let's say pleasurable, can lead to a so-called 'false consciousness' or wrong-headed conviction about how the world really is. But there has always been a resistance to this sort of criticism. There is something about picturesque images that cannot be waved away or dispelled: their pleasure. No matter how much any rational critique is made, individuals tenaciously cling to the pleasure of this or that image, no matter how far others find the same image to be appalling, clichéd, trite or 'senseless'. There is, I suggest, a fascination with the image as beautiful that persists in spite of conscious criticism about the social, eco-material or political status of landscape pictures. Even if the critique is about a photograph serving up 'rural myths', romanticized views that negate the pollution or human destruction of natural land, a spectator can appear as in the grip of some emotional effect of pleasure which no amount of deconstruction or rational criticism can touch or stop.

One way to understand this grip of pleasure is through the composition of the picture in relation to the spectator. The beauty of objects in representational forms is commonly regarded as having something to do with proportion and symmetry. When a spectator's eye drifts off out of the frame they are no longer looking at the picture. Good composition, it is said, as any photography handbook will have as an unwritten rule, is about keeping the eye of the spectator within the frame.[14] So long as the spectator's eye is within the frame, they are looking at the picture. To do this,

the scene must harmonize the parts to the whole. In picturesque beauty (for example a Constable painting), a conventional 'good composition' is one that enables the spectator also to recognize the scene as a scene – it is what makes the whole structure work. This pleasure in 'recognition' should not be underestimated. The beauty spot gives the viewer an *imaginary* command of the scene. In the activity of seeing, the 'drive to master' is one of the key components of looking. The picturesque is a form in which everything is supposed to be 'in the right place', organized as precisely 'composed' and controlled. The poor peasant or agricultural worker is seen working in their master's field and so on. Everything is 'in the right place'. Here content and form become one through 'harmony' and 'balance'. A good composition in relation to the pictorial form of the picturesque gives a certain type of satisfaction and pleasure for the viewer, which results in the spectator having an experience of the beautiful. 'Good composition' satisfies the composure of the viewing subject.[15]

In Freudian psychoanalysis, it is the ego that constantly attempts to organize the human subject, it keeps the mass of drives functioning as a coherent (if imaginary) 'person'. The ego is the seat of 'composure', it is an agency of control. Composure of a person then, the subduing of various parts to a whole (i.e. unconscious and super-ego) is just like composition in a picture; it is a way of organizing and containing excitement, since adult life is mostly about containing, binding sexual excitement into sublimated forms. The pleasure derived from the composition of picturesque beauty is a pleasure in the recognition of order, precisely what the ego wants: a unity and organization of the (imaginary) coherent 'self'. It is as if someone says to themselves: 'This order and harmony that I see in the picture is the order and harmony that I wish in myself.' The organization of the picture is identified with a corresponding internalized sense of satisfaction of the ego in the human subject: 'I have finally organized everything into a unity, it is all in the right place.'

If this structural relation between the composure of the human subject and the composition of the pictorial object sounds preposterous, just think of the way that when someone loses a loved object (e.g. a person or thing) their composure and self-value can crumble or be damaged. Someone can quite literally 'go to pieces' at the loss of a loved thing, thus *losing* their own composure too. What is externally lost is reciprocated internally as the lost property of the ego. Conversely, a badly composed picture may well invoke a sense of distress (or dis-interest), but for the reason that it fails to provide a seat of composure. Or alternatively, someone who suddenly cries when they see a picturesque scene may well be, unconsciously, recognizing his or her own lack of composure. Such remarks obviously require further scrutiny. However, the picturesque is certainly a form that invites composure through a narcissistic identification with, and mastery of, the organized scene. The picturesque offers an image for potential 'fullness'. So when someone says 'this picture is for me', or 'this

is my sort of picture', they are implicitly recognizing themselves in, as belonging to, identifying with, the organization of the scene. These sorts of argument are already intuited in the way that picturesque beauty is so despised and maligned, as a 'too easy pleasure', by critics. In contrast with the sublime, it is rare to find contemporary cultural critics advocating the picturesque as a radical or interesting form. Discussion of the picturesque is mostly in negative terms, but this underestimates the extent to which it can be valued positively, as something that gets you through a situation, something that enlists you into a composure, but one which may nevertheless ultimately be complacent.

In fact, the issue of the politics of this pleasure becomes much clearer and acute when considered in relation to particular issues, for example when landscape is invoked by discourses of nationalist fervour, class anxieties (expressed as a fear of social disorder), or in struggles of property rights, ecological debates and during wars. National or other identities may well find the 'composition of the land' crucial in constructing its *imaginary community*.[16] So when land is invoked as something to be protected as the 'blood and soil' of a nation or specified ethnic group (rather than the entire population made up of different ethnic groups), as has so often been the case in the historical uses of landscape imagery, the idea of 'composure' (a narcissistic unity to the exclusion of others) becomes a real problem; it elicits, invites, a violent process of cleansing the 'contaminating' elements – that is, the unwelcome debris of people's 'rubbish' – from the otherwise 'pure' scene.

It is precisely in the idea which says that someone or something 'does not fit' in the picture that the composure of an 'us' is constituted as an 'ideal' picture, which at the same time construes the exclusion of a 'them' or 'that'. Or in any social cultural 'identity crisis' of who 'we' are or what 'we' identify with, a picturesque landscape responds reassuringly that 'this picture represents what we believed has been lost', whatever that is (e.g. Englishness, Japaneseness, Frenchness or Africanness etc. perhaps), which this image also makes present again 'here and now'. This is why landscape is so often associated with a contemplative mood akin to melancholia, a 'pleasure' or satisfaction derived from longing for something past or lost. Perhaps this is why the pastoral picturesque scene has, over the centuries, offered itself as a kind of solution to the discontents of civilization. Discontent is invested in a 'return to nature'. 'Nature' is the name given to the appeal to completeness, an attempt at mastery over a cultural structure that almost inevitably resists it.

As for the sublime, the relation to composure is clearly one of *testing* the capacity of the ego to tolerate excitements. This is a different kind of pleasure, one that excites desire rather than subduing or disarming it. Whereas beauty in the picturesque form is insensitive to outrage, the sublime revels in it, enjoys and tests capacity for pain. In the writings of Edmund Burke, who was politically a conservative, the category

of the beautiful is linked with notions of 'society' and the social. So for Burke the picturesque suggests the harmonizing of individual passions to the whole (society), whereas the sublime is linked with anti-social or asocial feelings and invokes passions, which he thought isolated individuals in fearful states of self-preservation. Consider this in relation to recent advertisements, where a product is shown as protecting you or your family from a sublime threat (nature, other people, the 'city', etc.), as for example in automobile advertising. Edmund Burke's gloss on the sublime makes the rising of the passions seem like a vice not a virtue, a potential threat to 'stabilized society'. It must then be obvious why avant-garde art has so often been associated with the aesthetics of the sublime, precisely to invoke the 'unthinkable' in society. It is notable, for instance, that the work that Walter Benjamin champions in his essay on photography (cited above) is that of John Heartfield, whose photomontage work uses mostly a rhetoric of the *sublime*, anchored in a politics of anti-fascism (see Figure 7.3 in Chapter 7: *Art Photography*).

However, it would be wrong to close, 'essentialize', the categories of picturesque and sublime by polarizing them as good or bad, because the issue of beauty or pleasure derived from these forms has to be related to the particular strategic goals of the work. (I am assuming, of course, as Benjamin did, that a photographer has a commitment to 'something' in their work.[17]) In recent years, artists and

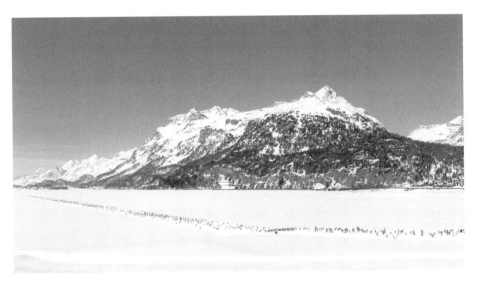

Figure 5.4 Andreas Gursky (1955–), 'Engadin', 1995.
C-Print, 160 × 250 cm (framed). © Andreas Gursky/VG
Bild-Kunst. Image courtesy of Monika Sprüth/Philomene
Magers, Cologne, Munich & London. (Original in Colour.)

photographers have been working, consciously or not, both with the sublime and the beautiful in ways that challenge the assumptions of both. The picturesque has been 'quoted' so as to critique it, while the sublime has been used, for example in environmental or feminist critiques, in relation to representations of female sexuality and the ideology of nature in ecological arguments.

Consider a photograph by the famous German artist-photographer Andreas Gursky (Figure 5.4). Gursky is known for his large-scale photographs, which show the technical virtuosity of detail that photographic imaging is capable of rendering. His photograph 'Engadin' (1995) shows the well-known vacation valley in the Swiss Alps. The point of view that Gursky's photograph gives us seems neutral or natural. The composition is in thirds. The lower third, snow-covered land, is the foreground, the middle third is the mountain and its peak as the background, and the top third is the deep blue sky. These three parts form the composition of the picture, which is almost a picturesque scene. However, the mountain is just off-centre and slightly towards the right, indicating that the picture is not only about the mountain, a view which in fact is disturbed by the presence of the trail of human figures in the foreground. The human presence disturbs the idea of a calm picturesque scene. The miniscule human figures look like a line of ants, insects that show not only the vast scale of the mountain, but also a high density of people around it. Tourist brochures rarely show people queuing for anything, but here we are shown a high density of people more associated with the industry and city working life. Urban queues and crowds at non-places like airports, garages and bus terminals seem more normal than a long queue to see 'nature'. On closer inspection it can be seen that the figures in the picture are actually skiing along a *piste* or track.

Gursky's picture depicts a kind of *tragic sublime*. It shows the awful consequence of mass tourism: humans as the blight on an otherwise picturesque nature. Neither quite picturesque nor sublime, the picture nevertheless depends on their opposing characteristics by combining them. The view hovers from one to the other and back again, until the descriptive value of the picture, as *photographic vision*, with all its detail, returns us to the denotative values of the photograph. The precision of information in Gursky's picture is echoed in his title, which simply anchors it to the picture as a place: 'Engadin'. This factual connotation makes the picture seem like a document and this 'objective' character of photographic information offers a shield against the picture as 'subjective'. This idea of a neutral grasp of the scene, through a mastering viewpoint, is a strategy also developed in the idea of the panoramic view.

PANORAMAS

It is curious that one of the early things that amateur digital cameras were designed to do was to stitch together several pictures into a panorama, because this is exactly what early nineteenth-century photographers did too. As early as the mid-1840s, William Henry Fox Talbot worked with the painter Calvert Richard Jones to join frames together to create panoramic 'joiners' or, as they were called, 'conjoined prints' – a panoramic view made from paper negatives.[18] A specially designed panoramic camera had already been invented by 1847 and the idea of a spectacular landscape scene, already familiar from the dioramas of Daguerre (first made popular through lithographs), became a commonplace form of photographic landscape, usually showing tourist spots or famous sights.[19] Later developed by cinema into a 'Panavision', the panoramic view ideally shows the vast magnitude of 'nature' and the miniscule details of that space that photography has the potential to record. These landscape views create a massive spectacle, at once sublime in scale and information, yet diminishing in that spectators can feel miniscule in relation to them. The panoramic – panoptic – view offers a kind of mastery over the scene and, by implication, over 'nature' itself. Like a child in front of a cake too big to digest, the panorama is impossible to eat or digest, thus it is satisfying and dissatisfying in terms of the aim of *seeing*. The panorama is 'magnificent', both picturesque *and* sublime. The viewer is as much absorbed in the technological feat of the representation as the scenes they have seen. The pleasure that accompanies such images, often a sense of being 'disembodied' as in a bird's-eye view, is precisely that: the enjoyment of a 'disembodied' experience, an identification as within the space itself. We might then add this panoramic aspect: the capacity to render precise information of photographic vision into the existing aesthetic categories of picturesque and sublime.

CONCLUSION

In summary then, the aim of the beautiful (to find an ideal object and form which apprehends it) is something that can never finally be achieved. The picturesque is a form that tries to subdue it (something which can be loved as 'mastered', e.g. nature, a woman, etc.). The sublime is the form that shows (or enjoys) the impossibility of this subduing. The relation of any spectator to these tendencies depends on the way that scenes have been pictured, or 'coded', the cultural context in which they are seen and the particular disposition of the spectator to those feelings of composure or terror. Yet inevitably, with our 'postmodern' formations, the neat, polarized oppositions that sustain these categories are themselves mutating, just as the classical forms of landscape, which still dominate its history, are also subject

to transformations. The invention of virtual computer landscapes and their use as viewer platforms in successful computer games, surely draw on the same classical logic of landscape aesthetics (albeit sometimes coded as futuristic settings) to seek composure and mastery and the thrills of terror.

Meanwhile, the history of fine art landscape photography has been the history of the struggle between aesthetics and non-aesthetic 'photographic' description. Today, where photography, video and film, despite their differences, have such a monopoly over the landscape genre in photographic representation, we might think that all this is no longer an issue. Yet, even today, any landscape photographer still has to negotiate these aesthetic principles, even where they wish only to *describe* a space.

Chapter Summary

- The term 'landscape' already implies a visual separation in relation to nature.
- Landscape has a long pictorial tradition in painting before photography.
- Photography delivered a high-resolution delineation of the land in a mechanically reproduced picture system of representation.
- Landscape is a privileged form for the signification of longings and desire (social, political, economic, ideological and highly personal) on to a mute landscape environment.
- Against the categories of the *picturesque* and *sublime*, photography introduced the new ideal of *photographic vision*, an unpainterly 'non-aesthetic' vision.

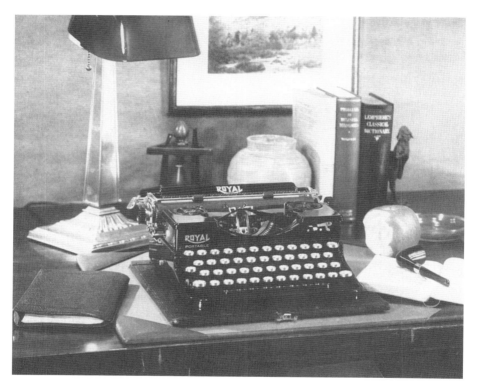

Figure 6.1 Samuel Manners (active *c.* early 1900s–
1930s), advertisement with typewriter on desk, *c.* 1927.
Photographic process: 3-colour carbon. RPS Collection at
the National Media Museum/SSPL. (Original in Colour.)

6 THE RHETORIC OF STILL LIFE

Still life is one of the most neglected genres, not only in photography but also in the history of art. It is only rarely discussed, despite the still-life picture being as pervasive as it is maligned. Art historians too complain that the still life is neglected and ignored. This is even indicated in the title of Norman Bryson's book on still-life paintings: *Looking at the Overlooked*.[1] Yet paradoxically, still-life images are also some of the most highly rated and revered pictures of all time. No one would deny the painterly quality of Chardin's carefully balanced tabletop scenes of food or the famous apples in Cézanne's Post-Impressionist paintings or the ever-popular expressionist *Sunflower* paintings by Vincent van Gogh. Many, if not all, people love still-life pictures, and one might even be forgiven for thinking that still life is a form where visual innovation often occurs first, especially in the history of avant-garde art.

Cubism, for instance, not only used still life (guitars, vases, crockery) repeatedly to develop its thinking, it also completely dismantled its objects by breaking with any illusion of three-dimensional depth in pictorial 'realism'. Evidence of the importance of the genre is given in philosophy too, where the humble still-life picture pops up in Martin Heidegger's essay 'The Origin of the Work of Art'. Heidegger uses a painting by Vincent van Gogh, titled *Pair of Shoes* (more bleak than the *Sunflower* pictures he is famed for), to meditate on a philosophy of art.[2] A discussion of the same Van Gogh still life reappears in Frederic Jameson's classic 1980s essay on postmodernism, while Jacques Derrida's book, *Truth in Painting*, also engages with it – partly as his response to Heidegger and to deconstruct the claim that it *is* a pair of shoes.[3] Still life offers the opportunity to depict objects in space and also a space for the *critique* of objects. What seems odd is this quiet persistence and presence of the still-life picture. Still life as a category will not go away. Resolute, stoic and despite being dismissed as trivial, it exists – and more, it *innovates*. So from these, admittedly brief, examples we might surmise that still life is actually much more important than it has

been given credit for. In the history of still-life art it is domestic objects pictured on a tabletop that typify the genre. Depictions of food or flowers on a table are one of the most common scenes, *nature morte*, but photography brought something new: the picture of industrial objects, including photography itself.

One notable industry where still life reigns supreme in photography is in 'commercial work', a synonym for advertising photography. Essentially based on 'objects', still-life photography lends itself well to the picturing of products. Still life quickly developed a ready application and function within the advertising industry: the task of representing products. Yet ironically still life still finds itself ranked at the low end of the spectrum, a 'low genre'. Even in advertising, where still-life images abound, they are seen as of 'low interest', less 'exciting' than the high drama of fashion work or complex location shoots in exotic places. Instead, the still-life image is seen as thoroughly domestic, quietly focussed in the studio where it has all the drama of a kitchen sink. Audiences do not necessarily recognize the technical virtuosity involved.

Critically neglected, it is worth making a short excursion into this field of still-life usage in advertising, because it substantially developed and exploited the still-life photographic category in its own way. Indeed, such is the dominance of advertising photography that any other types of still-life photograph (e.g. documentary, art, anthropology and science), despite their differences, can probably not be read outside of any relation to it.

ADVERTISING

Advertising relies heavily on pictures of commodity objects designed to show off the basic product. One indicator of the overwhelming importance of still life in advertising is that it even has its own language to describe them: the commercial 'pack shot'. If terms like pack shot lack any grace or charm it is precisely because they refer to the function of these photographs within the advertising industry. A 'pack' or 'product shot' is just that, the shot of a product. Choose any glossy magazine or shopping catalogue and you will find it populated by still-life photographs showing objects in advertising. Whether it is glamorous, object-based fashion magazines that show shoes, handbags, cosmetics, jewellery, hats, briefcases, watches, gloves, etc., or photography magazines (cameras, lenses, flash guns, etc.), shopping catalogues (home equipment: kitchenware, telephones, computers, lamps, furniture, etc.) or hobby magazines (e.g. gardening products, utensils, flowers, seeds and bulbs) etc., the still-life photograph will be steadily at work there. This universe of objects also has its own 'language'. An object is never just an object. In the field of advertising, a product requires social meanings to make it attractive (no matter how bland and

uninteresting the object is in itself) – its 'use-value'. The object is given a human meaning, despite being non-human. Look at Figure 6.1. This advertisement for a typewriter situates the product on a desk, as though 'in use'. The other types of object around it confer a value on it by *association* with them: the bitten apple meaning the person is 'healthy', the neat (but not *too* orderly) desk means the person who buys the typewriter is 'organized', and so on. Look now at Figure 6.2.

Today it may be difficult to guess the exact significance given to these vegetables, pictured in a 1931 still-life photograph. However, they do fit a discourse of 'culinary preparation': the knife 'points' towards the vegetables that it will cut on the preparation board; this is the very picture of a 'healthy' 1931 diet. Even at the banal level, it is the work of the advertising photographer to organize the still-life objects into the 'right' meaning, achieved through the way the things are photographed.

Indeed, the less there is any real difference between a basic product advertised in the marketplace (e.g. types of soap, cosmetics, phones, water) the more important

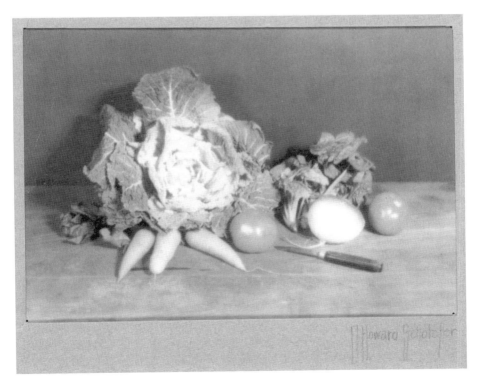

Figure 6.2 Howard Schotofer, 'Still Life', *c.* 1931. RPS Collection at the National Media Museum/SSPL. (Original in Colour.)

the cultural distinction and value attached to this or that object in one brand or another. The photograph is used to *qualify* the product, to give it its 'exchange value' by specifying what makes this one more attractive for consumption to the designated audience. So a small, thin phone might be pictured to connote 'masculinity' if aimed at men, whereas the same phone will be made to connote 'femininity' for women. (I am talking about what is typical in the industry.) The advertising agency photographer uses their technical skills to produce these meanings, which are usually given to them in the 'brief' from the art director or 'creative' (the people whose job it is to invent ideas for images). It is here, within quite a narrow sense, that advertising photography is seen as a field of 'creative photography'. The advertising industry is dedicated to making images, primarily photographic (now heavily dependent on digital post-production work), where creativity is the means to persuade an audience about the meanings and values of a product. Thus the advertising industry occupies a contradictory place in contemporary culture. On the one hand it is seen as a 'creative industry', likened to the famous Renaissance schools run by artists like Michelangelo, an inspiring industry full of 'creative' innovation; on the other it is even seen by critics as a waste of space, time and money.

CRITIQUE OF ADVERTISING

In 1968, the French sociologist Jean Baudrillard argued that the discourse of advertising 'constitutes a useless and unnecessary universe'.[4] Like Plato, Baudrillard is highly suspicious of images (in his later life he published his own photographs, which arguably support this scepticism). Baudrillard's study, *The System of Objects*, where he criticizes advertising, goes on to interrogate what he names the 'procession of generations of products, appliances and gadgets' that increasingly informs the advertising world of products. Other critics have gone further, saying that advertising conspires against the consumer in a deceitful public image industry behind which hide multinational, national, and global corporations. 'Global*ism*' implies this saturation of the world by a few dominant product brands. Hiding behind a 'public face' of advertising insinuates products into people's lives without them noticing and massages public opinion about what is important and about 'what they *really* want'.[5]

So, advertising is seen as highly creative *or* very (even dangerously) persuasive. Clearly these arguments are interrelated, advertising is in fact both. Creativity in advertising *is* the means by which a representation becomes persuasive. In other words, creativity is the means to an end; the rhetoric of an advertising image is the creative means of persuasion. This is why advertising is seen as 'clever'; it surprises

audiences with how it relates a product to the social world to give it a cultural meaning. It is this role of creativity that makes advertising so instrumental to ideology, the rhetorical art of persuasion in how to make us see and relate to objects in the modern world.

The cultural critic Raymond Williams described advertising as the '*official art of modern capitalist society*' [my italics].[6] This argument has a good deal of truth in it, given that advertising can be found displayed in so many prominent public places for everyone to see. Everyone can see what everyone else supposedly desires too. Advertising images are part of an ever-changing environment; their presence is constant across public and private spheres of culture. Almost unavoidable, they are experienced like an always-present, ever-changing exhibition space, where images and texts with messages and meanings come to us as apparently *free*. The *choice* of whether to look at billboard advertising or not is inhibited by the fact that they are in such ever-present proximity to people's everyday activities. The frequent urban travel routes of masses of people are filled with advertising billboards, strategically placed, while magazines, newspapers, television and www all carry advertising. Advertising is interspersed between news stories and other items. Seeing an advertising message, even only fleetingly, is integrated into the unconscious sensory experience of daily life. This is the sharp end of advertising, whose endgame is persuading people, the target audience, to think about that product in even just a split second of their fleeting vision. Sigmund Freud's remarks about photographs working in relation to memory makes a crucial point here (see Chapter 1: *History*).

In Victorian England, pressure groups started to campaign and protest against the widespread installation of advertising billboards along public roads and city streets. From the 1860s onwards, campaigners argued that the increasing number of billboards were spoiling the public landscape, destroying the 'natural beauty' of the land, especially where they made incursions into the countryside.[7] The result was an introduction of government law and legislation to control and regulate billposters, including where they could be put up. Although now regulated in uneasy alliances, such disputes were symptoms of the massive new growth of the advertising industry. (From the 1930s onwards, many documentary photographers began to include billboards within their own photographs, because of the way they could reveal something of the cultural values and ideology at work in that society.)

ADVERTISING AGENCY

Modern advertising agencies are a product of the twentieth century, a phenomenon that developed when it became clear that there was a need to orchestrate the growth

in industry of the production, distribution and display of advertising images. Advertising agencies became the new hub for the industry. Clients sought them out, and they became employers of photographers; they wrote and designed the copy texts, straplines and captions for the publicity images too. Agencies organized and planned the advertising 'campaigns', targeted at specific audiences, within the expanding domain of magazines, newspapers, billboards and then television (and the www). The self-taught belief within advertising is that the industry is there to *inform* the public about what is available. It does this on behalf of its many and varied clients (e.g. private and public companies selling goods and services from drugs to cat food, charities, governments and their agencies, the police, military, and other social services). In this logic of *information*, the techniques of persuasion are engaged as a necessary means to enable consumer choice, and make the product appear in as interesting a way as possible.

Harnessed to the sale of commodities and the lifestyles in which they make sense, advertising images effuse an effervescent optimism. Even depression or period pains manage to look like uplifting experiences in advertising. It seems almost as though a product treatment will make you even better than you were before. This uplifting world creates a domain where pain does not exist, where the very depiction of a headache already feels like its cure. Smooth, soothing experiences are shown via visual pleasure and a sense of gratification dominates the *depiction* of the product: it is not necessarily a direct result of the product itself. This aspect of advertising, what, in the work cited above, Raymond Williams calls the 'magic system', is where the creative art of image-making is aimed as persuasion. Persuasion is rhetoric combined with pleasure in an art of commerce.[8]

SOCIAL FANTASY

Advertising is a domain of social fantasy that exists to provide for and exploit the gaps, the 'voids', in the social structure. Advertising promises to fulfil the parts of the viewing individual that are still unfulfilled. Worried about the environment? Buy this car, its 'greener'! No girlfriend? Buy this car (beer or aftershave, etc), 'women will love it' (i.e. you)! The satisfaction is always short-lived; desire is never fulfilled (displaced from one thing to another, the endless 'metonymy of desire' as Jacques Lacan had called it[9]) due to the constitutive lack in the human subject. Objects do not fulfil desire, they only temporarily subjugate it. Successful advertising understands this domain of social fantasy. Clever advertising knows how to occupy the empty space in individuals with the discourse of a product and how to tap into, even exploit, personal, moral and social anxieties – all the concerns that *already* circulate in any culture and between individuals. Thus, advertising is rarely innovative, it only

creatively follows existing trends. Of course, this dimension of social fantasy is at work in other public media institutional practices too, like the 'news', but nowhere else is social fantasy so explicitly the aim of an institution. This is why advertising images are interesting for the study of culture, because they mirror anxieties and social contradictions, and offer fantasy solutions to individual and collective desire, primarily through the deployment of photographic images.

PRODUCT SHOTS

From supermarket food signs, shop window displays, mail order and online catalogues through to high-class cosmetics, objects are given a 'look' in an ideal scene. Whatever the product or the domain in which it is valued, in these scenes we can see the product pictured. Hamburgers, for example, are mostly represented on abstract backgrounds, with nothing else in the scene. Trademark fast-food brand franchises pride themselves on having large, illuminated photographs of the food you can purchase above the serving counters. You can *see* what you can *buy*. Visually, these photographs show food against a 'clean' background and usually isolated from any specific cultural context. The viewer sees only the object, the *product*. Occasionally they will appear shown on a table-like surface, but no real table can be seen. This abstraction from any social context or background gives the food an anonymous quality; it does not belong to anyone. The picture generalizes the product for the audience: 'it can be yours!' – 'buy it'.

This type of pack-shot, still-life picture in advertising is extremely common and regularly encountered. These stylized pictures of a commercial product are seen as creative and hard to achieve for the uninitiated, but they are nonetheless often seen as 'boring' pictures for an accomplished studio photographer to do. The endless, repetitive, technically demanding precision required in their production becomes tedious except to the dedicated. On the one hand the majority of such photographs are utterly banal, monotonous in their everyday presence and lacking in any variety of composition, on the other hand, they obviously *work*. Of course there are exceptions to such banality, more elegant and celebrated still-life pictures by artists who worked in advertising, for example by Irving Penn, Edward Weston or Robert Mapplethorpe, but these are exceptions to the industry rather than the norm.[10] The general aim is deceptively simple: to show an object in its ideal form and they are extremely effective, hence their repetition.

Different objects are shown from different angles but there is hardly much range between products and they are almost always systematically photographed in the same ways. Objects are shown in various profiles (similar to police mugshots but with different camera angles): full frontal, three-quarter and side view profiles.

The camera height and distance vary, depending on scale (whether it is a car, food, saucepans or shoes, etc.) and the best viewpoint of the object (depending on what it is: phone, furniture, camera, etc.). Still-life pictures are a little like portraiture: an 'object' is depicted from its best angle(s) in front of some sort of background with the camera positioned above, below, neutral or at an angle to the horizon line behind it. Backgrounds can be varied, serving to give the 'object' a simple contextual colour, or a defined type of surface on which it rests, or a slightly out-of-focus 'social situation' (e.g. garden, interior, farm, etc.). All these choices, usually made by an art director, whether it is a pure colour or a lifestyle scene, are aimed at giving a context in which the object makes sense. Photographers also use a variety of techniques – infinity curves, light tables (a translucent table lit from underneath) and diffusers – to achieve the now-common effect of an object 'floating in space'. These different types of background can be sub-divided into different lexicons of meaning, from the 'abstract' background of pure colour, floating space or tangible surface, through to the types of social scene that are projected behind the object. Whatever the choice, it will be determined by the aim of the intended advertisement.

We need to consider these basic formulas, so often repeated, for example, across pack-shot photography, to find out what lends the basic technique so much stability and success. Is there a hidden motive for these techniques, or are they just a matter of chance? The highlight 'sheen', for example, that so many product shots in advertising repeat must surely have some sort of function, even if photographers only repeat it because they know that 'it works'?

TECHNIQUES

In a pack-shot photograph, an object is usually presented against a simple background colour and lit in such a way as to make the object stand out, or even seem precious. The practical success of this type of photography is twofold. Firstly, a simple or abstract background gives more focus, quite literally, to the object itself in the foreground. Taken out of its normal context, an object has more emotive power. This focus on the object gives an *informational* value (*denotation* in semiotics) to the object. How is this information produced? The juxtaposition between object and background creates an opposition. As there is nothing else to look at in the picture, the inert object is *described*. The pure background colour hints at abstractness. In art, abstract paintings are generally the most reviled type of picture, only enjoyed by specialists, a minority few. Common hostility to abstract painting is precisely in the sense of a 'nothing to see', a 'void', only barely tolerated by those who are used to seeing the world as objects in representations.

The pack-shot relation between product and background creates an antithesis between a thing (the commodity object) and 'nothing' (the background). We can see here the fundamental structure of a pack shot as the rhetoric of contrast (*antithesis*). This antithesis in information provides the basis for a second *symbolic* meaning, which is parasitic on the informational meaning. In effect, the object proposes itself against a background that has a symbolic *emptiness*. The product offers itself literally as the thing that will fill in what is otherwise a non-space, a void. In contrast to this void, the object is made more meaningful and significant, even an object of fantasy. The signifier floats in an empty space. So the greater the sense of emptiness behind the object, the greater the seduction that the object depicted can fill it. The object occupies the symbolic cultural space of the picture. The object is the *thing* that will fill the empty space behind it. The two levels of meaning, *informational* and *symbolic*, are combined in any instantaneous reading of the image. One level is descriptive (denotative) and the other is symbolic, ideological (connotative). Together they offer the product to the consumer. In a sense, the picture threatens us with emptiness if we do not take up the offer of the product. This threat, however, has to be controlled and limited; it must not make the spectator feel too uncomfortable or they might reject looking at the picture. (The specificity of the target audience is crucial here.) The anxiety that such an emptiness can invoke needs to be controlled. This is why simple plain colour backgrounds are used to subtly control it.

In addition, backgrounds can be used to hint at cultural significations, for example as subtle indications of masculinity or femininity. To state the obvious, blue and pink can do this, though they might also signify cold or warm environments, or more 'rugged' or 'soft' feelings. Colours are notoriously polysemic and promiscuous in cultural meaning. However, use of colour backgrounds creates more subtle contrasts between object and background than the 'nothing' of a stark white background behind an object. In contrast, 'slick' photographs (where the object has a sheen like the background) lessen the difference by making the object 'objectless'. Slick objects are without character; they have none of the stains of life that contaminate normal social existence.

Other techniques can be used to modify the meaning of the object. A drop or bead of water in the foreground or an out-of-focus flower, for example, can be used to alleviate the starkness of a background. Singular objects, like food (a biscuit, cake, sandwich, etc.) are sometimes depicted with a crumb fallen off it or a bite taken from it, to give the product a more human and 'homely' feel. This is designed to show signs of the proximity of another human presence. Perhaps, in a rather obtuse way, this is why images of hamburgers are depicted with beautifully lit sesame seeds on the top of the buns, which compensate for or complement the insular singularity of the object with the sign of a multiplicity. We might say, however, more philosophically,

that the internal dilemma of still life, the rhetoric between object and background, is not the real emptiness of the picture. The real emptiness is hidden in the very illusion of perspectival space – that is, the space *beyond* the vanishing point of all photographic images, which is never seen in any picture.

Some of these tactics were already developed in the history of still-life painting, which were dedicated to representing – describing – the objects of mercantile capitalism.

THE ART OF DESCRIPTION

In the heyday of Dutch and Flemish still-life painting during the seventeenth century, for example, bowls, glassware, foods, cutlery and linen were meticulously painted against simple cloth backgrounds. On the one hand, the extraordinary verisimilitude of these paintings shows the acquisition of scientific skills in rendering perspective by the painters and the subtle handling of form and shape through colour in their application of paint. The use of perspective by these painters in Dutch art has led the art historian Svetlana Alpers to name such images as the 'art of describing'.[11] The most accomplished artists achieved the *description* of objects with the verisimilitude of the *camera obscura* via painting. The paintings were 'photographic' in aspiration. Today, of course, photographers no longer have such a struggle to achieve verisimilitude, since the camera and lens automatically produce perspectival images, the illusion of depth in photographs. However, photographers still have to exercise control over the arrangement of objects, lighting and background and employ the technological system of photography to construct meaning within the images, an aim that is often less easily forthcoming than might be expected. Photographers have to use skill to control the rhetorical dimension of the picture, its symbolic meaning, just as painters did in the seventeenth century.

It is quite clear that Dutch and Flemish still-life paintings of the 1600s used the same rhetorical opposition of separating objects in the foreground from the background. Tables were 'filled' with objects against the emptiness of the background, a technique attributed to the painter Pieter Claesz.[12] Almost monochrome, the paintings created a contrast between a busy table, crowded with objects, against a background where there is nothing to see. Other painters, like Jan Davidsz. de Heem, used brightly coloured objects like red lobsters and lemons to heighten the contrast between foods and background. These exotic objects also showed off the wealth of commodities available, since lemons and lobsters were not native and came from Dutch colonial trade.[13] These paintings also have symbolic – allegorical – meanings; in fact still life was a remarkably moral genre, making comments about abstinence,

waste, erotic habits and even about economic investments. They functioned like modern advertising.

STILL-LIFE SUB-GENRES

Although still a minor genre, still-life painting in the seventeenth century shows a remarkable degree of sophistication, with different categories of still life clearly defined. For example, the Greek term *rhopography* referred to the depiction of insignificant objects, 'odds and ends', while a *xenion* picture was usually a still life of food (a present made to guests as a sign of hospitality), either in a larder or on a table about to be served.[14] These were different categories from *grylloi*, fantastic scenes, or the '*meal on a table*' picture, which represented a specific meal (The Christian 'Last Supper' scene would be one example of this) and '*flower painting*'. Fruit could indicate health, erotic intent or moral turpitude, just as the apple does in the biblical story of Adam and Eve.

Paul Cézanne famously painted apples in a way that made them less visible, lacking visual detail and description, which, oddly, reaffirmed the purity of the apples. Still-life images today are not exempt from such techniques in making meanings, and any photographer ignores the symbolic dimension of what they photograph at their own peril. Many of the same techniques are currently used in still-life photography, although for different ends, where different photographers, intuitively or wittingly, work with similar techniques. However, we might here also make a significant distinction between the object represented as desirable (advertising) and uses of objects that serve to make a *picture* desirable. In this respect there is often a confusion for example, within advertising, between pictures that are successful among other photographers, the public and critics, and pictures that are successful in increasing sales of the product. These satisfactions are not necessarily mutual to each other, as the awards for industry advertising images testify. (Advertising campaigns that win creative awards for agencies are not necessarily the most successful campaigns for the paying clients.)

HYPERBOLE

In modern photography, the close-up created an absence of anything 'cultural' in the background of the basic pack shot, which enabled a new effect. The lack of any specific reference in the background deprives the spectator of the sense of scale of the object. With no means of measurement, the object in the picture is *dis*-embodied, and it can become as large (*hyperbole*) or small (*understatement*)

as the viewer imagines it to be in their mind. (It was precisely to inhibit such an effect that archaeology and anthropology developed the use of a ruler at the edge of photographs so the objects depicted would have a precise measurement scale in the picture.) If we look back historically, this disembodied floating-in-space object was a strategy developed by photographers in early twentieth-century photography. The 'free-floating' object emerged from within the experimental realm of art and design as part of the 'new photography' of the 1920s and 1930s. This is also coincidentally when the advertising industry consolidated its use of the photographic image.

THE NEW OBJECTIVITY

The notion of a 'new photography' emerged in the techno-industrial develop-ments of Europe, the USA and Japan. During the 1920s, German photographic technology accelerated ahead, leading the way for optics, cameras, film, lighting and printing techniques. These technical developments informed the rise of mass photography, but also the representations of industrial products in magazines, flyers and billboards. *Neue sachlichkeit* (new objectivity) had originally referred to a small group of painters in Germany but was taken up to refer to photography, and the representation of objects. The new-found use of photography was useful in its ability to represent 'objectness'. In Lucia Moholy's book, *A Hundred Years of Photography*, first published in 1939, she notes:

> The high standard of technique, the perfection of material and the scientific methods, only recently introduced (Hurter and Driffield, Vogel, Scheiner, etc.) provided the technical foundation for modern object photography. The dominant position of the object in trade and industry, typical of the twentieth century, suggested the ideological part. The modern arts, emphasising the value of tone and balance and the modern film, which in the meantime had reached a high level of perfection, contributed to the formal side.[15]

Lucia Moholy posits three contributing factors to this new photography: technical, ideological and formal. The confluence of these three developments gave rise to a type of 'pictorialism' that invoked 'clarity' (deceptively named as 'straight' photography), a new objectivity of photography. Technology, the industry of commodity objects and the aesthetic developments within the arts contributed to a *new objectivity*, where objects could be enlarged 'to any size required'.[16] As Moholy argues, this interest in 'objectness' unveiled a whole new domain of looking: 'not only the shape, delineation and expression of the human face, but the sculptural details of the head and the texture of skin, hair, nails and dress which became attractive subjects to the photographer.'[17] Suddenly a micro-world was opened up, and parts of the human body became objects in their own right, through their multiple magnification.

Photography re-invented the body as part-object. Just as cinema discovered the close-up shot (first used to magnify the faces of women actresses), so photographers discovered the object-making potential of the close-up.[18] (The historical confluence of these two types of close-up in photography and cinema have yet to be addressed; not least, the 'objectification' of the celebrity in photographic terms.)

Early innovators of fashion images were quick to value this use of the close-up shot in stills photography. Man Ray in particular, the American photographer in Paris, working simultaneously across fashion, portraiture and avant-garde Surrealism, was one of the first to use the modern close-up of the face or even the eye, neck or hair. These close-ups of parts of the body emerged as a new type of image, a new domain of still-life photography. (The contemporary Japanese photographer Araki has made similar images to those developed in Man Ray's object-based photography.[19]) Perhaps because such work often draws the negative connotations of *objectification* or 'fetishism' it has fallen outside contemporary debates and discussion.

In the 'new vision', more often called the New Objectivity, photographers sought out sharpness, precision and focus not only because the new electrical lamps permitted it, but also because of the new-found virtues in photography as photography. Photography and photographers achieved self-confidence in this period: a new vision for the new century had been found in 'photographic objectivity'. Photography could create objects from the way it represented things. Industrial photographers found a new subject matter for photography too: industrial objects. The industrial product became a kind of heroic object, as something to be depicted *for the masses*. In celebration of the new industrial age (no doubt inspired by the positive gloss given to the growths of industry after the Russian Revolution and in the USA, the objectness of things was itself a positive concept. (This might be likened to the rise of Social Documentary photography in the same period.) It is of course inseparable that the representation of women as objects in photography belongs resolutely to this age. The 'new woman' is represented as free and autonomous, as depicted by the models that represented her in photographs. Hence the critique: parts of the female body are turned into objects in certain photographs just like photographs of industrial objects.

In Germany, this notion of New Objectivity also came under fire from critics precisely for its promotion of the ideal of 'objectness' at the time. Walter Benjamin's famous remarks on photography include his criticism of new objectivity acceding to a style of image readily absorbed by advertising. Indeed, in his 1931 essay 'A Short History of Photography', Benjamin is extremely hostile towards this trend. Written two years after the Wall Street crash, when the financial implications were hitting Europe hard, Benjamin's view of such photography is that it is 'inauthentic'. Benjamin clearly despises the type of work that was developing:

> The lens now looks for interesting juxtapositions; photography turns into a sort of arty journalism. ... The more far-reaching the crisis of the present social order, the more rigidly its individual components are locked together in their death struggle, the more has the creative – in its deepest essence a sport, by contradiction out of imitation – become a fetish, whose lineaments live only in the fitful illumination of changing fashion. The creative in photography is its capitulation to fashion. *The world is beautiful* – that is its watchword. Therein is unmasked the posture of a photography that can endow any soup can with cosmic significance but cannot grasp a single one of the human connexions in which it exists, even where most far-fetched subjects are concerned with saleability than with insight. But because the true face of this kind of photographic creativity is the advertisement or association, its logical counterpart is the act of unmasking or construction.[20]

The photograph of a soup can reveals nothing about its social relations, its production or consumption, it is only idealized as an object. (One wonders what Benjamin would have made of Andy Warhol and his 'Factory'. Warhol's mechanized screenprint reproductions of Campbell's Soup cans both beautify the image of Campbell's Soup and simultaneously make a caricature of them with his *faux* standardization of art as an industrial production process.)

For Benjamin, the work of photography should be the 'unmasking' of appearances, not making myths through appearance. Benjamin was arguing for what we might generally call a documentary impetus – towards a social criticism – which he found in diverse types of work. Whether it was in the old streets of Eugène Atget's Paris photographs, the regional portraits in Germany by August Sander or the political photo-montage constructions by John Heartfield, these were the vital practices dealing with social reality. Benjamin's favourite works all engage the social as a substantial part of the picture. For Benjamin, the new 'creative' photography, whether a facial expression, a product glamorized on a sheet of steel, or an object magnified to glorious proportions, this was all by itself nothing, only setting out to 'charm or persuade'.[21]

Benjamin's writing shows the dramatic rise of advertising photography in this period, at which his hostility is directed, leaving little space for analysis of its subsequent and continued success. Some perceive subsequent attempts to analyse such practices (and the semiotics used to analyse it) as in some way complicit with the industry. Thus, the varied criticism directed at writers like Roland Barthes, who during the 1950s preferred to marry his cultural criticism with semiotic *analysis*. In *Mythologies*, a book clearly inspired by work in anthropology but directed at his own culture, Barthes proposed a *semio-clasm* to dismantle the 'myths' peddled across culture, including advertising campaigns.[22] Yet at the same time, he takes apart their

rhetoric to see how they work, their mode of ideological operation. Advertising campaigns for soap powder and floor-cleaning products trade on neurotic fears of dirt, he argues, while myths of 'nation' and nationhood provide the material discourse for tourism, or colonial aggression. His work was precisely one of 'unmasking or construction' that Benjamin had already called for in response to the growth of advertising as an industry for 'creative photography'.

RHETORIC OF THE IMAGE

Roland Barthes's most sustained analysis of an advertising image is his brilliant essay on a French pasta advertisement. *Panzani* make a pasta that seems Italian but is French-made. In 'Rhetoric of the Image' Barthes dismantles the rhetoric of this *Panzani* advertising image to show how the photographic image simultaneously creates connotations to link the product to different discourses: *Italianness* (not Italy but a tourist fantasy of it), *culinary sophistication* and even the narrative of *shopping*.[23] These connotations reach discourses far beyond the blandness of the actual product and into the existing domain of the desiring spectator. Barthes shows that the mechanisms of the advertising image are not arbitrary or haphazard, that the image structures meanings according to various discourses, which it tries to suck the spectator into. Above all, Barthes argues, the photographic image naturalizes the product and the messages it contains. The rhetoric of photography is the ideology that photographs merely 'describe', give information about objects. What seems natural – the photograph – is a means of hiding the source of the symbolic meanings. The signs and codes of the photograph trigger connotative processes, which is where the status and value of any object 'in itself' is established. In short, then, in advertising photography, we are asked to fall in love with an object through its *image*.

THE OBJECT IMAGE

In psychoanalysis, an 'object' is a thing through which a desire seeks to attain its satisfaction.[24] The object can be a person, part of them (a *part-object*) a real object or imagined. The photographic image offers itself as a medium for all these things; *in* the photograph I can have this or that object, in fact, *every* object. But nobody wants *every* object. An object is something chosen to achieve an aim. An aim has a source and in psychoanalysis this source is embedded in the constitution of the human subject, the viewer. In the strict sense, this is beyond the realm of a book like this, but it is important because the aim of still life photography is involved in it. We might work backwards, however, and consider what the aim in still life photography can tell us about the source from which it – photography – comes.

The English dictionary notes that the word 'objective' has several meanings: from 'the end' or final cause, an 'object of an action'; a philosophical 'object of consciousness'; and objectiveness, meaning the 'quality or character of being objective'. Furthermore, the word objective in French is the word for lenses, which implies a status of the photographic lens as having both an *aim* and *objectivity*. We can see here the rational 'philosophical' aspect of the still life, the role of the 'objectness' in an object. 'Objectivity' in these senses may have little to do with 'realism', but rather more to do with a passion for objects, more accurately described as *fetishism*. In this sense the aim of photography is fetishistic, especially given the idea that photography is involved in the idealization of objects. We might predict, then, that the source of the aim for photography (producing photographs or the enjoyment in looking at particular images) is derived from the search for 'objects' (people, things, part-objects, body-parts, etc.). Freud long ago argued that scopophilia – pleasure in looking – was a drive towards mastery. (Idealization is not far away either.) The source for this mastery is over an object, whether as part of that person's body in their infantile life experience or some later external version.

A good example of what I mean here is given at the end of Orson Welles's classic 1942 film *Citizen Kane*. When his character (Kane) is on his deathbed and utters the word 'Rosebud' in his last gasp of living breath, it clearly refers back to the beloved object of his childhood (a snow sledge). It is the object from which he was parted

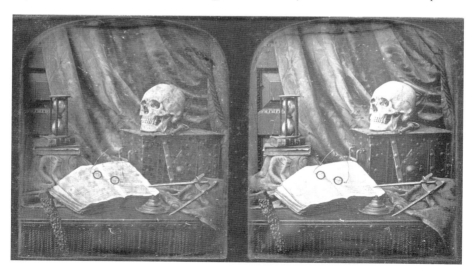

Figure 6.3 Thomas Richard Williams (1825–71), 'Nature Mort' or 'The Sands of Time', c. 1852. A stereoscopic Daguerreotype. RPS Collection at the National Media Museum/SSPL.

as a child, such that, along with Freud, this shows that the value of an object lost is a source of joy when refinding it in another one. Yet, ultimately, the accumulation of new objects will pale into significance, as in the allegory of all *vanitas* pictures, where death emerges precisely because nothing compares to the nostalgia for the original *lost object*. In the end, it is death that beckons beyond the illusion of the empty backgrounds in still life. Indeed, death is often represented as literally *in the background* as in this stereoscopic still-life *vanitas* photograph by Thomas Richard Williams (see Figure 6.3).

Victor Burgin once remarked that fascination with the 'glossy' photograph recalls a case of fetishism described by Freud (a patient's *glanz* at a shiny nose). However, Burgin goes on to remark:

> To observe a structural homology between the look at the photograph and the look of the fetishist is not to claim, excessively, that all those who find themselves captivated by an image are therefore (clinically) fetishists. What is being remarked is that photographic representation accomplishes that separation of knowledge from belief which is characteristic of fetishism. It is the pervasive structure of disavowal which links fetishism to the image and to phantasy.[25]

It is no coincidence that Freud and Karl Marx both found the structure of 'magic', belief separated from knowledge, when it came to the value of objects. We can see here what is at stake in the industry of still-life photography, the elevation of objects to the dignity of things, whether in the name of conformity or critique.

Chapter Summary

- Still life is a 'low' genre, often neglected in historical literature.
- Advertising depends heavily on the rhetoric of still-life photography.
- The idea of 'objectness' is central in the logic of still-life pictures.
- New Objectivity photography in the 1930s began to serve advertising of industrial products.
- 'Product shots' are a development of still-life photography for advertising purposes, but can be linked to historical uses of still life, for example in Flemish and Dutch paintings in the seventeenth century.

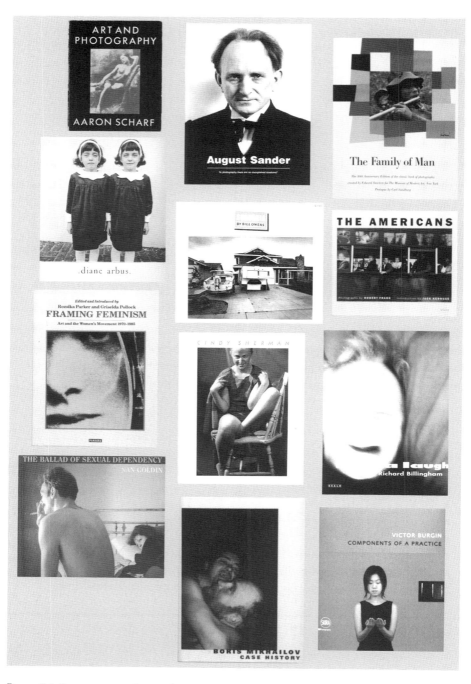

Figure 7.1 Some covers of art and criticism books.

7 ART PHOTOGRAPHY

Two key questions underpin discussions about photography and art. The first – 'what is art?' – is usually ignored, while the second – 'what contribution does photography make to art?' – can easily be reversed to ask 'what contribution does art make to photography'? The answers to these questions open out onto a range of issues and problems relevant to contemporary art photography. Let's start with the first question.

ART

The word 'art' can mean different things to different people in different times and places. To speak of the art of cooking, the art of gardening, or the art of cricket, for example, does not mean that food, plants or a game will automatically be guaranteed an exhibition in a major art gallery – although you never know. The use of the word 'art' in this sense, as meaning a *skill*, has long been in use. Historically, 'art' has been crucial, for example, as part of the medieval university curriculum. The 'seven arts' of grammar, logic, rhetoric, arithmetic, geometry, music and astronomy were the 'liberal arts'.[1]

But the idea of 'Art' as a noun, indicating a separate institution, and the 'artist' as a person who practises within it, are relatively recent phenomena. These emerged mostly in the eighteenth century (some earlier) as 'Academies', institutions (Royal or Art), mostly in Europe, and were consolidated during the nineteenth century in developments of a range of related new art *institutions*, like the National Gallery in London. Thus *artist* and *artisan* (as specialized skilled craft person) were distinguished from scientist (and the *scientific* institution), as in the now still common (but problematic) distinction between an artist's *creative imagination* and the scientist's *rational experiment*. Such oppositions began to mirror another distinction between *art* (as 'fine art') and *culture*, a word whose emergence parallels the rise of the art institutions in the eighteenth and nineteenth centuries. These distinctions became particularly acute as the processes of industrialization began to grip an entire society.

When the *craft* skills of an artisan were separated from industrial production, the role that art (and the corresponding discourse of aesthetics) came to occupy was not about the *skills* of the artisan, but the special capacity of the artist, their *imagination*, to impact on 'culture'. Indeed, jumping forward a hundred years, the influential 1960s American critic, Clement Greenberg, saw art and culture as incommensurate with one another, as radically opposed. For Greenberg, 'culture' meant *mass* culture, which was *bad*. Art, or more specifically *painting*, was the salvation from a culture that was contaminated with, as he saw it, the lowly 'kitsch' values of the marketplace – including photography.[2] In this process, Greenberg banished from art all social criticism and even social reference – use of perspective in painting – that is so overwhelmingly present in photography. The autonomy of art for Greenberg meant an aesthetic specificity to the practice of art, formulated via painting as a way that *avoids* the social; hence, the propensity towards abstraction and surfaces of paintings, no depth illusions. Greenberg's notion of autonomy, art as a *separation* from society, is the rejection of any discourse on the social in art altogether, a key tenet of 'Western' formalism (the collapsing of content into a formal issue). However, there is another way of understanding the idea of autonomy in art that is more positive – that is, art as a space that has critical distance from a society.

AUTONOMY

Art and artists have of course existed long before the art institutions of the eighteenth century and long before antiquity. However, the social relations of artist to art production had a very different mode of existence to our modern art institutions, from the eighteenth-century academies onwards. Raymond Williams notes, for instance, in his study of this topic, that the Celtic bard poets of the sixth century were 'instituted' within the Welsh or Irish courts.[3] Here the function of the poet was to eulogize and provide a narration of events – stories in which the people who directly ruled them were glorified. There was very little autonomy or independence. The work of the poet was absolutely governed. There was more scope for negotiation in the later Renaissance courts and the Vatican, where market relations of patronage were more common. Here, at least, contractual negotiations, both monetary and aesthetic, were possible between artist and patron. A Renaissance patron's investment in art was linked to attributes of their power, but although the artist had some autonomy in negotiating the terms of reference of the work to be produced, political power was absolute.

The point of raising these historical examples is to show that the modern concept of art, as involving artistic 'autonomy' and creative 'independence', is different to other social relations between 'art' and 'artist' in institutions, and not only within

very differently organized societies. This should serve as a reminder that the present formation of art institutions is not inevitable or fixed beyond the specific organization of any particular society. This contingent condition is made obvious when we consider the position of artists in totalitarian regimes, their almost complete lack of autonomy and 'freedom of speech', whose positions are, in fact, not dissimilar to those of the poets in the sixth century Welsh courts just discussed. Autonomy, which is so built into current conceptions of art, whether economic, ideological or aesthetic, has no real social historical guarantees at all.

Modern liberal democracies with government or state funding have what is called an 'arm's length policy', where art is funded with no direct aesthetic or political accountability to the government of the day. Art institutions might have to justify their existence in terms of audience ratings, economics or popularity, the social impact of exhibitions and events in that gallery or museum, but beyond the offence of 'good taste' (and even sometimes here) the artist and institution has freedom to operate critically. It is *potentially* free to construct a set of propositions in art works that are radically distant from the values of the social formation that has sponsored it. Although it might be said, cynically, a government or corporation who tolerates, even sponsors, art that explicitly criticizes it has only *signified* its liberalism. Yet Art is tangibly a space for critique and critical distance, despite pressures and limits applied to it from a society.

This type of artistic autonomy or 'independence', a much-cherished belief within art, often means that involvement is short-lived, sporadic and precarious – as is so evident in the contemporary music industry. Artists come and go. It is perhaps a sobering thought also to recall that it was a 'Society of *Independent Artists*' who, in April 1917, *rejected* R. Mutt's (Marcel Duchamp's pseudonym) 'Urinal' art work for exhibition.[4] In such an economy, art sustains itself as a practice, as a process, through continuous evaluation and reevaluation of what art is, as good, bad or indifferent. Raymond Williams, writing in 1980, argued for a sociological account of the production of art as follows:

> Such work [art] can serve societal purposes, of the deepest kind: not as food, or as shelter, or as tools, but as 'recognitions' (both new and confirming marks) of people and kinds of people in places and kinds of place, and indeed often as more than this, as 'recognitions' of a physical species in a practically shared physical universe, with its marvellously diverse interactions of senses, forces, potentials.[5]

Even if Williams's account idealizes the actual processes of art or sees it as overly benign, there is nevertheless a ring of truth about this argument. Art has no 'practical' function so its 'social use' must have some other use: political power, a gratification

132 of 216 (document id:

that is symbolic in value; the 'recognitions' of people 'in places and kinds of place'. Art offers a space for social identifications.

This rather abstract account of art, whose values many would agree with, does little to amplify or indicate *whose* symbolic values are exemplified (e.g. corporate managers or factory workers), *how* they are seen in art or why. Such representations may be violently disputed when they do become art. There is probably less or little consensus, for example, about what symbolic values should be represented, how, where or why. So we might take such a *lack of consensus* to be one of the governing principles that drives art institutions and their discourses, including of course the key components: the production of ideas by artists, the activities of curators and the subsequent criticism they receive. In this system, the question raised is: what are the narratives in art that this lack of consensus produces? We can add a supplement to this question, which is, what role has photography played in these historical narratives of art practice? The last question first.

MEDIUMS

The history of art *before* photography is a history of *genres*. In the art academies, painting was located in a hierarchy of genres according to the critical values of the discourses that controlled them. With the invention of photography, everything changed, not simply because the medium of photography was invented, but because industrialization also transformed the entire outlook on art and images in culture.

Photography, for its part, transformed the idea of art (as Walter Benjamin argued in the 1930s), but was also crucial for the emergence of a whole new set of institutions, whose major function was the production of industrial images for increasingly mass markets. The medium of photography was a pivotal technology in the developing markets for images: advertising, news, tourism and social identity (portraiture). The subsequent transformation of the role of images across society had another impact too; it transformed 'art history' into a specialized discipline, with less purchase on the wider field of photographic images. Art history was eventually displaced (within universities, academies and art schools) by other, newer, emergent but competing fields of specialist knowledge, like cinema studies, television culture and photography theory. Looking back at the twentieth century, for example, there was a long struggle to construct new paradigms for the study of the modern intersecting media of photography-film-television, only really more fully articulated within 'communication studies' and the later related fields of 'cultural studies' and 'visual studies', developed since the 1960s, 1970s and 1980s. The ensuing tension between a 'medium-specific' study and keeping sight of its place in a more general view of 'visual culture' has been one of the key issues to haunt all these disciplines.

So when anyone talks about the impact of the medium of photography on art (or art on photography), this general picture of the social transformation in the production of visual images needs to be remembered and held firmly in mind. That is to say, the transformations of art since photography are also part of this general shift in the history of the use and purpose of pictures in different societies. We cannot completely separate the shifts in art practice (and its theory) from those general drifts of visual media in other parts of culture.

PAINTING AND PHOTOGRAPHY

The common view of the impact of photography on art is that it freed 'painting', left it to explore other avenues and ideas. The ambition to achieve 'likenesses' was no longer required. Jean-François Lyotard puts the challenge of photography to painting like this:

> The challenge lay essentially in that photographic and cinematographic processes can accomplish better, faster, and with a circulation a hundred thousand times larger than narrative or pictorial realism [in painting], the task which academicism has assigned to realism: to preserve various consciousnesses from doubt. Industrial photography and cinema will be superior to painting and the novel whenever the objective is to stabilize the referent, to arrange it according to a point of view which endows it with a recognizable meaning, to reproduce the syntax and vocabulary which enable the addressee to decipher images and sequences quickly, and so to arrive easily at the consciousness of his [sic] own identity as well as the approval which he thereby received from others – since such structures of images and sequences constitute a communication code among all of them. This is the way the effects of reality, or if one prefers, the fantasies of realism, multiply.[6]

The subsequent history of realism in the genres, once so dominated by painting, is fascinating as they become 'photographic'. Fascinating, not least for the contributions made to them by photographers and the photographs – in some ways mapped out in other chapters of this book – but also for what then happened to painting.

In Lyotard's view, painters had to 'refuse to lend themselves to such therapeutic uses' and 'question the rules of the art of painting', which is mostly what they did.[7] So while nineteenth-century painters went off to explore or experiment with a more 'subjective' vision in painting (Impressionism, Pointillism, Expressionism and even Cubism), photography simply replaced painting in its function of visual representation, the process of *representing* 'reality'. In the figurative art of portrait painting, for example, it was quickly transformed into a *photographic* imaging industry. Photography became the new pictorial paradigm for realism.

PARADIGMS

Yet the implications of these transformations in the role of representing, from painting to photography, were a long time coming to recognition within art discourses, especially for photography. I think it is possible to indicate five useful moments, where specific paradigms (thinking and practice) on *photographic* art were dominant:

- 1870s–1910s: Pictorialism;
- 1920–1930s: Avant-garde/Modernist [Formalism];
- 1945–1960s: New Realism/Humanist Photography;
- 1960–1979: Minimalism, Conceptualism/late Modernism;
- 1980–1990s: Postmodernism/Neoconceptualism.

We might regard these as all *sub-narratives* of the idea of 'modernity', as versions of 'what needs to be done' in the ambition to be *modern*. As such, these different moments of art and photography constitute the plural history of attempts to construct new narratives related to, different from, counter or alternative to the dominant ones existing in that society[8] (see Figures 7.2 and 7.3).

It would be possible, even desirable, to track through each of these paradigms and the type of art photography at work in them. These are, however, stories that are already well known or at least are established and articulated in the history of photography. Nineteenth-century debates on *pictorialism*; the *avant-gardes* in Europe and the Soviet Union; the growth of 'American' *modernist* photography; the struggle to recognize the new reality of post-Second-World-War culture within *humanist photography* (see Chapter 8: *Global Photography*); the rise of *conceptual art* and the use of photography within it, and the rather catch-all category of '*postmodernism*' that followed in the apparent decline of modernism.

Yet it is obvious that these paradigms leave the contemporary condition and situation untouched. Without in any way diminishing the work that still needs to be done critically in still unpacking those older paradigms, it is more useful to start here with the contemporary, rather than cramming the entire field of photography as art, destined to fail in complexity, into the space here. In this way at least it may be possible to then consider the historical debates most relevant for the contemporary condition of twenty-first-century art photography.

PHOTOGRAPHY IN CONTEMPORARY ART

It is indeed a real question to ask whether current art photography bears any trace of the twentieth-century debates on photography at all. Such has been the transformation of views on photography within major art institutions in the last few

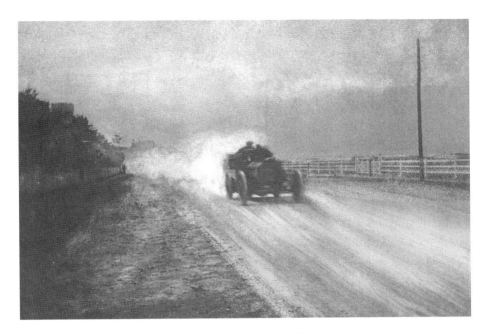

Figure 7.2 Robert Demachy (1859–1936), 'Vitesse' [*Speed*], 1904. Royal Photographic Society Collection/NMeM/ Science & Society Picture Library. This is a romantic image of motor transport, unlike the hard-edged images of speed and machinery that characterized Modernism. Demachy was an amateur photographer and painter, master of the gum bichromate process.

years that the current discourses on art photography and what is said about them appears to have little resemblance to older paradigms from the last century.

An opposition, between 'artists who use photography' and 'photographers who aspire to art', characterized some of the later twentieth-century debates about art and photography. This was an implicit distinction between two tendencies: conceptual art and fine art photography, with the latter emphasizing the craft- (almost artisan) produced photograph. If such a distinction seems ridiculous today, it should be remembered that, in the UK for example, the Tate museum did not collect or exhibit 'photography' at all until its first photography exhibition in 2003. Although it had long since shown photographs (by conceptual artists), it would not show work make by 'photographers'. The British conceptual artist Keith Arnatt ridiculed this collecting and exhibition policy by drawing out the illogical nature of the distinction, made apparent in his essay title of 'Sausages and Food', from 1982. Arnatt wrote that 'The Tate':

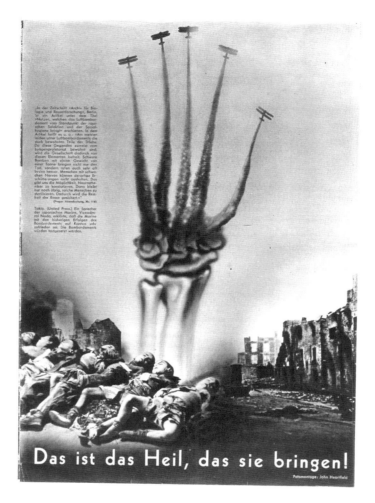

Figure 7.3 John Heartfield (1891–1968), 'Das ist
das Heil, das sie bringen!' ['*That is the salvation
they bring!*'], 29 June 1938. © Akademie der
Künste, Berlin.

says that they collect artists rather than photographs though they would not
collect an artist if he or she was an artist purely in the photographic media. It
might appear then, as though the Tate collects artists who are photographers
but not photographers who are artists. If this is so it is not terribly clear what
distinction is being drawn between artist/photographer and photographer/
artist.[9]

Probably somewhere in the world such distinctions are still being fought over, but in the international art world, the debate is fundamentally dead. Nevertheless, it shows how far things have changed and also the fundamentally unstable – mutable – character of not only the definition of photography as art, but of what art itself actually is. It was precisely such questioning about what art *could be* that drove thinking in conceptual art.

The contemporary position that photography now occupies in art is intriguing. The mass absorption of photography within major art institutions (and increasingly commercial art dealers) has been growing in wholesale numbers. This means that the discourse of art and criticism has had to address 'photography' too. The recent epidemic of books on the theme of contemporary art and photography or photography *as* art that have appeared in the last decade are symptomatic of this fact. This new central importance of photography has displaced painting as *the* dominant medium via which contemporary art is theorized, although like painting before it, photography remains in dialogue with sculpture and other forms of art, video, performance and installation. Even the argument of a 'post-medium condition', floated by Rosalind Krauss at the end of the 1990s, finds itself returning to the 'differential specificity' of 'the medium as such'.[10] Photography is simply unavoidable. Even more striking is the way that contemporary art photography is now valorized, in that the terms of photography's acceptance belong precisely within the values of a programme that had been mostly rejected by modern painting in the twentieth century: pictorial realism.

THE PICTORIAL PARADIGM

A 'pictorial' paradigm establishes a relation of resemblance between the picture as things in the mind and the world. Modernism, especially painting, had long rejected this ideology of 'transparency'. So it is perhaps surprising to see it return to such dominance in art photography, even though photography obviously had a disposition towards it. Reference and referents are hard to avoid in photography. Yet, art photography now also occupies a place in art in a way that replicates the old pre-modernist values of painting as a hierarchy of pictorial genres. Photography implicitly conforms to the canonic values once dictated by the art academies. This relation of photography to the aesthetic paradigm of pictorial art in academy painting can be seen in a quite literal sense in recent discussions of art photography by art criticism.

When the well-known modernist art critic, Michael Fried, writes on art photography, he takes it up exactly where he had left off in painting: in the eighteenth-century tradition of *tableau* painting, a system championed by the French Enlightenment

critic Denis Diderot in his praise of artists like Jean-Baptiste Greuze.[11] In Fried's recent book, *Why Photography Matters as Art as Never Before*, he reworks his previous interest (some might say obsession) with pictorial figures in paintings who look out (away from the spectator) of the images – what he calls 'absorption'. Fried's interest in eighteenth-century tableau paintings is, quite literally, transmuted directly onto contemporary photographic art works, mostly: for example by Jeff Wall, Thomas Struth, Andreas Gursky, *et al*.[12] The significance of his particular book, of course, is that he is a key art critic, known for his work on painting. His evaluation of contemporary art photography situates it within a tradition of pictorial representation long since gone in terms of avant-garde art. In this sense, his argument neatly jumps back over the entire history of modernism since the invention of photography and situates contemporary art photography in the programme of a pre-photographic age. It is worth considering what this move does for contemporary photography. In short, what are the connections being made between recent art photography and the paradigm of pictorial realism in the old conception of painting? Perhaps the answers to this question can tell us something about now.

Indeed, it is highly instructive to see how contemporary art photography cited in Fried's argument fits so obviously into the old canonical logic, specifically, of genres. Fried does not make this argument; it is an exercise that I am doing here. Here, then, are contemporary artist-photographer's art works from Fried's book situated as they would appear within a historical (French) hierarchy of genres of painting for the Academy:

Genre	*Artist*
'History' Painting	Jeff Wall, Thomas Struth, Andreas Gursky, Thomas Ruff.
Landscape	Andreas Gursky, Hiroshi Sugimoto, Thomas Ruff, Bernd & Hilla Becher, Thomas Demand, Luc Delahaye, Stephen Shore, Candida Höfer, Jean-Marc Bustamante.
Portraiture	Thomas Struth, Thomas Ruff, Beat Streuli, Philip-Lorca diCorsa, Cindy Sherman, Rineke Dijkstra, Luc Delahaye, Hiroshi Sugimoto.
Still Life	Thomas Demand, Wolfgang Tillmans, Jeff Wall.

'History painting', regarded as the highest genre, takes the form of a *tableau* painting in a pictorial realism that invokes *narrative*. The task of telling narratives of social importance was inherited by photojournalism and social documentary photography

(see Chapter 3: *Documentary and Story-telling*). It was revived within art, as most clearly seen in the thinking and practice of Jeff Wall, the Canadian photographer whose works are highly constructed versions of scenes from 'everyday life'. Here the aims of an earlier *realist* art, that is, the attempt to address 'contemporary life', are returned to via photography.[13] As the slogan of the realists put it, to be contemporary: '*Il faut être de son temps*' [*One must be of one's own time*]![14]

In the old hierarchy, after **history painting**, the other genres are ranked as follows: **landscape**, an art of *space and place* (or 'non-place' in contemporary urban cultures) and **portraiture**, the art of *identity* and *recognition*, then **still life**, still trailing as the domain of work on *objects* and 'objectness'. It was not untypical to work across genres either, many painters did this. While recognizing that photography has liberalized these genre categories to some extent, it is still clear that contemporary art photography is actually working within those categories. Here is the victory of photography as the industrial art, par excellence, as large-scale *tableau* scenes that replicate the grandeur of eighteenth-century painting. As Lyotard argued, pictorial realism has returned in art, via photography.

It would not be preposterous here, except for the violence it does to history, to align contemporary 'photographic' artists' work with their historical counterparts: Gustave Courbet, the most famous politically radical Realist painter, and Edouard Manet, the most 'shocking' artist of nineteenth-century Paris. The fact that this is what Michael Fried does, to make such links explicit, between Jeff Wall's work and Manet is precisely to construct a *continuity* between them. (It would be equally easy to situate others – Ruff, Struth and Gursky – as variant responses to the demands of representing social contemporary reality too.[15]) Yet, oddly, in Fried's account, all this progress takes us back to his modernist theory about eighteenth-century pictorial realism, which is simply the problem of self-reference as autonomy. The figures who look out of Thomas Struth's museum pictures might as well be eighteenth-century characters for all the importance this has for Fried's discussion of photography. That is to say the realism of the photography is ignored in the criticism of forms, which allows leaps across history.

Now I hasten to say, emphatically, that Fried's account is not the only possible description of what is happening in contemporary art photography. The many other available books on recent art photography clearly demonstrate this.[16] Indeed, in comparison, there are some glaring omissions in Fried's book, particularly in terms of documentary and 'snapshot', aesthetically orientated photography: William Eggleston, Nan Goldin, Martha Rosler, Allan Sekula and many others. (Some of Fried's examples come from periods earlier than the 1990s, so there is no logic to their exclusion on those grounds.) Nor does Fried represent the history of 'fine art' photography or conceptual uses of photography. This, however, is not to criticize

the artists that *are* included in Fried's framework of criticism, nor to underplay the transformations that their photographic art has brought to the art world. But it is to show the limits of Fried's criticism that, like Clement Greenberg before him, reduces the objects of study to questions of form and formal properties. Their contents are strangely missing from the account. Self-referential, Fried's arguments return the reader to a type of *modernist* criticism, which many thought was long gone.

There are some key points to be drawn from this new canonization of photography as art as highlighted in Fried's book.

- First, the terms on which photographs are recognized and canonized as art represents a 'new pictorialism'. This is quite unlike the old pictorialism of the late nineteenth century, where photography was still fighting painting and had adopted 'impressionist' values in order to be accepted (see Figure 7.2). Today, photography is fully confident *as art* in its ability to depict pictorial realism, spectacular in endowing 'a recognizable meaning', as Lyotard had put it (quoted above).
- Secondly, modernist criticism, which treasures art as separate from social meaning and was thought to be extinct after 'postmodernism', is alive and well. (A 'return of the repressed'?)
- Thirdly, the role and position of art within the minds of contemporary photographers and the industries in which they work is very different from earlier art. As Charlotte Cotton notes in her 2004 survey of turn-of-the-century art photography: 'To identify "art" as the preferred territory for their images is now the aspiration of many photographers.'[17] This includes photography from other professions like photojournalism, advertising and editorial photography, even scientists aspiring to be photographic *artists*.

What does this mean and how did we get here? To understand the significance of this condition, we have to return to the things that preceded this current field of art photography, to the tributaries that perhaps informed it. These are threefold: conceptual art, street photography and fine art photography.

CONCEPTUAL ART

Like the civil rights movements of the 1960s, conceptual art, perhaps the last avant-garde, was born of the fight with 1950s and early 1960s values that were themselves becoming irrelevant and problematic for that new era.[18] The dematerialized object and anti-aesthetic strategy aimed to 'escape incorporation into the world of the spectacle', as Peter Wollen puts it.[19] Of course, the anti-aesthetic destruction of 'visual pleasure' was itself another kind of pleasure: an intellectual pleasure, tinged

with social knowledge. Here photography and language emerged as tools to re-engage with the social world that modernism had abstracted out of its picture and pushed far away. In an interview, the conceptual artist Victor Burgin, described two attitudes towards the use of photography in conceptual art:

> You can think about the medium in almost purely technological terms: to take a photograph is to exercise a number of options – plane of focus, shutter-speed, aperture, framing, angle and so on – and the 'content' of the work becomes your choice from amongst these options and the way you structure them. This is an attitude which comes out of Greenbergian Modernism. Or, you can start from the fact that photography was invented to give an illusionistic rendering of some aspect of the world in front of the camera – which leads into considerations of representation and narrative – which is what I am interested in.[20]

Important here is the way the issue of autonomy is drawn out. As we have seen there are two ways of understanding it in art. The question is, what kind of separation – autonomy – do art and artists have from the society that tolerates them? Is the point of autonomy to turn away from that society? Or is it as a means to confront, to gain critical purchase on that society? These two notions of autonomy, the artist freed from social constraints and the artist as free to criticize society, can be seen as the two dominant competing narratives of modernism and avant-garde art, as it is often put, between *art-for-art's sake* and *art for the world*. Both tendencies can also be seen at work in conceptual art too. As seen in Victor Burgin's own use of photography, it is the latter that beckons towards the social world, the diverse ethnic groups, issues of sexuality and the social position of women, as the social issues of that period that came directly into the frame of representation. Peter Wollen:

> Conceptual art, in particular, offered a new area – one which encouraged artists to ask fundamental questions about both art and the art world, about the politics and sociology of art. Moreover, conceptual work was relatively cheap to produce, portable and lacking in the self-conscious heroism of previous modernist movements. Women quickly became prominent in the world of conceptual art.[21]

Feminist action linked the dominant representations of women in the visual media environment to the traditional representations of women in art. Photography became an essential component in the art 'tool kit', not because of some 'essential' media form, but because it connected with the social representations in other parts of the world.[22] The uses of photography in conceptual art to *document* events, objects, performances, 'happenings', objects, etc., focussed on the worldly objects and things that appear as part of everyday life. In a sense, these conceptual interests were not a *purely* aesthetic category, but involved ideas that made links between quite

different things. Lacking a formalist aesthetic theory, the functional use of (mostly black and white) photography created a new kind of aesthetic, an 'anti-appearance', which itself has another type of attractiveness.[23] Compared with the glossy high production values of media images in mass culture, such images were gritty, as even in photographs of Andy Warhol's Factory. However, there was an overlap with this type of practical use of photography and its 'offbeat look' with a strand of more 'serious' photographic practice.

STREET PHOTOGRAPHY

'Street photography', as it has become known, explicitly engages the social and often critical-minded photographer in what is an 'almost documentary' aim. Developed since the late 1880s with more portable cameras, the street photograph became celebrated via the popularity of the work of Henri Cartier-Bresson, who co-founded the Magnum photography agency in 1947.[24] (See Figure 3.5, Chapter 3: *Documentary and Story-telling*.)

The real innovation in street photography came with Robert Frank's photographs, taken in 1955/56 but first published in 1958 as *The Americans*.[25] His use of a loose and more 'vernacular' idiom informed by snapshot aesthetics made a new critical form. As Jack Kerouac wrote in the introduction to the original book, 'After seeing these pictures you end up finally not knowing any more whether a jukebox is sadder than a coffin.' Frank's work looked more informal and casual than Henri Cartier-Bresson's heavily stylized decisive 'tableaux' (whose work Frank's most resembled before *The Americans*), and spoke to a generation 'on the move'. They were in a rush to change things. The street, already the site of civil rights protests in the 1960s, became the living room of the critical photographer right through the latter half of the twentieth century. More innovations followed: Diane Arbus brought the 6 × 6 format of square images (so loved by studio portrait, fashion and some news photographers) to the streets in the 1960s; Lee Friedlander, Gary Winogrand, Martha Rosler, Bill Owens, Allan Sekula and William Eggleston's colour work (in the USA); Tony Ray Jones, Victor Burgin, in the 1970s, and the quite different 'new colour' photography of the 1980s by Martin Parr (see Figure 5.3, Chapter 5: *In the Landscape*) and Paul Graham (in the UK), to name only a few, all created distinctive bodies of work 'on the streets'. Subsequent developments have moved to use of colour and even larger formats of camera with high-definition results – as in the works shown in Fried's book.

Much is owed, I think, to the path cut by Frank's book, an acknowledged reference for many later photographers using the space of the street as a critical paradigm. The eventual critical success of Frank's *The Americans* outstripped the

initial hostility directed towards it. The fragmentary feel of the book creates a strong sense of a fleeting glance, quite literally a snapshot of the USA as seen from a passing automobile: the ugly and tawdry side, ethnic divisions, urban alienation, small communities and the complexity of a vast nation. Street photography offered a paradigm of work that felt *engaged*, immediate and subjective, free from the usual constraints of a specific assignment as in photojournalism. Here autonomy was about *how* to work. This tradition of subjective photography formulated a balance between comment and criticism, description and inscription, where meanings were acknowledged as 'fleeting', as if meanings are in transition themselves.

Perhaps this work appealed to the traveller too, freed from the claustrophobic interiors of the world, open to the chance encounter of the street, as once formulated by the Surrealists. More recently, street-based photography has changed. It has reverted to a more classical framing of subject matter. Street cameras are placed on tripods. A point of view is fixed and spirit-levelled. Balance and 'neutrality', the major ethical and political issue in the media world, finds its place in photography in the level look of the camera. The camera is held in a steady gaze of description. This brings me to the third tributary, fine art photography.

'FINE ART' PHOTOGRAPHY

In the USA, a conception of *fine art* photography had developed apace. It was not politically oriented. In the USA, photographers like Alfred Stieglitz and the circle around his magazine, *Camera Work*, and *291* gallery, were more concerned with finding the appropriate forms for an American modern photography. For Stieglitz, who had a background in photogravure, high-quality printing was of the essence for pictorial photography at the beginning of the twentieth century to be considered as fine art. The photograph had to be 'straight', unmanipulated in the process of production of the photograph from negative to positive and remain true to the image *seen* by the photographer. Stieglitz rejected 'fancy' techniques, soft focus, vignette and painterly papers, all the paraphernalia of pictorialism, because it drew attention to the processes of photography and away from the subject matter. Deep focus seemed so important to this conception that one group named themselves after it: the 'f.64 group', which included Edward Weston. A contact print (a print the same size as the original negative) was the preferred manifestation of the picture, so as to stay true to the original 'vision'.

Stieglitz fostered high-fidelity pictorial values (not pictorial*ist*) and encouraged others around him to develop a specifically American idiom. This created a new iconography, as in the eclectic vision of Paul Strand: white picket fences, the American city and street, urban people, which together with Stieglitz's own increasingly abstract

compositions created a new 'formalism'. Content was reduced to an idea about forms. These ideas, fetishized by photographers like Edward Weston, became the dominant idea of fine art photography. These practices were resolutely anti-industrial and anti-commercial. Fine art photographers made labour-intensive craft-oriented prints, 'objects' that were hand-made usually by the photographers themselves. This idea of modernism as high-quality photographic forms created its own cul-de-sac, cut off from both the life-blood of mainstream art, the vivacity of street photography and distant from industrial commercial photography. Nevertheless, the values it proposed were highly influential, not least because of their international promotion in later years through the museum of Modern Art in New York, the first serious museum to really advocate photography as a *fine art*.

Now, it is possible to see these three strands of photography as having 'coalesced' in contemporary art photography. Certainly the space of the street and everyday life as content is central, as are the technical concerns (of fine art photography) for technical virtuosity, albeit on an industrial scale (the production values of art photography now are hardly *arte povera*), along with the use of conventions of performance, seriality, repetition, installation and construction of sets, etc., from conceptual art. Yet none of these explains the return to pictorial realism as the canonic form in art, through photography. This is because there are other factors, outside of the historical discourse of art that impinge on its practices.

POSTMODERNISM

'Postmodernism' was the collective name given to the shattering of modernism. In photography this was the direct challenge to the ideal of a *fine art photography*, whose values were established on an anti-commercial stance (Alfred Stieglitz, for example, was always explicit about this). At the end of the 1970s artists suddenly began to use the codes and conventions of commercial photography against itself (e.g. Cindy Sherman, Richard Prince, Barbara Kruger, Sherrie Levine, Laurie Simmons), but this was also symptomatic of the collapsing of an opposition that had maintained men as artists. The dramatic influx of female artists in 1980s postmodernism using photography had an impact on the very discourse on photography too, on the subject matter of art photography. New aspects of the social and private worlds of women made their way into the galleries in a number of guises and ideological positions.[26] Art was renewed from within, not only by different subject matter, but by new personnel too (e.g. Figure 4.5 in Chapter Four: *Looking at Portraits*). Little or none of these types of work figure within the canonical forms presented by Michael Fried as *Why Photography Matters as Art as Never Before*. But there is a more important issue here.

ART AS GLOBAL INDUSTRY

On the one hand, contemporary photographic art makes reference to other modes and media conventions of photography in order to attempt to address the contemporary world. On the other hand, this has meant that it is assimilated to a primarily photographic global economy of images, whose gravitational pull of attraction is extended via websites.

I think we have to consider the aspiration, identified earlier, of photography to art as a new global condition, not because 'everyone wants to be artists' or there is a new 'global democracy', but rather because *art is a global industry*. The statistics are staggering. Art biennales, triennials, photography festivals, exhibitions, are now all recognized ways of bringing trade to a city or region: art as spectacle and even tourism. In this market economy, the legibility of local traditions suffer the easily read image of the 'universal' language of pictorial realism. Here the dangers of globalism are all too obvious, not only of the potential loss of autonomy of the art industry, but of the imposition of the polished finish or the non-difficulty of work, values that bring art ever closer to the 'media extravaganza' from which it should be distinguished. There are some opportunities here though too. The influx of different ethnicities from across the globe into art, however small, makes necessary changes in the multi-polar global art industry. It remains to be seen whether the pluralism involved leads to a new type of marginalization, driven by quite different factors than the old geographic or ethnic discriminations – that is, conformity or non-conformity. Once the watchword of avant-garde movements, the pioneers of future interventions in art may still yet come from unexpected directions of 'non-conformity', amidst the restructuring of global power relations from both within and outside the world of art.

Chapter Summary

- The word *art* has several distinct and different meanings, as a type of value as well as referring to specific types of institution and institutional relations.
- *Autonomy* is a key concept in artistic freedom and responsibility to society.
- The history of the impact of photography on art is also the history of the impact of art on photography. We can identify distinct historical phases of these relationships since the invention of photography.
- Photography is central to debates in contemporary art discussions.
- The relation of photographic images as 'spectacle' is a crucial part of its success in a global art market, heralding the popular return to a pictorial paradigm in art practice.

8 GLOBAL PHOTOGRAPHY

In recent years, globalization is one of several new terms to appear in the demise (and fatigue) of 'postmodernism' as an academic debate. It is notable, for example, that the first book by one of the key theorists of postmodernism, Fredric Jameson, to come after it was called *The Geopolitical Aesthetic*.[1] Although far from easy reading, this book, published in 1992, attempts to map the local aesthetics of different cinema traditions for what they reveal about the global 'world system' in their 'geopolitical unconscious'.[2] While 'globalization' is now a well-established topic in the study of cinema, media and cultural studies, it is not at all developed yet within the field of photographic studies.

So this chapter begins to examine the neglected issue of globalization and photography. Globalization offers a new paradigm for thinking about photography. As a consequence it has surprising effects on thinking about the global impact of photography, a story that is *spatial* rather than chronological, as in the history of photography.

Indeed the spatial dimension of globalized photography is increasingly important, partly due to the ease with which images can slide around the world today. Questions immediately emerge here about the impact this facility has on specific local cultures or on values of culture more generally. Of course, there are provisos to the idea that the globe is saturated with accessible images. Economic hardship, state censorship, religion, geography and politics all still mean that access to modern media technology and the information it generates is not necessarily available to *everyone everywhere*. Yet, those issues notwithstanding, to *not* acknowledge the vast changes that have happened – and are still happening – would be to ignore the impact of the modern and inhibit our understanding of the global impact of photography.

While the meaning of globalization is still a contested concept (exactly what does it mean, is it a good or bad thing?), it certainly is a process that has affected and changed many people's lives around the world. Goods produced on one side of the world are often consumed on the other and this has clear economic, social, political, cultural and ecological implications for everyone involved. The question is what role does photography play in globalization? How, what and why does the circulation

of photographic images around the world contribute to globalization and what are its implications? This opens up a set of questions about the effects of the flow of photographs around the world. In this respect, it would be useful to make an initial distinction between the 'photographic representation *of globalization*' and 'the globalization of *photographic representation*.' The following will focus primarily on the latter, the global expansion of photographic representation, although representation of the global will return, via the idea of 'World Photography' and the humanist ambition to think of the world as a 'global village'.

THE GLOBALIZATION OF PHOTOGRAPHY

Theorists of globalization argue over when and where it started, what it means and for whom. This is partly because globalization has a highly uneven development, whether in the sphere of politics, economics, geographic movements of people, communications systems, or the merging of cultural forms and practices. When we consider the invention of photography we have a much more specific history to consider, which can be summarized as three key stages of development:

1. **Pre-photographic conditions** – the emergence of the scientific use of perspective in paintings in the European Renaissance and the importance of the *camera obscura* as a model for picture-making after the 1500s. The Western acceptance of perspective as the main convention for pictures provides the essential cultural precondition for the later fixing of a *camera obscura* image on glass with chemicals, discovered in the very early 1800s.

2. **The globalization of photographs** – the spread of photographs, the availability of photographic technology and their production techniques throughout the world during the mid- to late nineteenth century. This practical invention of photography was part of the industrial revolution and the development of a whole range of new industrial processes, including the huge impact of railways, mass printing and heavy industry production. Although discovered in Europe, photography quickly disseminated across the world and developed throughout the twentieth century, especially through print media, until the expansion of television and video.

3. **The reconfiguration of photographic values in the computer** – the potential for globalization of all pictures via computer systems with the technological reinvention of photography within the computer; the reconfiguring of photographic images for a digital domain. This stage really begins – and accelerated – with the invention of the Internet.

These are three stages generally relevant for the technology of photography moving towards a global use. From these three stages it can be seen that photography begins *theoretically* as a system with the common use of the *camera obscura* to make paintings during the Renaissance, although the globalization of photographs begins *practically* five hundred years later in the nineteenth century. Once the *practice* of photography began to spread, it also brought the theoretical model with it: perspective – the geometry of illusion as a universal imaging system. Perspective-based images eventually became dominant throughout the world as they are today.

THE FLOW OF PHOTOGRAPHY

What is striking about the invention of photography is how dramatically it spread: from Europe in 1839 (Louis Daguerre in France) to being found across the globe by the mid-1850s.[3] The Daguerreotype, bought by the French state and released publicly to the world, was copyright-free in 1839 and thus spread far and wide, suddenly and very quickly. In a matter of months, photography began to spread to major cities along the trade routes of Europe. Aaron Scharf notes that three months after the invention of the Daguerreotype Horace Vernet was taking pictures in Alexandria.[4] Then, in West Africa, for example, Daguerreotype portrait studios were already established by 1845.[5] When early English and French photographers travelled to the Middle East, India, China and Japan, it was not long before individuals from these countries became involved too and started photography. Of course, the extraordinary speed with which the invention of photography spread around the world also demonstrates how far European trade (economic, political and cultural) was itself becoming global during this period in imperialist projects.

In the USA, Daguerre's agent, François Gourand, toured the major cities in 1840 to promote the use of Daguerre's invention by demonstrating the process. He sold cameras and instruction manuals (already available in eight languages by 1840) which explained how the Daguerreotype process works. Given that the Daguerreotype was patent-free, this set off the rapid use of Daguerreotypes, especially in the American portrait industry. It is perhaps even more astonishing, given the lack of political or social rights (and existing slavery) that black, African-Americans were among the first to take up the new technology and set up commercial photography businesses. James Presley Ball, for example, a 'Free Negro' in 1845, and aged 20, opened a successful Daguerreotype studio that year in Cincinnati.[6] In this one respect, at least, photography appeared as democratic. A new technology, photography had advantages as a new industrial process for those who took it up professionally. It was an unknown quantity, initially relatively unfettered by the historical values of

painting and 'high art', and had an aura of modernity (not to everyone's taste) about
it.

In Japan, which (like China) had its own very strong cultural system of visual
representation, an enthusiasm for 'Westernization' developed during the 1870s
after the old Emperor died in 1868.[7] Western technology and industrialism were
embraced, alongside other attributes of Western culture, and the forms and practices
of Western visual art and photography were studied and developed through research.[8]
Meanwhile, as photographers (primarily Europeans) travelled across the world, so
the development of the photographic industry followed within those locations,
often via local people. We might say, after the French filmmaker Jean-Luc Godard's
comments about film, that in photography too: *Photography follows Trade*.[9]

Similar patterns can be seen elsewhere too. In colonized India, for example, the
Daguerreotype again appeared first, initially in Calcutta, then across the country.[10]
The famous early English photographer in India, Samuel Bourne (a bank clerk from
the English Midlands city of Nottingham), set up a studio in Calcutta from which he
made expeditions to the Himalaya mountains. He was the first to take photographs
above 18,000 feet.[11] British colonial administrators adopted photography for a
variety of purposes, medicine, geographic mapping and surveys, land topography,
military use and as 'topographical records', while commercial studios opened up
everywhere for portraiture.

In addition to these waves of expansion of photography, journalists and tourists
who brought images of 'other places' back home to their respective spheres of public
and private life created another enthusiasm, not just for others to visit those places
but to *photograph* them too. This had a double effect of distributing pictures of
other cultures and places, often for the first time, to people who had never seen
them and also increased interest in photography itself as the realistic means to
represent them. From centres to margins and margins to centres, photographs and
photographers began to flow across the planet. This is already to suggest that the flow
of photographs and representation reflected the uneven power relations in different
parts of the world. Locations difficult to access (or of 'no interest') had relatively few
visitors (except for wars or notable human dramas), while the 'well trodden' routes
of tourists and various professional photographers in certain places meant that they
were more often pictured than others.

The popular enthusiasm for 'photographic likenesses', the relative economic and
technical viability of making them – especially with the later invention of automatic
cameras – meant that photography became, within a few decades, attractive to anyone
who aspired to have their own pictures of travel experiences. Even if these were
mostly a repetition of the routes already trodden by others, they were nevertheless
'their own pictures', a demand that still preoccupies most tourists. The amateur

photography industry based itself to a large extent on these habits as its traditional base of production (e.g. increased production of photographic paper during holiday periods).

The expansion of photographic imaging continued hand in hand with technological developments in photography, trade, transport systems and through war.[12] The First and Second World Wars of the twentieth century rapidly accelerated the demand and use of photography in a number of respects. These wars were not only a competition of political ideals and strategy, but technology too. Aerial reconnaissance, propaganda printing and visual reportage were all developed speedily during these 'total wars'.[13] By the mid-twentieth century, the scale of production, circulation, distribution and consumption of photographic images was unprecedented in the history of the world. Photography in magazines, its dominant form of distribution, would be surpassed, in terms of popular consumption, within two decades of the 1950s by television in most developed industrialized nation-states and thereafter around the world.

WORLD PHOTOGRAPHY

As Europe, Japan and the other major battlegrounds of The Second World War blinked in the daylight after mass destruction, the idea of a new unity of humanity emerged. This was symbolized by the United Nations, set up in 1945, united against war and aimed at global cooperation and peace. (Despite the political rivalry between the USSR and USA.) It was at this mid-point of the twentieth century that the idea of international cooperation found expression in the most widely circulated photography exhibition still to this day, *The Family of Man* exhibition. In spirit, it was like the United Nations, promoting a global community and peace, a happy communality beyond 'cold war' politics.

Organized by the Museum of Modern Art in New York, it was created in 1955 and toured around the world with funds provided by the US government (Information Agency) until 1962. The exhibition of 503 photographic images, gathered internationally, was seen in 38 countries around the world in 91 separate exhibition events.[14] This great humanist project, distributed to so many parts of the world, also stimulated a wide interest in photography. In fact *The Family of Man* was responsible for establishing many dominant conventions and popular ideas of photography, whose ramifications and resonances are still felt around the world today. It established a commonsense view of photography as photojournalism, but conceived as a kind of 'artistic' endeavour. Less interested in journalism, criticism or social issues, this type of photography sought 'creative' impact through use of

clichés from public opinion, popular habits and social rituals (or natural events, like sunsets), and turned them into *aesthetic anecdote*s. The legacy of this notion of photojournalism as 'creative photography' has been far-reaching and is also still embedded in many educational ideas about photography. This 'soft' or 'popular humanism' was devoid of any critical stance, something that was read as echoing out from *The Family of Man* exhibition itself.

The Family of Man provides a fascinating case study for the idea of global communication. Sent out across the world, the exhibition narrated 'humanity'. It pictured a series of events, rituals and stories about human life across different parts of the world and also ordered them in a narrative sequence of human life. Perhaps inevitably, this narrative was saturated with post-war humanism, and an ideology of common experience, which belonged to the mid-1950s. Turning the pages of the exhibition catalogue, the narrative unfolds: a couple falling in love, marriage, pregnancy, birth of a child, youthful exuberance, family love, work and toil, leisure and entertainment, education, the joys of 'life' and varied human emotions (friendship, loneliness, pity, compassion, etc.), then finally death, in war or peace. Towards the end of the book we see a United Nations conference in action, followed by images of children as 'the future' and the hope of humanity. The final image is a splashing sea.

Resolutely international in perspective, Edward Steichen's *The Family of Man* includes the work of 273 photographers from 68 countries.[15] In 503 photographs, the exhibition and book showed the wish and the ambition to repair the damage done to human values by the Second World War. Yet this same wish for unity and internationalism led to immediate criticism, even at the time, that it had overlooked representing the real differences and conflicts in the world: racism and sexual discrimination, colonial exploitation and so on. It was not, of course, that the pictures were 'untrue' or false, but simply that the exhibition overwhelmingly idealized humankind, as a global community. This global community was conceived as a 'family', with all the patriarchal connotations that implied, e.g. poor cousins, strange uncles, etc.

CRITIQUE OF UNIVERSALISM

Of course it can be argued that the exhibition had positive effects. Disseminating pictures of other communities having fun or being educated is surely not bad? The exhibition also included reminders of the recent horrors of war: an anonymous photograph from the Warsaw ghetto, a body in a trench and the architectural ruins of war.

But when Roland Barthes saw the exhibition in Paris, he wrote, complaining that the exhibition had been renamed in France as *The* Great *Family of Man*:

> what could originally have passed for a phrase belonging to zoology, keeping only the similarity in behaviour, the unity of a species, is here amply moralized and sentimentalized. We are at the outset directed to this ambiguous myth of the human 'community', which serves as an alibi to a large part of our humanism.[16]

This critical view, summarized in Roland Barthes's famous short essay in *Mythologies*, goes on to make a scathing attack on the exhibition for the way that, from the diversity of human life-experiences shown in it, 'a unity is magically produced'.[17] Pluralism is reduced to a unity:

> man is born, works, laughs and dies everywhere in the same way; and if there still remains in the actions some ethnic peculiarity, at least one hints that there is underlying each one an identical 'nature', that their diversity is only formal and does not belie the existence of a common mould.[18]

The fact that photographers were recruited from around the world for the project had made little difference to the final outcome. Many other critics since Barthes have joined in the discussion, notably in the USA. Christopher Phillips, Allan Sekula and others more recently have continued to write critical commentaries on *The Family of Man*, a testimony to the historical significance, influence and importance of the exhibition.[19]

The breadth and scale of this exhibition and the massive audience it received is still quite staggering today for any photography project. It travelled across most continents, including the USA and Canada, Japan (in Tokyo *and* Hiroshima), Australia, Europe, Africa (touring South Africa extensively) and the Middle East. In Moscow, where the exhibition was also on display, 2.7 million people visited the exhibition in the six-week period that it was open in 1959. One of the visitors, a young African called Theophilus Neokonkwo, from Nigeria, 'tore down several pictures' from the exhibition, objecting to the way it

> portrayed white Americans and other Europeans in dignified cultural states – wealthy, healthy and wise, and Americans and West Indian Negroes, Africans and Asiatics as comparatively social inferiors – sick, raggerty, destitute, and physically maladjusted. African men and women were portrayed either half clothed or naked.[20]

Furthermore, the Soviet hosts also objected to a picture by George Silk (a *Life* magazine photographer) of a Chinese child, seemingly begging for food. It is an image easily recognized today as a 'victim'-type photograph, still abundant in

charity advertising.[21] Despite Edward Steichen's defence of the photography as a 'universal symbol of hunger and deprivation', the exhibition organizers removed it.[22] Representing 'the world' was not so easy. There is a lesson here.

LOCAL READINGS

Any globally distributed picture will have local readings, and a local identification politics. This shows that 'global' representation brings the politics of locality to representation. How, where and why things are represented, and in what circumstances, all matter to people; these are important questions. Of course, the Soviet objection to the image of a starving Chinese child (a *metonymy* for all Chinese people) had its own political play, with China then an ally and similarly under the political rule of a state Communist Party. In these local objections and Barthes's critique of *The Family of Man* exhibition are the prototypes for the types of opposition and criticism towards globalization today. Manifested in various ways, as objections to the hierarchies of difference, global *sameness* and homogeneity of the world, such criticisms insist on the potential of globalization for the destruction of local meanings, practices, culture and even a 'local' space. Anti-globalization movements make use of these arguments too.

The argument, as summarized by Roland Barthes, of the collapse of global plurality into a unity remains a valid, indeed crucial, question for globalization now. It is a question for any photograph shown internationally. How far does a message addressed to global masses have to strip away recognition of *diversity* for a simplified *unity*? If the local can become global, can the global also become local? What destruction or reconstruction of meaning within any culture or society does that imply, as in 'glocal'? Such debates have taken on a new urgency with the emergence of computer systems connected to one another. These new systems have created another new type of globalization, of media communication, with images apparently even more democratic and accessible. Photography is now part of a meta-system, the computer. Here, photographs are merely one type of file amongst others, which may be organized, converged or merged within other 'document' information.

WORLD WIDE WEB

British physicist, Tim Burners-Lee, working at CERN (European Particle Physics Laboratory) in Switzerland, invented and designed the World Wide Web, launched on 12 November 1990. The World Wide Web uses a computer 'language' system (HTML) that enables documents, sounds and images to be shared across the

Internet. The Internet was a system that had already been designed and used to enable (military) computers to 'talk' to one another, invented in 1972 and made operative in 1983.[23] Thus the 'Internet' is a system designed to share information between computers and the www provides the links that make the Internet system democratically available for mass use. While no one actually owns the www, battles to control it and the documents, images and sounds that we can hear on it are part of a new political and judicial power struggle.

The inventor Tim Burners-Lee is director of W3C (World Wide Web Consortium), whose proclaimed goal is to lead a 'forum for information, commerce, communication, and collective understanding'.[24] This democratically styled forum aims to support the *possibility*, which the www currently offers, to maintain or organize global links. For photography, this represents a new type of non-centralized network, especially mobile devices like camera-phones.

There is no doubt that the construction of perspective within computer software and what is usually called 'digital photography' connected to computers has enabled a massive new field of visual global dissemination. This field appears as quite different to the more centralized values of older distribution systems. Two key questions are associated with computers and photography: one is about the status of the 'digital photograph' and the other is about the significance of the extensive means of dissemination of those images.

THE DIGITAL PHOTOGRAPH

In relation to the first issue, the status of photography within computer systems has led some to call this a 'post-photography' condition. Whatever this means, an analogue obsolescence or an intermedia absorption of photography, the 'death' of photography has been claimed ever since the fundamental principles of the perspective system were translated into computer systems. Yet in any 'image capture', the use of conventional lenses and the illusion of three-dimensional space that it produces is still the dominant type of picture seen on computer screens. Ontological debates about *indexical* or chemical traces have served to obscure this obvious fact. Light is still registered on substrate materials, 'captured' by light sensors, pixel receptors, rather than in chemicals. The whole discussion of 'digital' versus analogue photography, mostly an arid debate, has in many ways served as a distraction from the myriad ramifications of electronically produced photographic images – which have quietly slipped into culture.

Even though the computer as a meta-system has been able to technologically absorb various genres of photography (and other media too: books, cinema, music, etc.), it is surprising how far these types of picture and media have all maintained

their identities within a computer environment. Genres can be combined in novel ways. The mixing of genres, already common practice in avant-garde and documentary photography and cinema of the 1920s and 1930s, is still found – is even common and quite normal – in many computer websites. Yet this has not destroyed distinctions between media, genres or pictorial forms. Certainly, the same old tricks of manipulation, forgery and deception are replicated from older media, but no less or more than in previous times.[25] It might be argued that a greater scepticism about truth and the veracity of photographic images – given how easy the process of modifying pictures is on a computer – should create a more critical audience and readership. Yet the so-called 'loss' of any reality effect of digital photographs has done little to dent, for example, the truth-value of the digital Abu Ghraib prison photographs from 2004. Or for that matter everyday news photographs, which we still take at 'face value'.

So it may turn out that it is rather less the issue of 'truth' in computer-processed photographs that is at stake. Instead, it is the anxiety and uncertainty created by the processes of rapid technological change that have fuelled a dramatic bi-polar optimism and pessimism about photography. That is to say, the sense of loss relates perhaps not to 'reality' (which all images contribute to) but to the *different* (some would say lower) aesthetic values that have emerged (casual framing, hyper-colour casts, exposure differentials, pixelation, etc.), which, because of the sheer quantity of digital photographic pictures in circulation, have changed the popular consensus of photographic aesthetic values. Computer-processed images increasingly dominate the picture environment, even if analogue in origin. Mobile camera phones, webcams and cctv cameras, for example, create images where the *interpolated* pixelation (transmission codes) give a distinct aesthetic experience understood as a quite different one among audiences brought up on analogue grain enlargement. This factor, a newer 'digital' code and the associated tolerance of lighting contrast in all conditions (way beyond the capacity of film sensitivity) ought, in fact, to make digital images seem more 'real'. If these images are not measured against the 'realist' codes of analogue photography, the potential for novel pictures and viewpoints, stimulated by the very mobility of mobile cameras, means that there is a new spectrum of images to be made. Language and culture and aesthetic experiences do change.

IMAGE DISSEMINATION

A second key issue is about the significance of a wider means of dissemination of images. This marks a distinctive cultural shift in photographic images, in that computers have enabled different patterns of distribution and dissemination to

emerge. These new patterns of exchange and communication are supported by the memory capacity of computers as meta-systems or 'multi-media' platforms. These platforms enable the user to combine images, sounds and language in different ways. If we accept that cultures (the values, meaning and practices of specific societies or social groups) are susceptible to change, although this is by no means inevitable, then the issue that globalization brings is not the fact that it may change culture, but more the problematic of *what* changes are brought, or put on offer. This can have positive *and* negative effects.

Without being overly optimistic or pessimistic, we might identify *three* main trends related to photographic image-use on the World Wide Web:

1. A local accumulation whose aim is global.
2. A global network whose aim and use is local.
3. An aim neither local nor global, but simply one that may be defined as 'distraction'.

It is worth looking at the consequences of these in the dominant global market of photography.

I. A LOCAL ACCUMULATION WHOSE AIM IS GLOBAL

Since the 1970s, as Paul Frosh has argued, photography 'super-agencies' like Corbis and Getty have been accumulating vast quantities of photographic images by purchasing existing photography collections, agencies and their archives.[26] These large agencies are recentralizing diverse local archives and collections of photographs and turning them into a global commodity. Historians and cultural critics see the copyright and ownership of public memories in the hands of these few agencies as a real legitimate political and historical concern and look at the centralization of these collections into the hands of the few with trepidation.

In addition to the accumulation of existing image collections, these and other agencies are generating vast quantities of a type of photography that has existed for some time, but which has a new, expanded market value by being made available through the Web. These photographs, somewhat bland, are 'generic' images that have no particular meaning. In a witty inversion of one of Roland Barthes's infamous semiotic slogans, Frosh claims that stock photography 'imparts a *code without a message*'.[27] Used in marketing, advertising, editorial, website and multimedia industries, the typical stock picture shows the generic characteristics of its subject matter. They are essentially stereotypes, of a canonic generality. Typical examples include: romantic couples kissing, or enjoying coffee together in a café, figures (men and women) on their way to work in business clothes or clean factory clothing.

Often monochrome (perhaps a connotative legacy from the photojournalistic-inspired art photography of *The Family of Man*?), stock photography offers a vast array of stereotypical pictures of cities, nature, people, etc. Using every genre, stock photography aims to sell images for any general-purpose use. The aim is to appeal to as many clients as possible in as many parts of the world, which exemplifies the fears of sameness, of a 'reality' without the *real*.

In the same way, 'international' hotel franchise chains repeat the same bland architecture, generic interior designs and food menus (like the television channels available in international hotels) to ease the anxiety of international business travel. By repeating the same wallpaper environment, a 'familiar' repertoire of experiences makes travel more comfortable. Life is 'reassuring' when it repeats itself, freed from the wild variations of local cultural difference. Stock photography, rapidly becoming the major photographic industry, promotes this outlook, an industry dedicated to providing inoffensive, bland and blank images – an endless repetition of sameness. The vast growth of these banks of stock photography has developed with the speed and ease of sending and receiving images from computer to computer via the World Wide Web. Their international production (stock photography is gathered from all parts of the world) leads to an image bank accumulation that decreases the economic market power of photographers to produce other types of picture, more complex and less 'generic'. This criticism can be counteracted, and it is important to point out that individual photographers in smaller markets can also intervene within the www image market with their own picture archives. As a counterpoint to the accumulation of highly centralized powerful agencies, whether as freelance photojournalist, paparazzi, documentary, editorial, or artist, all photographers have potential 'access' to a worldwide public, albeit as a smaller fish in a rather large pond. A global ambition, however, marks this trend out from the second one.

2. A GLOBAL NETWORK WHOSE AIM AND USE IS LOCAL

The success of websites like Flickr (now over 2 billion pictures), Facebook and eBay, not to mention all the other websites they overlap with, provide 'global' access for a local usage. These 'community' websites offer the possibility of making contact with other people for social, cultural, personal, economic and even political relations.[28] These Web relationships, which can be built up over time and space, work to complement a local culture, although there are tensions here too between globalism and localism.

The question of local versus global is significant, not only for local economic patterns of *access*, of the trade in photographic images (as under 1. above), but also in terms of the meanings, beliefs and values that images and the experience of them

carry and project into any locality. The experience of strange places or things seen on websites can create disjunctures and conflict in the social, political and cultural values of a locality. The effects of visual representation can be just as real as the effects of actual migration, as succinctly summarized by Arjun Appadurai:

> As families move to new locations, or as children move before older generations, or as grown sons and daughters return from time spent in strange parts of the world, family relationships can become volatile; new commodity patterns are negotiated, debts and obligations are recalibrated, and rumours and fantasies about the new setting are manoeuvred into existing repertoires of knowledge and practice.[29]

Postcolonial theory is useful here for the examination of clashes in cultures, of power relations, emergent cultural and social hybridity and the reimagining of communities. This might sound like a long way from simply buying a book or image on eBay or playing Internet chess games but the creative and conflictual outcomes of such encounters offer a significant shift in concepts of 'locality'.[30] The fact that one thing in one part of the world has an impact in another is much more easily transmitted today, with no guarantees of its consequential effect decided in advance.

3. AN AIM NEITHER LOCAL NOR GLOBAL, BUT SIMPLY ONE DEFINED AS 'DISTRACTION'

'Surfing the Net', just like 'zapping' across television satellite channels, is common practice. The temptation to surf across websites from one page to another in a state of distraction is built into the system. This system of thinking 'associatively', through associative paths of thought, replicates the state of consciousness that Sigmund Freud called 'daydreaming'. The daydreamer occupies an intermediate state, half-way between full consciousness and sleep. Absorbed in their own fantasies and wishes, the daydreamer is only half aware of their own desire. Thus drifting, they are able to pass hours or days surfing 'dreams' on prefabricated sites, where their every move has been anticipated by some commercial entrepreneur. As Freud pointed out so long ago, daydreams have erotic or ambitious wishes of the dreamer at their heart.[31] So it is no surprise that sexual fantasies are extensively provided for in the most obvious guise of pornography, a photographic industry that has become a massive Web-based industry. Advertising too, as an institution of social fantasy, exploits the will to daydream and build 'castles in the sky', and is also supplemented (or replaced) by website navigation or 'browsing'. Online films, photographs, animated scenes of every aspect of an erotic or ambitious wish or fantasy are provided in an endless stream of images. Whether sexual, social or political, even spiritual, Web-surfing

enables a platform for daydream browsing. The drifting viewer can engage in games that position that 'user' as omnipotent; or tests that test intellectual skills, endless specialist websites or news and gossip, all generally occupy the 'user', and these indicate the way that many types of images, experienced as peripheral, are absorbed and constitute a new domain for study of the use of photographic images.

Distraction, a long-standing enemy of 'concentrated work' and 'efficiency' (capitalist accumulation), is enjoying itself as a significant industry. (It is no co-incidence that one website design software is called *Dreamweaver*.) What was once an avant-garde gambit by artists in the early twentieth century (the Surrealists) as a response to the drudgery of mundane work, distraction is now factored into modern technological experience.[32] Indeed, much might be learnt by returning to (reread) the critical debates on the rapid technological transformations of mass photographic imaging during the 1920s and 1930s. Although quite different from today, distraction, shock and the dizzying effects of being showered with so many images and information from different parts of the world, which we simply do not have the capacity to absorb, is being repeated on a more massive global scale.

Moreover, alongside all these patterns of image distribution and use are questions about ownership, ethics, copyright and power over images in a 'globalized' communication environment. Today, globalization can mean simply the way a photographer advertises their work and skills (e.g. a 'global' wedding photographer) or it can mean the more complex issue of how, why and what something is represented to different populations in the world. In every sense, then, the still photographic image, even in its reconfigured form as a digitized computer file, held remotely on a mobile device, still remains at the heart of modern life today. These significant changes indicated here make a revision in thinking about photographic images even more important, not least the tenacity of the forms these photographs take, as portraits, landscapes, documentary snaps and still life. The globalization of photography through the Web requires a history, sociology, semiotics and a psycho-cultural analysis of its consequences. Only then might we see what contribution the dissemination of digitalized photographic images are making to our new conceptions of cultural time and space. Nevertheless, we can already see that, in a multi-polar world, the ebb and flow of images are part of the changes to the shape of power structures in the world. Photography is one means by which such structures are represented, and also a means by which to critique them.

Chapter Summary

■ Globalization offers a new paradigm for thinking about the development and impact of photography

■ 'World' or humanist photography aimed to find a global language of photographic communication.

■ 'Digital' photographs offer continuity with and difference from analogue-processed photographs.

■ Computers offer a 'meta-system' for the production and dissemination of photographs, moving images, words and sound.

■ Globalization has positive and negative effects.

QUESTIONS FOR ESSAYS AND CLASS DISCUSSION

INTRODUCTION

- What is *genre*?

1 HISTORY

- Is a photograph a document that we can draw upon for historical research?
- Is 'history' the process of historical events or the representation of those events?
- Why invent photography?
- What is the aim of the 'history of photography'?

2 PHOTOGRAPHY THEORY

- What is a 'theory' of photography?
- How do photographs achieve meanings?
- What is the importance of codes and conventions?
- Choose a photograph and make an analysis of its potential *meanings*.

3 DOCUMENTARY & STORY-TELLING

- What is a documentary photograph?
- Is there a difference between a photograph as 'document' and 'social documentary' photography?
- Can a single picture tell a complex story?
- Is the *decisive moment* about 'freezing time' or triggering an implied narrative?
- What kind of stories do documentary photographs describe?

4 LOOKING AT PORTRAITS

- What can we learn from a portrait?
- Does portraiture idealize, describe or criticize a sitter? How does it do this?
- Can the 'pose' be a type of defence?
- Why is portraiture so popular?
- Can the human face reveal anything about human character? Give visual examples.

5 IN THE LANDSCAPE

- Are landscape pictures always a metaphor for something else? Discuss, giving examples.
- Does the camera see 'nature' by itself?
- What is the difference between the categories of *picturesque* and the *sublime*?
- Why might the modern city often be seen as 'sublime'?
- Try taking two pictures of the same place (city, town, village, land) – one as *picturesque*, the other as *sublime*.

6 THE RHETORIC OF STILL LIFE

- Choose an advertising image (one that uses photography) and analyse its *rhetoric*. Discuss *what* the picture says about the product and *how* it says it, and address *why* it would promote the product in this way.
- Why do *you* think Jean Baudrillard said that advertising is 'useless' and 'unnecessary'?
- 'Advertising offers *imaginary* solutions to real social issues.' Discuss.
- How does the use of still life by artists differ from advertising 'pack shots'?

7 ART PHOTOGRAPHY

- What are the social implications of claiming 'the autonomy of art' from society?
- What is the role of art in society? How does photography play any part in this?
- Is there any difference between photography in conceptual art, fine art photography and street photography? If so, what are these differences and are they important?
- Is contemporary art photography different from earlier forms of art photography? Describe the differences.

8 GLOBAL PHOTOGRAPHY

- Can a photograph have a global meaning? Discuss, giving examples.
- What significance does the global dissemination of photographic images have for different communities in the world?
- Is the globalization of images an inevitable process?
- Is globalization good *and* bad? Discuss.

ANNOTATED GUIDE FOR FURTHER READING

Barthes, Roland, *Image-Music-Text,* London: Fontana, 1982.

This book is a brilliant collection of essays concerning Barthes's writings on photography, film and semiotic theory. Edited and translated by the British film theorist Stephen Heath, it is one of the most widely read theory books on photography. Although difficult in places, it shows Barthes working through a series of different models for thinking about types of photographic images, with each essay taking a different starting point and set of problems. Journalism, advertising and film stills photographs are all subject to theoretical discussion and critique.

Barthes, Roland, *Camera Lucida*, London: Fontana, 1984.

Widely read as a personal account of photography, Barthes's famous essay is actually based in phenomenology, a philosophy that uses the material of a subjective experience to examine 'theoretical' problems. In terms of a contribution to photography theory and criticism (it is certainly not a history), this book can be read as centred on what in psychoanalysis Jacques Lacan called 'the gaze'. For Jacques Lacan, the *gaze* is an imaginary look from someone or something in the picture directed *at the viewer*. What Barthes calls the *punctum*, something in the picture that 'punctures' the subject in a way that the original photographer could not have predicted, is very close to Lacan's conception of the gaze. A good complementary essay is 'The Third Meaning', whose categories of *obvious* and *obtuse* precede *studium* and *punctum* in *Camera Lucida*.

Belsey, Catherine, *A Very Short Introduction to Poststructuralism*, Oxford: Oxford University Press, 2002.

This is a very good introduction to the thinking and impact of structuralism and poststructuralist arguments on the analysis of culture via images and the way we live in or 'inhabit' language.

Bolton, Richard, ed., *The Contest of Meaning: Critical Histories of Photography*, London: MIT Press, 1992.

This collection of varied critical essays deals with the avant-garde and modern 'turns' in different European traditions and in USA photography, from the 1920s through to the 1980s when the book was first published.

Burgin, Victor, ed., *Thinking Photography*, Basingstoke: Macmillan, 1982.
 This collection of essays is valuable for two reasons. Firstly, it established a clear theoretical project, linking semiotics to critical discussions of a range of types of photography, from art and media to documentary and Soviet avant-garde debates. Secondly, the book is important now as a historical text, vibrant with the debates of the late 1970s and early 1980s. The contributions by Victor Burgin and Allan Sekula, both influential artists *and* theorists, can be read alongside their own visual practices circulating at that time. It is also worth noting that this book came out two years after Alan Trachtenberg's *Classic Essays on Photography* (see below) and in some ways the essays here can be read as adding what is missing from Trachtenberg's book.

Campany, David, ed., *The Cinematic Image*, London: Whitechapel/MIT Press, 2007.
 The slightly misleading title of this book hides the fact that this is a collection of essays primarily about 'still' photography and different potential relationships to time.

Cotton, Charlotte, *The Photograph as Contemporary Art*, London: Thames & Hudson, 2004.
 A useful survey focusing on turn-of-the-twenty-first-century art photography, which shows the art world moving gradually towards a more 'global' perspective of art.

Godfrey, Tony, *Conceptual Art*, London: Phaidon, 1998.
 Chapters include one on uses of photography by conceptual artists in what is a clear and general introduction to (rather than a critical evaluation of) conceptual art.

Frosh, Paul, *The Image Factory*, Oxford: Berg, 2003.
 Sociological in approach, this book addresses the growth of 'stock photography' and its cultural role in social representation.

Marien, Mary Warner, *Photography: A Cultural History*, London: Lawrence King, 2006.
 This is a general introduction to a general chronological history of photography. It is most useful for its introductory description of the earlier developments of photography, during the nineteenth and early twentieth centuries.

Newhall, Beaumont, *The History of Photography*, New York: MoMA, 1980 [1964].
 Still a good read, this book introduces historical photographs as situated within a modernist paradigm of thought. The book is bursting with the idea that photography *is* an art and charges through what is now a well-established canon of museum-collected photography.

Sontag, Susan, *On Photography*, Harmondsworth: Penguin, 1977.
 This is a 'classic', still popular, introduction to photography *criticism*. Widely read and a 'set text' for photography students, it attacks questions of the aesthetic, social and ethical issues of photography, Susan Sontag's book has provided many students and teachers alike with a critical view of photography. It is clearly a product of its time and place: New York and the photographic modernism of the 1970s. Any contemporary reader would do well to refer to the images of the photographers she discusses to see why she makes her arguments the way she does, since many of the photographers referred to were already then in the collection of the Museum of Modern Art, New York. (See also Beaumont Newhall, *The History of Photography*, New York, 1980.)

Trachtenberg, Alan, ed., *Classic Essays on Photography*, Newhaven: Leete's Island, 1980.

This is an excellent collection of many key historical writings on photography from the USA and Europe up until 1980. In four parts, the first section gives a useful introduction to the early nineteenth-century discussions about photography after its immediate invention, followed by the second section on late-nineteenth century aesthetic debates. The last two sections deal mostly with the key early twentieth-century essays on photography by photographers and theorists alike, indeed photographers often *are* the theorists. The book came out two years before Victor Burgin's edited collection, *Thinking Photography* (above), which in many ways is the key critical successor to the arguments found in *Classic Essays on Photography*.

Williams, Raymond, *Culture*, London: Fontana, 1981.

Raymond Williams (1921–88), a British literary historian, made a massive contribution to what was called 'culturalism': the analysis of culture as a historical process. This book, somewhat dry, gives a very clear description of the different relations between 'producers' (e.g. artists, photographers, etc.) and institutions, in terms of artistic goals, power and aims.

NOTES

Introduction

1. The only recent attempt to deploy genre *as a concept* in the discussion of photography is in Paul Frosh's book, *The Image Factory* (Oxford: Berg, 2003).
2. Steve Neale, 'Questions of Genre', *Screen* (Oxford University Press, volume 31, number 1, spring 1990), p 45.
3. Steve Neale, *Genre* (London: BFI, 1980).
4. Neale, 'Questions of Genre', *Screen*, p 46.
5. Hal Foster, *et al.*, *Art Since 1900: Modernism, Antimodernism, Postmodernism* (London: Thames & Hudson, 2004).

Chapter 1 History

1. Sigmund Freud, 'Civilization and its Discontents' [1930], *Civilization, Society and Religion*, Pelican Freud, Volume 12 (Harmondsworth: Penguin, 1989), p 279.
2. Raymond Williams, *Keywords* (London: Fontana, 1988).
3. See for example: Helmet and Alison Gernsheim, *The History of Photography* (London: Oxford University Press, 1955); Jean-Claude Lemagny and André Rouille, eds., *A History of Photography* (New York: Cambridge University Press, 1987); Naomi Rosenblum, *A World History of Photography* (London: Abbeville, 1984); Michel Frizot, ed., *A New History of Photography* (Cologne: Könemann, 1998) [1994 in French]; *The History of Japanese Photography*, Kaneko Ryūichi *et al.* (Houston: Museum of Fine Arts, 2003).
4. The essay has been reprinted several times since 1971; see Linda Nochlin, *Women, Art, and Power and Other Essays* (London: Thames & Hudson, 1989).
5. Karl Marx, 'The Eighteenth Brumaire of Louis Bonaparte', *Marx/Engels: Selected Works* (London: Lawrence & Wishart, 1980), p 96.
6. Karl Marx, 'The Eighteenth Brumaire of Louis Bonaparte', p 96.
7. The book was originally based on a 1937 exhibition and catalogue called *Photography, 1839–1937*, held at the Museum of Modern Art, New York. See Beaumont Newhall, *The History of Photography: From 1939 to the Present Day* (New York: Museum of Modern Art, 1964).
8. See Christopher Phillips, 'The Judgement Seat of Photography', *The Contest of Meaning*, R. Bolton, ed. (London: MIT, 1992), p 196.
9. See, for example, the work of Abigail Solomon-Godeau, especially 'Calotypomania' and 'Cannon Fodder'; both in *Photography at the Dock* (Minneapolis: Minnesota Press, 1995).
10. John Tagg, *The Burden of Representation* (Basingstoke: Macmillan, 1988), p 118.
11. See Michel Foucault, *The Archaeology of Knowledge* (London: Tavistock, 1985).

12. Tagg, *The Burden of Representation*, p 118.

13. Tagg, *The Burden of Representation*, p 119.

14. Classic examples of this are: Roland Barthes, 'Rhetoric of the Image', *Image-Music-Text* (London: Fontana, 1982); Victor Burgin, 'Art, Commonsense and Photography', reprinted in J. Evans, ed., *The Camerawork Essays* (London: Rivers Oram, 1997); Judith Williamson, 'A Currency of Signs' in *Decoding Advertisements: Ideology and Meaning in Advertising* (London: Marion Boyars, 1978); Victor Burgin, 'Photographic Practice and Art Theory' and Allan Sekula, 'On The Invention of Photographic Meaning' in *Thinking Photography* (Basingstoke: Macmillan, 1982).

15. Barthes, 'Rhetoric of the Image', *Image-Music-Text*, p 46.

16. Barthes, 'The Photographic Message', *Image-Music-Text*, p 17.

17. Barthes, 'The Photographic Message', *Image-Music-Text*, p 28.

18. See Larry J. Schaaf, *The Photographic Art of William Henry Fox Talbot* (Oxford: Princeton, 2000), p 190; Carol Armstrong, 'A Scene in a Library: An Unsolved Mystery', *History of Photography*, Summer 2002.

19. Larry J. Schaaf says there are at least six previous pictures by Talbot of books. See Larry J. Schaaf, *The Photographic Art of William Henry Fox Talbot*, p 190.

20. W. H. F. Talbot, *The Pencil of Nature*, no page nos (facsimile published New York: Hans P. Kraus Jr. Inc, 1989). See also Carol Armstrong, *Scenes in a Library: Reading the Photograph in the Book, 1843–1875* (London: MIT Press, 1998).

21. Stuart Hall, 'Re-construction Work', *Ten.8* (Volume 2, no 3, 1992), p 106.

22. I refer to the argument made in Jean-François Lyotard's *The Postmodern Condition* (Manchester: Manchester University Press, 1986).

23. Eric Hobsbawm, *Age of Extremes: The Short Twentieth Century, 1914–1991* (London: Penguin, 1994), p 500.

24. In another example, Maureen Turim, writing on Hollywood cinema, suggests that Hollywood films only tell historical events through the experience of individuals, whereas Sergei Eisenstein's cinema, for example, avoided this 'personification of history'. See Maureen Turim, *Flashbacks in Film* (London: Routledge, 1989), p 103.

Chapter 2 Photography Theory

1. Walter Benjamin, 'The Work of Art in the Age of Mechanical Reproduction', *Illuminations* (London: Fontana, 1973), p 229.

2. John Berger, *Ways of Seeing* (London: Penguin, 1990).

3. Barbara Rosenblum, *Photographer at Work: A Sociology of Photographic Styles* (New York: Holmes & Meier, 1978).

4. Roland Barthes, 'The Photographic Message' and 'Rhetoric of the Image', in *Image-Music-Text* (London: Fontana, 1977).

5. Victor Burgin, ed., *Thinking Photography* (London: Macmillan, 1982).

6. Louis Althusser, 'Ideology and Ideological State Apparatuses', *Lenin and Philosophy, and Other Essays*, translated Ben Brewster (London/New Left Books, 1971).

7. Other key figures are: the anthropologist Claude Levi-Strauss, Jacques Durand's work on photography, Jacques Derrida's philosophy of 'deconstruction', Jacques Lacan's introduction of semiotics to psychoanalysis, the introduction of psychoanalysis to social semiotics in Julia Kristeva's work and Michel Foucault's work in and on the theory of history.

8. Roland Barthes, *Mythologies* (London: Paladin, 1980).

9. Barthes, *Roland Barthes by Roland Barthes* (Berkeley: University of California Press, 1994).

10. Barthes, *Camera Lucida* (London: Fontana, 1984).

11. Barthes, *Elements of Semiology* (New York: Hill & Wang, 1968).

12. Ferdinand de Saussure, *Course in General Linguistics* (New York: Fontana/Collins, 1981), p 65.

13. See Umberto Eco, 'Critique of the Image' in *Thinking Photography*, ed. Victor Burgin (Basingstoke: Macmillan, 1982), p 35.

14. See Jean Louis Schefer, 'Split Colour/Blur' in *The Enigmatic Body: Essays on the Arts*, edited and translated by Paul Smith (Cambridge: Cambridge University Press, 1995).

15. Aristotle, *The Art of Rhetoric* (London: Penguin Classics, 1991).

16. Victor Burgin, *Thinking Photography*, p 41.

17. Rhetoric is 'born of the conventionalisation of as yet unuttered iconic solutions, then assimilated by society to become models or norms of communication.' Umberto Eco, 'Critique of the Image', *Thinking Photography*, p 37.

18. André Bazin, 'The Ontology of the Photographic Image' in *Classic Essays on Photography*, ed. A. Trachtenberg (New Haven: Leete's Island, 1980), p 237.

19. Bazin, 'The Ontology of the Photographic Image', p 238.

20. See Victor Burgin, 'Art, Commonsense and Photography' reprinted in *The Camerawork Essays*, ed. J. Evans; and Umberto Eco, 'Critique of the Image' in *Thinking Photography*, ed. Victor Burgin.

21. André Bazin, one of the most sophisticated realist critics, developed his theory of realism to argue that 'illusory appearances' was by itself only 'pseudorealism' and therefore insufficient to proper realism, which was really about giving 'significant expression to the world' – a theme important for documentary photography in particular (see Chapter 3: *Documentary and Story-telling*).

22. A book published after Roland Barthes's death shows how he subjected the idea of *neutrality* to scrutiny. See Roland Barthes, *The Neutral*, translated by Rosalind E. Krauss and Denis Hollier (New York: Columbia University Press, 2005).

23. Jean-Jacques Rousseau (1712–78) a philosopher and educational novelist, argued that humans should live in social harmony with one another and the state of nature.

24. See Roland Barthes, 'The Third Meaning', *Image-Music-Text*, pp 52–68.

Chapter 3 Documentary and Story-telling

1. See Raymond Williams, 'The Growth of the Popular Press', *The Long Revolution* (London: Hogarth Press, 1992), especially pp 206–9.

2. For a discussion of *Life* magazine, see Carol Squiers, 'Looking at *Life*', *Illuminations: Women Writing on Photography from the 1850s to the Present*, Liz Heron and Val Williams, eds. (London: I B Tauris, 1996).

3. The classic work on this subject is Harold Evans, *Pictures on a Page: Photojournalism, Graphics and Editing* (London: Pimlico Press, 1997).

4. See Gerry Badger and Martin Parr, eds., *The Photobook: A History*, Volumes 1 and 2 (London: Phaidon, 2004 and 2006).

5. Eric Hobsbawm, *Age of Extremes: The Short Twentieth Century* (London: Penguin, 1994), p 191.

6. For a succinct discussion of the Soviet ideological debates on photography, see Victor Burgin's 'Photograph, Phantasy, Function' in *Thinking Photography* (Basingstoke: Macmillan, 1982).

7. Eric Hobsbawm notes that for every Briton who bought a daily newspaper, two bought a cinema ticket in the 1930s. See Hobsbawm, *Age of Extremes,* p 192.

8. Hobsbawm, *Age of Extremes,* p 191.

3

9. Martha Rosler, *Decoys and Disruptions* (London: MIT, 2004), pp 178–9. A case study of French photographic humanism is developed in Peter Hamilton's essay in *Representation*, eds. S. Hall and J. Evans, Open University Press, 1999.

10. See 'The International Worker Photography Movement' in *Photography/Politics: One*, T. Dennett and J. Spence, eds. (London: Photography Workshop, 1980).

11. The classic work on this field of state-sponsored photography is John Tagg's, *The Burden of Representation* (Basingstoke: Macmillan, 1988).

12. Jacob A. Riis, *How the Other Half Lives* (Harmondsworth: Penguin, 1997).

13. See Lewis Hine's essay 'Social Documentary', reprinted in Alan Trachtenberg, ed., *Classic Essays on Photography* (Newhaven: Leete's Island, 1980).

14. John Thomson (with texts by Adolphe Smith), *Street Life in London* (London: Dover Publications [1877], 1994).

15. Walter Benjamin, 'A Short History of Photography' [1931], reprinted in Alan Trachtenberg, ed., *Classic Essays on Photography*, pp 210–11.

16. Otto Steinart, *Subjective Photography* [*Subjektive fotografie*], two volumes (Munich: Bruder Auer, 1955).

17. Eugène Atget's work, on which there is already a growing body of literature, probably merits an entire chapter of its own, given the comprehensive nature of his work about Paris. See Molly Nesbit, *Atget's Seven Albums* (London: Yale University Press, 1992) for a general introduction to his photographs. On photographs of the city as a crime scene, see Peter Wollen, 'Vectors of Melancholy' in *Scene of the Crime*, ed. Ralph Rugoff (London: MIT, 1997).

18. Eric Hobsbawm, *Age of Extremes*, p 192.

19. Peter Wollen, 'Fire and Ice', *The Photography Reader*, Liz Wells, ed. (London: Routledge, 2003), pp 77–8.

20. Walker Evans, 'The Reappearance of Photography' in Trachtenberg, *Classic Essays on Photography*, p 188.

21. See John Grierson, *The Documentary Film Movement: An Anthology*, Ian Aitken, ed. (Edinburgh: Edinburgh University Press, 1998).

22. This is discussed in Roland Barthes's essay 'Diderot, Brecht, Eisenstein' in *The Responsibility of Forms* (Berkeley: University of California Press, 1993), p 93. See also Victor Burgin's argument 'Diderot, Barthes, Vertigo' in *The End of Art Theory* (London: Macmillan, 1986).

23. Henri Cartier-Bresson, 'Images à la sauvette' [1953] ('The Decisive Image'); extracts are reprinted in David Campany, ed., *The Cinematic Image* (London: Whitechapel/MIT Press, 2007), p 43.

24. John Grierson, 'Untitled Lecture on Documentary' (1927–33) in *The Documentary Film Movement: An Anthology*, Ian Aitken, ed., p 76.

25. John Grierson, *The Documentary Film Movement*, p 76.

26. Ian Walker, for example, makes an analysis of Cartier-Bresson's famous 1932 picture 'La Place de l'Europe', where his reading of it as 'a wasteland of indecisiveness' can be linked to the title of the picture 'The Place of Europe' which turns it into an *allegory* of Europe in 1932. See Ian Walker, *City Gorged with Dreams* (Manchester: Manchester University Press, 2002), pp 174–5.

27. See Marja Warehime, *Brassaï, Images of Culture and the Surrealist Observer* (London: Louisiana State University Press, 1996), p 86.

28. See Alan Trachtenberg, 'Signifying the Real: Documentary Photography in the 1930s' in Alejandro Andreus, Diana L. Linden and Jonathan Weinberg, eds., *The Social and the Real: Political Art of the 1930s in the Western Hemisphere* (Pennsylvania: Pennsylvania State University, 2004).

29. See Sigmund Freud, *Three Essays on Sexuality*, translated by James Strachey, Pelican Freud Library Vol. 7 (Harmondsworth: Penguin, 1983).

30. Jacques Lacan, *The Four Fundamental Concepts of Psycho-Analysis* (Harmondsworth: Penguin, 1979), p115.

31. See Laura Mulvey's classic 1975 paper 'Visual Pleasure and Narrative Cinema' in *Visual and Other Pleasures* (London and Basingstoke: Macmillan, 1989).

32. See Geoffrey Crawley, 'Colour Comes to All' in *The Story of Popular Photography*, ed. Colin Ford (Bradford: National Museum of Film, Television and Photography, 1989).

33. See the discussion on Jeff Wall in Chapter 7: *Art Photography*.

Chapter 4 Looking at Portraits

1. On 'identity', see Stuart Hall 'Introduction: Who Needs Identity?' in *Questions of Cultural Identity* (London: Sage, 1996).

2. John Tagg, *The Burden of Representation* (Basingstoke: Macmillan, 1988).

3. John Tagg, *The Burden of Representation*, p 37.

4. Aaron Scharf, *Art and Photography* (Harmondsworth: Penguin, 1979), pp 39–76.

5. In 'The Third Meaning' essay, Roland Barthes (see *Image-Music-Text*) makes a distinction between the *obvious* and *obtuse* meanings of a photograph, which in *Camera Lucida* becomes the distinction between *studium* and *punctum*.

6. A good example of this is Roland Barthes's last book *Camera Lucida*, in which he consciously speculates on the phenomenological *affect* of random photographs. The pictures turn out to be mostly portrait photographs and Barthes realizes through writing the book that certain aspects in those pictures (details) grab his attention – reminding him of his mother who had just died. It is a moving story. Curiously, when Barthes thinks of his mother in photographs, it is only one picture of her, as a little girl – when he would not have known her – that seems to be the 'real her', his mother. We can also gather from this book that, in all pictures that initially create our 'general interest', what Barthes calls their *studium*, there is another interest, the *punctum*, sometimes provoked by a picture. The punctum is a feeling, like an arrow shooting through you. This can be linked to what in psychoanalysis is called the *gaze* (by Jacques Lacan), a 'message' received without *knowing* exactly what it means, but which pertains to our own identity being *addressed* in some way.

7. See: Suren Lalvani, *Photography, Vision, and the Production of Modern Bodies* (Albany, New York: State University Press of New York, 1996); Robert Sobieszek, *Ghost in the Shell: Photography and the Human Soul, 1850–2000* (Cambridge, MA: MIT Press & Los Angeles County Museum, 2000).

8. Allan Sekula discusses Francis Galton in 'The Body and the Archive', from *The Contest of Meaning*, Richard Bolton, ed. (London: MIT Press, 1996), pp 342–79.

9. See, for example: William A. Ewing, *Face: The New Photographic Portrait* (London: Thames & Hudson, 2006) and Max Kozloff, *The Theatre of the Face: Portrait Photography Since 1900* (London: Phaidon, 2007).

10. See Roland Barthes, 'The Third Meaning', *Image-Music-Text*.

11. Michael Powell's infamous film *Peeping Tom* (1960), although not a horror film as such, is an interesting example. The story is based on a cine-photographer who kills women with his camera tripod, whilst using a mirror to make his victims see their own expression of horror as they die.

12. Laura Mulvey, 'Visual Pleasure and Narrative Cinema', *Visual and Other Pleasures* (London and Basingstoke: Macmillan, 1989).

13. Roland Barthes, 'The Face of Garbo', *Mythologies* (London: Paladin, 1980); also Laura Mulvey, 'Close-ups and Commodities' in *Fetishism and Curiosity* (London: BFI, 1996).

14. See John Fiske, 'The Jeaning of America' in *Understanding Popular Culture* (London: Unwin Hyman, 1989), pp 2–3.

15. Barthes: 'the bourgeoisie is defined as *the social class which does not want to be named*.' Roland Barthes, 'Myth Today' in *Mythologies*, p 138. [Italics in original.]

16. See the classic structuralist study on fashion by Roland Barthes is his book *The Fashion System*, translated by Matthew Ward and Richard Howard (New York: Hill & Wang, 1983). Also John Flugel's book *The Psychology of Clothes* (London: Hogarth Press, 1930) is still an amazing treasure, full of analysis of the function and fashion of clothing and body decoration.

17. One might speak here of the way fashion organizes the feminine body as representation. It narrates the successive instants of her social function: youth, seduction, adornment, pregnancy, motherhood and carer … as a patriarchal narrative. In short, the cycles of women's fashion for eroticizing particular parts of the female body are not arbitrary, but driven by social demands upon her 'function'.

18. For a psychoanalyst like Jacques Lacan, the deceit is that there *is* something to hide – there is really nothing but emptiness behind images. See Jacques Lacan, *The Four Fundamental Concepts of Psycho-Analysis* (Harmondsworth: Penguin, 1979), p 112.

19. Charles Baudelaire, 'The Modern Public and Photography' in *Classic Essays on Photography*, A. Trachtenberg, ed. (New Haven: Leete's Island Books, 1980), pp 86–7.

20. See Sigmund Freud, 'Beyond the Pleasure Principle' (Section V), *On Metapsychology*, Pelican Freud Library, Volume 11 (Harmondsworth: Penguin, 1983).

21. For an early essay on this topic see Erwin Panofsky's 'Style and Medium in the Motion Pictures' in his *Three Essays on Style* (London: MIT Press, 1997).

22. See Jean Laplanche and Jean-Bertrand Pontalis, 'Fantasy and the Origins of Sexuality', in C. Kaplan, V. Burgin and J. Donald, eds., *Formations of Fantasy* (London: Methuen, 1986).

23. See Jacqueline Rose, 'The Imaginary', *Sexuality in the Field of Vision* (London: Verso, 1986) especially pp 176–7.

24. 'It follows that the preliminary stage of the scopophilic instinct, in which the subject's own body is the object of the scopophilia, must be classed under narcissism, and that we must describe it as a narcissistic formation.' Sigmund Freud, 'Instincts and their Vicissitudes' (1915) translated by James Strachey, in *On Metapsychology*, Pelican Freud Library, Vol. 11 (Harmondsworth: Penguin, 1983), p 129.

25. It would be another essay, but Roland Barthes's concept of the '*punctum*' in *Camera Lucida* (London: Fontana, 1984) could well be the subject of discussion as a form of 'introjection'.

26. Ernst Gombrich, 'Portrait Painting and Portrait Photography', *Apropos*, no. 3, 1945, p 5. Also see especially 'Discourse XIV' in Joshua Reynolds, *Discourses on Art* (London: Yale University Press, 1997).

27. See Ernst Gombrich, 'Harmony Attained' in *The Story of Art* (London: Phaidon, 1999), p 228.

28. Ernst Gombrich, 'Harmony Attained' in *The Story of Art*, p 228. See also Darian Leader, *Stealing the Mona Lisa* (Washington DC: Shoemaker & Hoard, 2002).

29. See *Thomas Ruff: Portraits*, Benjamin Buchloh, ed. (Mosel: Schirmer, 1998).

Chapter 5 In the Landscape

1. Cited in Aaron Scharf, *Art and Photography* (Harmondsworth: Penguin, 1979), p 100.

2. Mario Praz, *The Romantic Agony* (London: Fontana, 1966), pp 37–40.

3. A rediscovery of a first-century text by the Greek writer Longinus, *On the Sublime*, was published in 1674, and provided a key reference for the revival of the sublime in the late seventeenth and early eighteenth centuries.

4. Edmund Burke, *A Philosophical Enquiry into the Origin of our Ideas of the Sublime and the Beautiful* (London: Routledge and Kegan Paul, 1967 [1757]).

5. For an analysis of the political dimension of Turner's sublime, see Paul Gilroy, *The Black Atlantic: Modernity and Double Consciousness* (London: Verso, 1993), pp 187–223.

6. Burke, *A Philosophical Enquiry*, p 39.

7. Ansel Adams 'The New Photography' in *Modern Photography, 1934–1935*, ed. Geoffrey J. Holme (New York and London: The Studio, 1935), p 13.

8. The introductory text to the work of *New Topographics: Photographs of a Man-Altered Landscape* (1975) is reprinted in *Readings into Photography*, Tom Burrow *et al.*, eds. (Alburquerque: University of New Mexico Press, 1982).

9. See for example, Joel Snyder, *One/Many: Western American Survey Photographs by Bell & O'Sullivan* (Chicago: The University of Chicago Press, 2006).

10. See Nissan N. Perez, *Focus East: Early Photography in the Near East, 1839–1885* (New York: Harry N. Abrams, 1988) and Edward Said, *Orientalism* (London: Penguin, 1979).

11. 'The camera introduces us to unconscious optics as does psychoanalysis to unconscious impulses.' Walter Benjamin, 'The Work of Art in the Age of Mechanical Reproduction', *Illuminations* (London: Fontana, 1979), p 239.

12. Cited in Julia Van Haaften, *Egypt and the Holy Land in Historic Photographs* (New York: Dover Books, 1980), p xvi.

13. Walter Benjamin, 'The Author as Producer', in *Thinking Photography*, Victor Burgin, ed., *Thinking Photography* (Basingstoke: Macmillan, 1982).

14. See Burgin, 'Looking at Photographs', *Thinking Photography*.

15. See 'On Composure' by Adam Phillips, *On Kissing, Tickling and Being Bored* (London: Faber & Faber, 1993).

16. See Perry Anderson's classic, *Imagined Communities* (London: Verso, 1989).

17. For a discussion of 'commitment' in relation to art see Jacques Rancière, *The Politics of Aesthetics*, translated by Gabriel Rockhill (London: Continuum, 2004), pp 60–6.

18. The German photographer Frederich von Martens invented a 150-degree-wide 'Megaskop-Kamera'. See Joel Snyder, 'Photographic Panoramas and Views', *One/Many: Western American Survey Photographs by Bell & O'Sullivan* (Chicago: University of Chicago, 2006), p 31.

19. For a general history of panoramas see Stephen Oettermann, *The Panorama: History of a Mass Media* (New York: Zone Books, 1997).

Chapter 6 The Rhetoric of Still Life

1. Norman Bryson, *Looking at the Overlooked* (London: Reaktion, 1990).

2. Martin Heidegger, 'The Origin of the Work of Art' [1935], *Basic Writings*, ed. David Krell Farrell? (London: Routledge, 1994).

3. See Fredric Jameson, 'Postmodernism of the Cultural Logic of Late Capitalism', *New Left Review*, no 146 (July/August 1984) p 59; and Jacques Derrida, *The Truth in Painting* (Chicago: University of Chicago Press, 1987).

4. Jean Baudrillard, *The System of Objects*, translated James Benedict (London: Verso, 1996), p 164.

5. There is a vast array of books that support this position, from Daniel Boorstin's famous 1960s book, *The Image* (Harmondsworth: Pelican, 1962), through to Naomi Klein's *No Logo* (London: Flamingo, 2000). Roland Barthes's 1950s classic *Mythologies* is also a benchmark text, though his semiotic analyses focus more on the ideology of products and their images than the institutions

that produced them. See also the classic semiotic-critical analysis of advertising: Judith Williamson, *Decoding Advertisements: Ideology and Meaning in Advertising* (London: Marion Boyars, 1978).

6. Raymond Williams, 'Advertising: The Magic System', *Problems in Materialism and Culture* (London: Verso, 1980), p 184.

7. See John Taylor, 'The Alphabetic Universe', *Reading Landscape: Country-City-Capital*, ed. S. Pugh (Manchester: Manchester University Press, 1990), pp 188–91.

8. Williams, 'Advertising: The Magic System'. For a discussion of the tensions about advertising and art in the USA during the late 1920s see Patricia Johnston, *Real Fantasies: Edward Steichen's Advertising Photography* (London: University of California Press, 1997), pp 39–41.

9. '… desire *is* a metonymy, however funny people may find the idea.' Jacques Lacan, 'Agency of the letter in the Unconscious', *Écrits* (London: Tavistock, 1982), p 175.

10. For a discussion of Irving Penn's still-life art and advertising work see Rosalind E. Krauss 'A Note on the Simulacral' in *The Critical Image: Essays on Contemporary Photography*, Carol Squiers, ed. (Seattle: Bay Press, 1990).

11. Svetlana Alpers, *The Art of Describing: Dutch Art in the Seventeenth Century* (Chicago: University of Chicago, 1983).

12. See Hanneke Grootenboer, *The Rhetoric of Perspective: Realism and Illusionism in Seventeenth-Century Dutch Still-life Painting* (Chicago: University of Chicago Press, 2005), p 64.

13. The best overview of Dutch and Flemish still-life painting is still Charles Sterling, *Still Life Painting, from Antiquity to the Present Time* (New York: Universe Books, 1959).

14. Sterling, *Still Life Painting, from Antiquity to the Present Time*, p 11.

15. Lucia Moholy, *A Hundred Years of Photography* (Harmondsworth: Penguin, 1939), p 165.

16. Moholy, *A Hundred Years of Photography*, p 165.

17. Moholy, *A Hundred Years of Photography*, p 165.

18. See for example, Laura Mulvey, 'Close-ups and Commodities', *Fetishism and Curiosity* (London: BFI, 1998.)

19. See, for example, Nobuyoshi Araki, *Tokyo Still Life* (Birmingham: Ikon Gallery, 2001).

20. Walter Benjamin, 'A Short History of Photography' [1931] *One Way Street and Other Writings*, translated by Edmund Jephcott and Kingsley Shorter (London: Verso, 1992).

21. Benjamin, 'A Short History of Photography' [1931] *One Way Street and Other Writings*, p 255.

22. Roland Barthes, *Mythologies* (London: Paladin, 1980).

23. Roland Barthes, 'Rhetoric of the Image', *The Responsibility of Forms* (Berkeley: University of California Press, 1991).

24. See Jean Laplanche and Jean-Bertrand Pontalis, *The Language of Psychoanalysis* (London: Karnak Books, 1988), pp 273–6.

25. Victor Burgin, *Thinking Photography*, p 190.

Chapter 7 Art Photography

1. Raymond Williams, *Keywords* (London: Fontana, 1988), pp 40–1.

2. Clement Greenberg, *Art and Culture* (Boston: Beacon Press, 1961).

3. Raymond Williams, *Culture* (London: Fontana, 1981), p 37.

4. See Thierry de Duve *Kant After Duchamp* (London: MIT, 1996), pp 89–120.

5. Williams, *Culture*, pp 128–9.

6. Jean-François Lyotard, *The Postmodern Condition: A Report on Knowledge* (Manchester: University of Manchester, 1986), p 74.

7. Lyotard, *The Postmodern Condition*, p 74.
8. The concept of narrative here is related to the 'grand narrative of legitimation' in Lyotard, *The Postmodern Condition*, pp 31–2.
9. Keith Arnatt, 'Sausages and Food' [1982], reprinted in *Art and Photography*, D. Company, ed. (London: Phaidon, 2003), p 228.
10. Rosalind E. Krauss, *A Voyage on the North Sea: Art in the Age of the Post-Medium Condition* (London: Thames & Hudson, 1999), p 56.
11. See Michael Fried, *Absorption and Theatricality: Painting and Beholder in the Age of Diderot* (Chicago: University of Chicago Press, 1986).
12. Michael Fried, *Why Photography Matters as Art as Never Before* (London: Yale University Press, 2008).
13. See Linda Nochlin, *Realism* (Harmondsworth: Penguin, 1978), pp 103–11.
14. See Nochlin, *Realism*, p 28.
15. Fried, *Why Photography Matters as Art as Never Before*, pp 340–1.
16. See, for example: Company, ed., *Art and Photography*; Charlotte Cotton, *The Photograph as Contemporary Art* (London: Thames & Hudson, 2004); T. J. Demos, ed., *Vitamin Ph: New Perspectives in Photography* (London: Phaidon, 2006); Okwui Enwezor, *Snap Judgements: New Positions in Contemporary African Photography* (Göttingen: Steidl, 2006); Uta Grosenick *et al.*, *Photo Art: The New World of Photography* (Thames & Hudson, 2008).
17 Cotton, *The Photograph as Contemporary Art*, p 7.
18. See, for example, *1965–1972 – When Attitudes Became Form* (Cambridge: Kettles Yard, 1984).
19. One of the best summaries of conceptual art is 'Global Conceptualism and North American Conceptual Art', by Peter Wollen, in *Paris Manhattan: Writings on Art (*London: Verso, 2004), pp 29–31.
20. Victor Burgin, 'Interview' [1981], reprinted in *Art and Photography*, D. Campany, ed.
21. Wollen, *Paris Manhattan*, p 30.
22. See for example, the classic book by Rozika Parker and Griselda Pollock, *Framing Feminism: Art and the Women's Movement 1970–1985* (London: Pandora, 1987).
23. See the essays in *The Last Picture Show*, Douglas Fogle, ed. (Minneapolis: Walker Art Centre, 2004).
24. Joel Meyerowitz and Colin Westerbeck, *Bystander: A History of Street Photography* (Boston: Bulfinch Press, 2001).
25. Robert Frank, *The Americans* [1958] (Göttingen: Steidl/National Gallery of Art, Washington, 2008).
26. Charlotte Cotton describes this type of work as 'Intimate Life' in *The Photograph as Contemporary Art*, pp 137–68.

Chapter 8 Global Photography

1. Fredric Jameson, *The Geopolitical Aesthetic: Cinema and Space in the World System* (London: BFI, 1992). See also Fredric Jameson and Masao Miyoshi, eds., *The Cultures of Globalization* (Durham, N.C: Duke University Press, 1998).
2. Jameson, *The Geopolitical Aesthetic*, p 3. See also Jameson and Masao Miyoshi, eds., *The Cultures of Globalization*.
3. Talbot's Calotype negative/positive process emerged patented in Britain two years later, in 1841.
4. Aaron Scharf, *Art and Photography* (Harmondsworth: Penguin, 1979), p 80.

5. See Ann M. Shumard, *A Durable Memento: Portraits by Augustus Washington: African-American Daguerreotypist* (Washington, DC: National Portrait Gallery/Smithsonian, 1999).

6. See George Sullivan, *Black Artists in Photography, 1840–1940* (New York: Cobblehill Books, 1996), p 39. Also see: Deborah Willis-Thomas, *Black Photographers, 1840–1940: An Illustrated Bio-Bibliography* (London: Garland, 1985).

7. See Eric Hobsbawm, *The Age of Capital 1848–1875* (London: Weidenfeld & Nicolson, 1975), p 152.

8. This was at the Kaiseijo Research Institution, developed from the 'Institute for the Investigation of Western Books'. See Kinoshita Maoyuki, 'The Early Years of Japanese Photography' in *History of Japanese Photography*, Anne Wilkes Tucker, Dana Friis-Hansen, Kaneko Ryuichi, eds. (London: Yale University Press, 2003), p 22.

9. In fact, Godard says 'Trade follows films'. See Colin MacCabe, ed., *Jean-Luc Godard, Son + Image, 1974–1991* (New York: Museum of Modern Art, 1992), p 131.

10. See Christopher Pinney, *Camera Indica: The Social Life of Indian Photographs* (London: Reaktion Books, 1997), p 17.

11. See G. Thomas, *History of Photography: India, 1840–1980* (Hyderabad: Andhra Pradesh State Akademi of Photography, 1981), p 8.

12. On the use of photography in the First World War see John Taylor, 'Photography as a Weapon at the Front', *War Photography: Realism in the British Press* (Manchester: Manchester University Press, 1991).

13. See Eric Hobsbawm, 'The Age of Total War' in *Age of Extremes: The Short Twentieth Century, 1914–1991* (London: Penguin, 1994). On the use of photography also see Taylor, 'Photography as a Weapon at the Front', *War Photography: Realism in the British Press.*

14. See Edward Steichen, *The Family of Man* (New York: Museum of Modern Art, 1955), p 3 and Eric J. Sandeen, *Picturing an Exhibition: The Family of Man and 1950s America* (Alberquerque: University of New Mexico, 1995), p 95.

15. Steichen, 'Introduction', *The Family of Man*, p 3.

16. Roland Barthes, 'The Great Family of Man' in *Mythologies* (London: Paladin, 1980), p 100.

17. Barthes is in a long line of anti-humanist criticism in France, which perhaps only shows how deeply popular humanism was embedded in French culture. Also see 'Truth of the Colonies' … David Bate, *Photography and Surrealism* (London: IB Tauris, 2004).

18. Barthes, 'The Great Family of Man' in *Mythologies*, p 100.

19. See: Christopher Phillips, 'The Judgement Seat of Photography', *The Contest of Meaning*, Richard Bolton, ed. (London: MIT, 1992); Allan Sekula, 'Traffic in Photographs' in *Against the Grain* (Nova Scotia: NSCAD, 1986); Blake Stimson, 'Photographic Being and The *Family of Man*', *The Pivot of the World: Photography and its Nation* (London: MIT, 2006).

20. See Sandeen, *Picturing an Exhibition*, p 155. (My thanks to Leena Saraste and Elina Heikka for pointing me to this Moscow incident.)

21. The offending photograph is printed in *The Family of Man* catalogue, p 153.

22. Sandeen, *Picturing an Exhibition*, p 155.

23. Tim Burners-Lee, *Weaving the Web* (New York: Harper Collins, 2000). See also: http://www.w3.org/People/Berners-Lee/FAQ

24. http://www.w3.org

25. These manipulations usually turn out to have more to do with the aims of the people who use photography rather than the technology itself.

26. See Paul Frosh, *The Image Factory* (Oxford: Berg, 2003).

27. Frosh, *The Image Factory*, p 74.

28. For a case study of 'anti-globalization' organizations using the web see: Jeffrey S Juris, 'The New Digital Media Activist Networking with Anti-Corporate Globalization Movements' in Jonathan Xavier Inda and Renato Rosaldo, eds., *The Anthropology of Globalization: A Reader* (Oxford: Blackwell, 2008).

29. Arjun Appadurai, 'Disjuncture and Difference', *The Anthropology of Globalization*, p 60.

30. Slavoj Žižek gives the example of the impact of the Danish newspaper cartoon of the Prophet Mohammad, which circulated and was reacted to as though it was published *in* those Muslim countries. The web collapsed the geographical distance between countries into one space 'on the web'. See Slavoj Žižek, *Violence* (London: Profile Books, 2008), p 50.

31. Sigmund Freud, 'Creative Writers and Day-Dreaming' [1908], *Art and Literature*, Pelican Freud Library Volume 14 (London: Penguin, 1985), p 134.

32. Victor Burgin gives an excellent example of the role of the image in modern distraction in *The Remembered Film* (London: Reaktion, 2004); see especially pp 7–14.

SELECT BIBLIOGRAPHY

Alpers, Svetlana, *The Art of Describing: Dutch Art in the Seventeenth Century*, Chicago: University of Chicago, 1983.

Althusser, Louis, *Lenin and Philosophy: and Other Essays*, translated by Ben Brewster, London: New Left Books, 1971.

Appadurai, Arjun, 'Disjuncture and Difference', in Jonathan Xavier Inda and Renato Rosaldo, eds., *The Anthropology of Globalization: A Reader,* Oxford: Blackwell, 2008.

Araki, Nobuyoshi, *Tokyo Still Life*, Birmingham: Ikon Gallery, 2001.

Armstrong, Carol 'A Scene in a Library: An Unsolved Mystery', *History of Photography*, 26: 2, 2002, pp 90–9.

Arnatt, Keith, 'Sausages and Food' [1982], reprinted in *Art and Photography*, ed. D. Campany, London: Phaidon, 2003.

Barasch, Mose, *Theories of Art 2: From Winckelmann to Baudelaire,* London: Routledge, 2000.

Barthes, Roland, *Image-Music-Text,* London: Fontana, 1982.

Barthes, Roland, *Mythologies*, London: Paladin, 1980.

Barthes, Roland, *The Fashion System*, translated by Matthew Ward and Richard Howard, New York: Hill & Wang, 1983.

Barthes, Roland, *Camera Lucida*, London: Fontana, 1984.

Barthes, Roland, 'Semiology and Urbanism', *The Semiotic Challenge*, Oxford: Blackwell, 1988.

Barthes, Roland, 'Rhetoric of the Image', *The Responsibility of Forms*, Berkeley: University of California Press, 1991.

Barthes, Roland, *The Neutral*, translated by Rosalind E. Krauss and Denis Hollier, New York: Columbia University Press, 2005.

Bate, David, *Mise-en-Scène*, London: Institute of Contemporary Arts, 1994.

Bate, David, *Photography and Surrealism: Sexuality, Colonialism and Social Dissent*, London: IB Tauris, 2004.

Baudrillard, Jean, *The System of Objects*, translated by James Benedict, London: Verso, 1996.

Baxandall, Michael, *Painting and Experience in Fifteenth-Century Italy*, Oxford: Oxford University Press, 1988.

Bazin, André, 'The Ontology of the Photographic Image', in Alan Trachtenberg, ed., *Classic Essays on Photography*, New Haven: Leete's Island, 1980.

Benjamin, Walter, 'The Work of Art in the Age of Mechanical Reproduction', *Illuminations*, London: Fontana, 1979.

Benjamin, Walter [1931], 'A Short History of Photography', *One Way Street and Other Writings*, Trans. Edmund Jephcott and Kingsley Shorter, London: Verso, 1992.

Berger, John, *Ways of Seeing*, London: Penguin, 1990.

Bermingham, Ann, *Landscape as Ideology: The English Rustic Tradition, 1740–1887*, London: Thames & Hudson, 1987.

Boorstin, Daniel, *The Image,* Harmondsworth: Pelican, 1962.

Bourdieu, Pierre [1965], *Photography: A Middle-Brow Art*, Cambridge: Polity, 1990.

Bryson, Norman, *Looking at the Overlooked*, London: Reaktion Books, 1990.

Buchloh, Benjamin, ed., *Thomas Ruff: Portraits*, Mosel: Schirmer, 1998.

Burgin, Victor, ed., *Thinking Photography*, Basingstoke: Macmillan, 1982.

Burgin, Victor, *The Remembered Film*, London: Reaktion, 2004.

Burgin, Victor [1976], 'Art, Commonsense and Photography', in Jessica Evans, ed., *The Camerawork Essays*, London: Rivers Oram Press, 1997.

Burners-Lee, Tim, *Weaving the Web*, New York: Harper Collins, 2000.

Campany, David, ed., *The Cinematic Image*, London: Whitechapel/MIT Press, 2007.

Cotton, Charlotte, *The Photograph as Contemporary Art*, London: Thames & Hudson, 2004.

de Duve, Thierry, *Kant After Duchamp*, London: MIT, 1999.

Eco, Umberto, 'Critique of the Image', in *Thinking Photography*, ed. Victor Burgin, Basingstoke: Macmillan, 1982.

Emerson, P. H., *Naturalistic Photography*, New York: Spon, 1890.

Evans, Harold, ed., *Pictures on a Page: Photojournalism, Graphics and Editing*, London: Pimlico Press, 1997.

Fenichel, Otto [1935], 'The Scoptophilic Instinct and Identification', in Jessica Evans and Stuart Hall, eds., *The Visual Culture Reader*, London: Sage Publications/Open University, 1999.

Fiske, John, 'The Jeaning of America', *Understanding Popular Culture*, London: Unwin Hyman, 1989.

Foster, Hal, *et al*, *Art Since 1900: Modernism, Antimodernism, Postmodernism* (London: Thames & Hudson, 2004.

Flugel, John, *The Psychology of Clothes*, London: Hogarth Press, 1930.

Fogle, Douglas, ed., *The Last Picture Show*, Minneapolis: Walker Art Centre, 2004.

Foucault, Michel [1967], 'Different Spaces', in James Faubion, ed., *Aesthetics: Essential Works of Foucault, 1954–1984*, Volume 2, London: Penguin, 1998.

Frank, Robert, *The Americans* [1958], Göttingen: Steidl/National Gallery of Art, Washington, 2008.

Freud, Sigmund [1915], 'Instincts and their Vicissitudes', *On Metapsychology,* translated by James Strachey, Pelican Freud Library Vol. 11, Harmondsworth: Penguin, 1983.

Freud, Sigmund [1908], 'Creative Writers and Day-Dreaming', *Art and Literature*, translated by James Strachey, Pelican Freud Library Vol. 14, Harmondsworth: Penguin, 1985.

Freud, Sigmund, [1930], 'Civilization and its Discontents', *Civilization, Society and Religion*, translated by James Strachey, Pelican Freud Library Vol. 12, Harmondsworth: Penguin, 1989.

Fried, Michael, *Why Photography Matters as Art as Never Before*, London: Yale University Press, 2008.

Frizot, Michel, ed. [1994 in French], *A New History of Photography*, Cologne: Könemann, 1998.

Frosh, Paul, *The Image Factory*, Oxford: Berg, 2003.

Gernsheim, Helmet and Alison Gernsheim, *The History of Photography*, London: Oxford University Press, 1955.

Gombrich, Ernst H., 'Portrait Painting and Portrait Photography', in Paul Wengraf, ed., *Apropos* No. 3, London: Lund Humphries, 1945, pp 1–7.

Gombrich, Ernst H., *The Story of Art*, London: Phaidon, 1999.

Greenberg, Clement, *Art and Culture*, Boston: Beacon Press, 1961.

Grierson, John, 'Untitled Lecture on Documentary' (1927–33) in *The Documentary Film Movement: An Anthology*, ed. by Ian Aitken, Edinburgh, Edinburgh University Press, 1998.

Grootenboer, Hanneke, *The Rhetoric of Perspective: Realism and Illusionism in Seventeenth-Century Dutch Still-life Painting*, Chicago: University of Chicago Press, 2005.

Hall, Stuart, 'Re-construction Work', *Ten.8*, Volume 2, no 3, 1992.

Hawkes, Terence, *Structuralism and Semiotics*, London: Methuen, 1977.

Heidegger, Martin [1935], 'The Origin of the Work of Art', in David Krell Farrell, ed., *Basic Writings*, London: Routledge, 1994.

Hobsbawm, Eric, *The Age of Capital 1848–1875*, London: Weidenfeld & Nicholson, 1975.

Hobsbawm, Eric, *Age of Extremes: The Short Twentieth Century, 1914–1991*, London: Penguin, 1994.

Jameson, Fredric, 'Postmodernism of the Cultural Logic of Late Capitalism', *New Left Review*, no 146, 1984.

Jameson, Fredric, *The Geopolitical Aesthetic: Cinema and Space in the World System*, London: BFI, 1992.

Jameson, Fredric and Masao Miyoshi, eds., *The Cultures of Globalization*, Durham, NC: Duke University Press, 1998.

Johnston, Patricia, *Real Fantasies: Edward Steichen's Advertising Photography*, London: University of California Press, 1997.

Juris, Jeffrey S., 'The New Digital Media Activist Networking with Anti-Corporate Globalization Movements', in Jonathan Xavier Inda and Renato Rosaldo, eds., *The Anthropology of Globalization: A Reader*, Oxford: Blackwell, 2008.

Kinoshita, Naoyuki, 'The Early Years of Japanese Photography' in Anne Wilkes Tucker, Dana Friis-Hansen and Kaneko Ryuichi, eds., *The History of Japanese Photography*. New Haven, CT: Yale University Press, 2003.

Klein, Naomi, *No Logo*, London: Flamingo, 2000.

Kozloff, Max, *The Theatre of the Face: Portrait Photography Since 1900*, London: Phaidon, 2007.

Krauss, Rosalind E., 'A Note on the Simulacral' in Carol Squiers, ed., *The Critical Image: Essays on Contemporary Photography*, Seattle: Bay Press, 1990.

Krauss, Rosalind E., *The Originality of the Avant-Garde and Other Modernist Myths,* London: MIT Press, 1997.

Krauss, Rosalind E., *A Voyage on the North Sea: Art in the Age of the Post-Medium Condition* (London: Thames & Hudson, 1999).

Kristeva, Julia, *Black Sun: Depression and Melancholia*, translated by Leon S. Roudiez, New York: Columbia University Press, 1989.

Lacan, Jacques, 'Of the Gaze', *Four Fundamentals of Psycho-Analysis*, London: Hogarth Press, 1977.

Lacan, Jacques, *The Four Fundamental Concepts of Psycho-Analysis*, Harmondsworth: Penguin, 1979.

Lacan, Jacques, 'The Mirror-stage as Formative of the I', *Écrits*, translated by Alan Sheridan, London: Tavistock Publications, 1980.

Lalvani, Suren, *Photography, Vision, and the Production of Modern Bodies*, New York: State University Press of New York, 1996.

Laplanche, Jean and Jean-Bertrand Pontalis, 'Fantasy and the Origins of Sexuality', in Victor Burgin, James Donald and Cora Kaplan, eds., *Formations of Fantasy,* London/New York: Methuen, 1986.

Laplanche, Jean and Jean-Bertrand Pontalis, *The Language of Psychoanalysis*, London: Karnak Books, 1988.

Lavin, Maud, *Cut with the Kitchen Knife*, London: Yale University Press, 1993.

Leader, Darian, *Stealing the Mona Lisa*, Washington, DC: Shoemaker & Hoard, 2002.

Lemagny, Jean-Claude and André Rouillé (eds), *A History of Photography*, New York: Cambridge University Press, 1987.

Lyotard, Jean-François, *The Postmodern Condition*, Manchester: Manchester University Press, 1986.

MacCabe, Colin, ed., *Jean-Luc Godard: Son+Image, 1974-1991*, New York: Museum of Modern Art, 1992.

Marx, Karl, 'The Eighteenth Brumaire of Louis Bonaparte', *Marx/Engels: Selected Works*, London: Lawrence & Wishart, 1980.

Meyerowitz, Joel and Westerbeck, Colin, *Bystander: A History of Street Photography*, Boston: Bulfinch Press, 2001.

Moholy, Lucia, *A Hundred Years of Photography*, Harmondsworth: Penguin, 1939.

Mulvey, Laura [1975], 'Visual Pleasure and Narrative Cinema', *Visual and Other Pleasures*, Basingstoke and London: Macmillan, 1989.

Mulvey, Laura, 'Close-ups and Commodities', *Fetishism and Curiosity*, London: BFI, 1996.

Neale, Steve, *Genre*, London: BFI, 1980.

Neale, Steve, 'Questions of Genre', *Screen*, 31:1, 1990, pp 45–66.

Nesbit, Molly, *Atget's Seven Albums*, London: Yale University Press, 1992.

Newhall, Beaumont, *The History of Photography: From 1939 to the Present Day*, New York: Museum of Modern Art, 1980 [1964].

Nochlin, Linda, *Realism*, Harmondsworth: Penguin, 1978.

Nochlin, Linda, *Women, Art and Power and Other Essays,* London: Thames & Hudson, 1989.

Oettermann, Stephen, *The Panorama, History of a Mass Media,* New York: Zone Books, 1997.

Panofsky, Erwin [1934], 'Style and Medium in the Motion Pictures', in Irving Lavin, ed., *Three Essays on Style*, Cambridge, MA: MIT, 1997.

Parker, Rozika and Pollock, Griselda, *Framing Feminism: Art and the Women's Movement 1970–1985*, London: Pandora, 1987.

Paulson, Ronald, 'The Poetic Garden', *Emblem and Expression*, London: Thames & Hudson, 1975.

Phillips, Christopher, 'The Judgment Seat of Photography', in Richard Bolton, ed., *The Contest of Meaning*, London: MIT, 1992.

Pinney, Christopher, *Camera Indica: The Social Life of Indian Photographs*, London: Reaktion Books, 1997.

Pollock, Griselda, *Vision and Difference,* London: Routledge, 1989.

Praz, Mario, *The Romantic Agony*, London: Fontana, 1966.

Rancière, Jacques, *The Politics of Aesthetics*, translated by Gabriel Rockhill, London: Continuum, 2004.

Riis, Jacob A., *How the Other Half Lives* Harmondsworth: Penguin, 1997.

Rose, Jacqueline, 'The Imaginary', *Sexuality in the Field of Vision*, London: Verso, 1986.

Rosenblum, Barbara, 'Style as Social Process', *American Sociological Review*, 43, 1978, pp 422–38.

Rosenblum, Naomi, *A World History of Photography*, London: Abbeville, 1984.

Rosler, Martha, *Decoys and Disruptions*, London: MIT, 2004.

Roudinesco, Elizabeth, 'Surrealism in the Service of Psychoanalysis', *Jacques Lacan & Co: A History of Psychoanalysis in France 1925–1985*, translated by Jeffrey Mehlman, London: Free Association Books, 1990.

Rugoff, Ralph, ed., *Scene of the Crime*, London: MIT, 1997.

Sandeen, Eric J., *Picturing an Exhibition: The Family of Man and 1950s America*, Alberquerque: University of New Mexico, 1995.

Saussure, Ferdinand de, *Course in General Linguistics*, New York: Fontana/Collins, 1981.

Schaaf, Larry J., *The Photographic Art of William Henry Fox Talbot*, Oxford: Princeton, 2000.

Scharf, Aaron, *Art and Photography*, Harmondsworth: Penguin, 1979.

Schefer, Jean Louis, 'Split Colour/Blur', in Paul Smith, ed. and transl., *The Enigmatic Body: Essays on the Arts*, Cambridge: Cambridge University Press, 1995.

Sekula, Allan, 'Traffic in Photographs', *Against the Grain*, Nova Scotia: NSCAD, 1986.

Sekula, Allan, 'On The Invention of Photographic Meaning', in Victor Burgin, ed., *Thinking Photography*, Basingstoke: Macmillan, 1982.

Sekula, Allan, 'The Body and the Archive', in Richard Bolton, ed., *The Contest of Meaning: Critical Histories of Photography*', London: MIT Press, 1996.

Shumard, Ann M., *A Durable Memento: Portraits by Augustus Washington: African-American Daguerreotypist*, Washington, DC: National Portrait Gallery/Smithsonian, 1999.

Snyder, Joel, 'Photographic Panoramas and Views', *One/Many: Western American Survey Photographs by Bell and O'Sullivan,* Chicago: the University of Chicago Press, 2006.

Sobieszek, Robert, *Ghost in the Shell: Photography and the Human Soul, 1850–2000*, Cambridge, Massachusetts: MIT Press & Los Angeles County Museum, 1999.

Solomon-Godeau, Abigail, *Photography at the Dock*, Minneapolis: Minnesota Press, 1995.

Squiers, Carol, 'Looking at *Life*', *Illuminations: Women Writing on Photography from the 1850s to the Present*, eds. Liz Heron and Val Williams, London: I B Tauris, 1996

Steichen, Edward, *The Family of Man*, New York: Museum of Modern Art, 1955.

Steinart, Otto, *Subjective Photography* [*Subjektive fotografie*], two volumes, Munich: Bruder Auer, 1955.

Sterling, Charles, *Still Life Painting, from Antiquity to the Present Time*, New York: Universe Books, 1959.

Stimson, Blake, *The Pivot of the World: Photography and its Nation*. London: MIT, 2006.

Sullivan, George, *Black Artists in Photography, 1840–1940*, New York: Cobblehill Books, 1996.

Tagg, John, *The Burden of Representation*, Basingstoke: Macmillan, 1988.

Takeba, Joe, 'The Age of Modernism: From Visualization to Socialization', in Anne Wilkes Tucker, Dana Friis-Hansen and Kaneko Ryuichi, eds., *The History of Japanese Photography*. New Haven, CT: Yale University Press, 2003.

Taylor, John, 'The Alphabetic Universe', in Simon Pugh (ed.), *Reading Landscape: Country-City-Capital*, Manchester: Manchester University Press, 1990.

Taylor, John, 'Photography as a Weapon at the Front', *War Photography: Realism in the British Press*, Manchester: Manchester University Press, 1991.

Thomas, G., *History of Photography: India, 1840-1980*, Hyderabad: Andhra Pradesh State Akademi of Photography, 1981.

Trachtenberg, Alan, 'Signifying the Real: Documentary Photography in the 1930s' in Alejandro Andreus *et al*, *The Social and the Real: Political Art of the 1930s in the Western Hemisphere*, Pennsylvania: Pennsylvania State University, 2004.

Tucker, Anne Wilkes, Friis-Hansen, Dana, Ryuichi, Kaneko and Takebo, Joe (eds.), *The History of Japanese Photography*, New Haven, CT: Yale University Press, 2003.

Turim, Maureen Cheryn, *Flashbacks in Film*, London: Routledge, 1989.

Van Haaften, Julia, *Egypt and the Holy Land in Historic Photographs: Seventy-seven Views by Francis Frith*, New York: Dover Books, 1980.

Warehime, Marja, *Brassaï, Images of Culture and the Surrealist Observer*, London: Louisiana State University Press, 1996.

Williams, Raymond, 'Advertising: The Magic System', *Problems in Materialism and Culture*, London: Verso, 1980.

Williams, Raymond, *Culture*, London: Fontana, 1981.

Williams, Raymond, *Keywords, A Vocabulary of Culture and Society,* London: Fontana, 1988.

Williams, Raymond, 'The Growth of the Popular Press', *The Long Revolution*, London: Hogarth Press, 1992.

Williamson, Judith, *Decoding Advertisements: Ideology and Meaning in Advertising*, London: Marion Boyars, 1978.

Willis-Thomas, Deborah, *Black Photographers, 1840–1940: An Illustrated Bio-Bibliography*, London: Garland, 1985.

Wollen, Peter, 'Fire and Ice', *The Photography Reader*, ed. Liz Wells, London: Routledge, 2003.

Wollen, Peter, *Paris Manhattan: Writings on Art*, London: Verso, 2004.

Žižek, Slavoj, *Violence*, London: Profile Books, 2008.

INDEX